San Francisco Bay

San Francisco Bay

PORTRAIT OF AN ESTUARY

Text by
JOHN HART

Photographs by
DAVID SANGER

UNIVERSITY OF CALIFORNIA PRESS

BERKELEY · LOS ANGELES · LONDON

University of California Press
Berkeley and Los Angeles, California

University of California Press, Ltd.
London, England

Designed by Jennifer Barry Design, Fairfax, California
Layout production by Kristen Wurz
Maps by Ben Pease, Pease Press, San Francisco, California

Library of Congress Cataloging-in-Publication Data

Hart, John, 1948–
 San Francisco Bay : portrait of an estuary / text by John Hart ;
photographs by David Sanger.
 p. cm.
 Includes bibliographical references and index.
 ISBN 0-520-23399-9 (cloth : alk. paper)
 1. San Francisco Bay (Calif.)—Pictorial works. 2. San Francisco Bay (Calif.)—
Description and travel. 3. San Francisco Bay (Calif.)—Environmental conditions.
4. Sacramento–San Joaquin Estuary (Calif.)—Pictorial works. 5. Sacramento–San Joaquin
Estuary (Calif.)—Environmental conditions. 6. Natural history—California—San Francisco
Bay—Pictorial works. 7. Natural history—California—San Francisco Bay. 8. Natural
history—California—Sacramento–San Joaquin Estuary. I. Sanger, David, 1949– . II. Title.

F868.S156 H365 2003
979.4'6'00222—dc21 2002152223

Manufactured in Italy

12 11 10 09 08 07 06 05 04 03
10 9 8 7 6 5 4 3 2 1

The paper used in this publication meets the minimum requirements
of ANSI/NISO Z39.48-1992 (R 1997) (*Permanence of Paper*).

Patrons

The authors gratefully acknowledge the generous contributions of the following toward the preparation of this book:

The Bay Institute of San Francisco
Audubon's San Francisco Bay Restoration Program
The Resources Legacy Fund on behalf of
 the David and Lucile Packard Foundation
The Nu Lambda Trust
The Mary A. Crocker Trust
Furthermore: a program of the J.M. Kaplan Fund
The San Francisco Bay Joint Venture
The Fred Gellert Family Foundation
Professor Harrison C. Dunning
The CALFED Science Program,
 through support of a related product

The publisher gratefully acknowledges the generous contribution toward the publication of this book provided by the General Endowment Fund and the Director's Circle of the University of California Press Associates, whose members are

Jeanne Falk Adams
Jola and John Anderson
Elaine Mitchell Attias
Alice and Robert Bridges
June and Earl Cheit
Margit and Lloyd Cotsen
Camille Crittenden
Sonia Evers
Wilma and William Follette
Jean Gold Friedman
Phyllis K. Friedman
August Frugé
Sukey and Gil Garcetti
Sheila and David Gardner
Thomas C. Given
Harriett and Richard Gold
Ann and Bill Harmsen
Florence and Leo Helzel
Mrs. Charles Henri Hine
Marsha Rosenbaum and John Irwin

Barbara S. Isgur
Beth and Fred Karren
Jeannie and Edmund Kaufman
Nancy Livingston and Fred Levin,
 The Shenson Foundation
Sally Lilienthal
Sheila and David Littlejohn
Susan and James McClatchy
Jack Miles
Thormund Miller
Nancy and Timothy Muller
Joan Palevsky
Mauree Jane and Mark Perry
Jennifer and Mark Richard
Bernat Rosner
Frances and Loren Rothschild
Shirley and Ralph Shapiro
Sharon and Barclay Simpson
Judith and William Timken
Valerie Barth and Peter Wiley

The publisher also gratefully acknowledges the generous contributions of Audubon and of The Bay Institute of San Francisco in support of this publication.

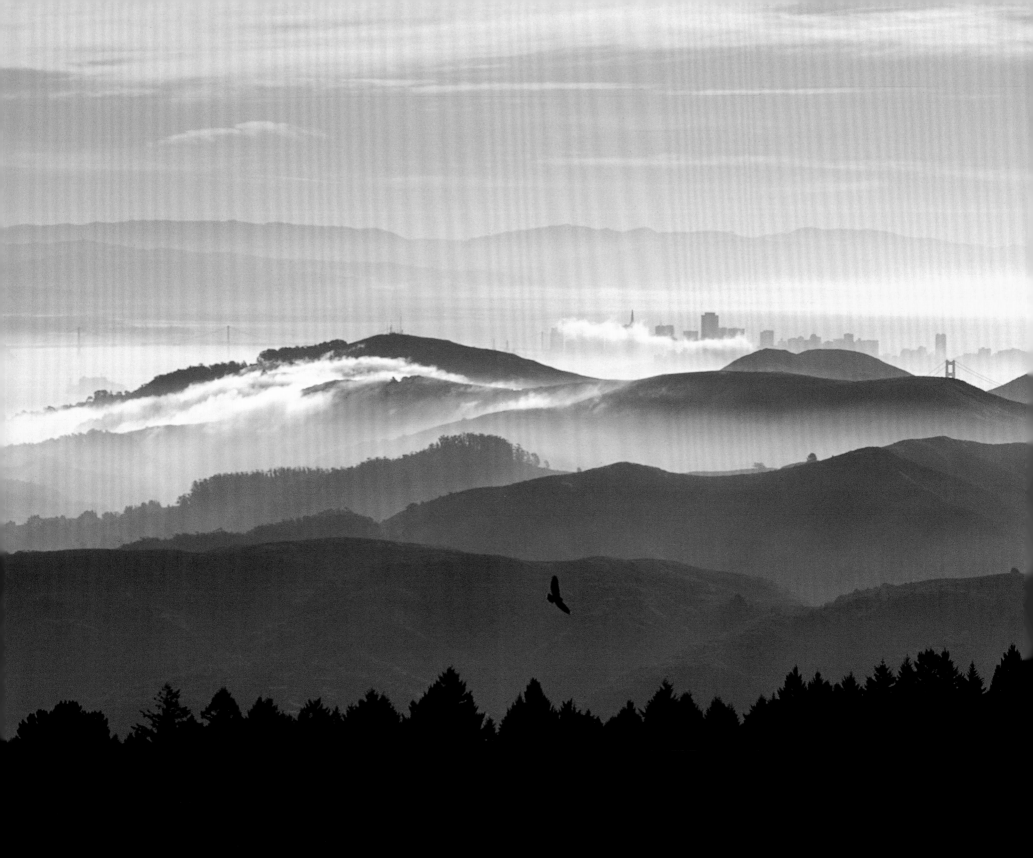

Contents

View southeast from Mount Tamalpais.

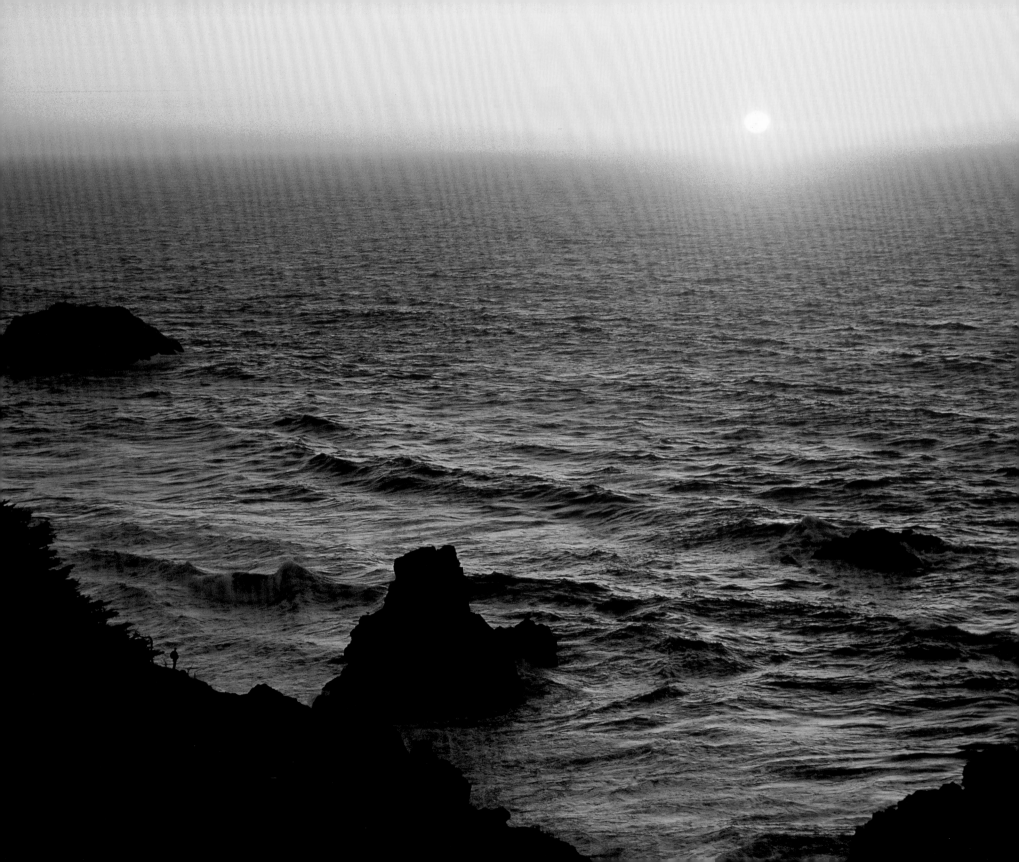

Foreword

During the twentieth century the American conservation movement concentrated almost exclusively on defense: saving plants and animals from extinction, preserving habitat, and halting pollution. It was all conservationists could do to simply "save the pieces," as the naturalist Aldo Leopold once said, with little energy left over to think about actual restoration.

While that vital work continues throughout the United States, a growing coalition of concerned citizens, community, business, and conservation groups is focused on an exciting new opportunity: to restore large sections of the wetlands that once surrounded San Francisco Bay and the Sacramento–San Joaquin River Delta.

Through this plan to reassemble major pieces of one of America's most prominent ecosystems, a large region of northern California would begin to recover lost ecological functions and would eventually return to a natural splendor not seen in most settled areas for generations.

Like the Everglades, San Francisco Bay and its Sacramento–San Joaquin Delta—collectively called the San Francisco Estuary—form an ecosystem unique in its complexity, scale, economic value, and recreational opportunities. Unfortunately, it is also one of the most substantially degraded estuaries in North America.

Restoring the San Francisco Estuary's health means acting to remedy the four major stresses that have damaged it.

The first is the loss of the wetlands that once fringed San Francisco Bay. In 1850 there were three hundred square miles of salt marshes west of the delta; today only one in five of these is left. Only a fraction of this area exists in large, mature blocks, complete with the meandering channels that make the best nurseries for fish and prime habitat for birds and other marsh-dependent animals.

The second stress is the reduction by nearly half, on average, of freshwater flows into the estuary from the larger Central Valley watershed during the crucial spring snowmelt season.

The third is pollution, reduced from the high levels of the 1960s but still severe enough that northern Californians are warned to limit consumption of bay-caught fish. This continues to make a big economic impact on the bay's once-productive fisheries.

The fourth is the influx of exotic plants and animals that arrive from around the world, mostly on ships, constantly changing and destabilizing the estuary's ecosystem.

Fog off Lands End at the southern entrance to the Golden Gate. A band of fog is usually present in summer along this coast, off the shore or on.

Ultimately, the restoration of San Francisco Bay will require that all four factors be addressed. Recently, the coalition of public and private organizations has focused efforts on the acquisition and restoration of wetlands. The vision of a restored bay has emerged, and a detailed plan exists for restoring ninety square miles of tidal marshes and improving the management of another sixty square miles of associated bay habitat, such as salt ponds. To put into perspective the scale of these parcels, consider that the entire city of San Francisco covers just forty-nine square miles.

The restoration of something as complex and productive as a tidal marsh takes time and involves many challenges. This book describes some of them, but we are already taking the first big steps down this path. At press time, almost half the former marshlands slated for restoration are publicly owned. The unique public-private acquisition of twenty-five square miles of salt ponds in the South Bay, together with the fifteen square miles in the North Bay acquired a decade ago, signifies the bay's potential for recovery and demonstrates the level of commitment that is already in place to make this vision a reality.

The restoration effort doesn't stop at the bay's edge. It harnesses the power of students and teachers, community groups, and all levels of government to extend up the many streams and rivers that feed the estuary's ecosystem. Conservationists are working to rehabilitate streams that have been degraded and sometimes even buried by urban development; they are also pioneering the reestablishment of riverside forests. Further cause for celebration are the first releases of water to the San Joaquin River, which had been seasonally dry for more than half a century as a result of dams and diversions.

We hope you'll enjoy this book's panoramic view of the San Francisco Estuary's varied past, complex present, and promising future. We also hope you'll be inspired to learn more about helping fulfill the promise of bay restoration. Whether you like to get your hands dirty restoring a creek, monitor birds at your favorite spot by the bay, or just experience the serenity of a salt marsh, we urge you to discover what else you can do to help conservation organizations and policymakers advance the great work of restoring the bay!

Grant Davis, Executive Director, The Bay Institute of San Francisco
John Flicker, President, Audubon

Acknowledgments

This book owes its existence to the generosity of many people, in many forms.

The Bay Institute of San Francisco, our original sponsor, has been our partner at every turn. We are honored to have Audubon's San Francisco Bay Restoration Program as co-sponsor. Our warm appreciation also to the patrons listed opposite the copyright page and to generous donors Adobe, Inc.; Alexander & Baldwin, Inc.; Jack Beggs; Bill Booth; and Meadowsweet Dairy.

Many people shared with us their knowledge of aspects of San Francisco Bay and the Sacramento–San Joaquin Delta. Among the most generous of these guides and informants were Chris Bandy of Alameda National Wildlife Refuge; Saul Bloom of Arc Ecology; Gary Bobker of The Bay Institute of San Francisco; Scott E. Bohannon of the Can-Can Club in Suisun Marsh; Dick Bunce of the Golden Gate National Parks Association; Jim Cloern of the U.S. Geological Survey; Joshua N. Collins of the San Francisco Estuary Institute; James Counts of the San Mateo County Mosquito Abatement District; William T. Davoren of The Bay Institute of San Francisco; Mike Eaton of The Nature Conservancy; Ramona Garibay, Native Ohlone Monitor; Jack Heyman of the International Longshore and Warehouse Union; Marc Holmes of The Bay Institute of San Francisco; Gordon Hough, skipper of the party boat *Morning Star;* Tom Huffman of the California Department of Fish and Game; Bill Jennings, the DeltaKeeper; Leslie Emmington Jones of Collinsville on the Sacramento River; Kay Kerr, co-founder of the Save San Francisco Bay Association; Norm Kidder of the East Bay Regional Parks District; William Kier of William Kier Associates, fisheries biologists; Nancy Kittle, kayaker and birder; Ernie Koepf, skipper of the herring boat *Ursula B;* Marge Kolar, manager of Don Edwards San Francisco Bay National Wildlife Refuge; Larry Kolb of the San Francisco Bay Regional Water Quality Control Board; Florence and Philip LaRiviere of the Citizens Committee to Complete the Refuge; Marilyn Latta of Save the Bay; Anna Lee, herring fisher; Bob Licht of Sea Trek; Samuel N. Luoma of the U.S. Geological Survey and CALFED; Grier Mathews of the Golden Gate National Parks Association; Sylvia McLaughlin, co-founder of the Save San Francisco Bay Association; Captain E. D. Melvin of the San Francisco Bar Pilots; Elaine Miller of Marine Terminals Corporation; Peter Moyle of the University of California at Davis; Keith G. Olsen of the Crockett Museum; Beverly Ortiz of Coyote Hills Regional Park; Randy Parent, helicopter pilot, East Bay Regional Park District;

David H. Peterson of the U.S. Geological Survey; Alan Ramo of the Golden Gate University Environmental Law Clinic; Fritz Reid of Ducks Unlimited; Paul Revier of Save the Bay; Captain Charles Rhodes of the San Francisco Bar Pilots; Marilyn Sandifur of the Port of Oakland; Jim and Sally Shanks, farmers on Staten Island; Jean Siri of the East Bay Regional Park District; Regina Stoops of Angel Island State Park; Tina Swanson of The Bay Institute of San Francisco; Will Travis of the San Francisco Bay Conservation and Development Commission; Peter Vorster of The Bay Institute of San Francisco; Philip Williams of Philip Williams and Associates, hydrologists; pilot Daniel Wilson; and Bryan Winton of San Pablo Bay National Wildlife Refuge.

Warm thanks of another sort are due to the people who pitched in to bring this unusually complex book project to realization, including Jennifer Barry of Jennifer Barry Design; Sam Bloomberg-Rissman, for invaluable office assistance; Marcia Brockbank of the San Francisco Estuary Project; Tony Crouch of the University of California Press; Grant Davis of The Bay Institute of San Francisco; Debbie Drake of Audubon's San Francisco Bay Restoration Program; Professor Harrison C. Dunning, water policy guru; Robert J. Erickson of The Bay Institute of San Francisco; John Flicker, President of Audubon; Tracy Grubbs of Audubon's San Francisco Bay Restoration Program; Hugh Helm of the New Lab; Delia Hitz of The Bay Institute of San Francisco; Deborah Kirshman and Doris Kretschmer of the University of California Press; Lynn Meinhardt, also of the Press; Dev Novack of Audubon's San Francisco Bay Restoration Program; Robert Outis, attorney; Ben Pease, cartographer; John C. Racanelli of The Bay Institute of San Francisco; Robyn Rickansrud of Cantoo Lab; Sally Sanger, for continuing support and encouragement; Nicole Stephenson for invaluable office assistance; Mary Anne Stewart, copyeditor extraordinaire; Carmen Torres of Audubon's San Francisco Bay Restoration Program; Rose Vekony, project editor at University of California Press; Janet Villanueva, production coordinator at the Press; and Kristen Wurz of Jennifer Barry Design.

Important assistance along the way came also from Brian Aldrich of the U.S. Coast Guard; Lew Allen of the Can Club in the Napa-Sonoma Marshes; George M. Anderson of the California Department of Water Resources; Chuck Armor of the California Department of Fish and Game; Peter Baye of the U.S. Fish and Wildlife Service; Norma Beck of the California Department of Water Resources; Lieutenant

Dawn Black of the U.S. Coast Guard; Joseph E. Bodovitz, first executive director of the Bay Conservation and Development Commission; Sam Bowerman, whaleboat racer and artist; Brent Bridges of the U.S. Bureau of Reclamation; Randall Brown of CALFED; John Carlier of the San Francisco Bar Pilots; Ernie Carlson of the Army Corps of Engineers; Andrew N. Cohen of the San Francisco Estuary Institute; Rick Coleman of the U.S. Fish and Wildlife Service; John Conomos of the U.S. Geological Survey; Matt Coolidge of The Center for Land Use Interpretation; Jack Costa, longshoreman; Al Davis of Cantoo Labs; Frank and Janice Delfino of the Citizens Committee to Complete the Refuge; Joe Didonato of the East Bay Regional Parks District; Giselle Downard of the San Pablo Bay National Wildlife Refuge; Renée Dunn of the Port of San Francisco; David R. Duval of the California Department of Water Resources; Mrs. Linda Dutra, Director, Dutra Museum of Dredging; former congressman Don Edwards and his wife, Edith; Malcolm Edwards of the Blue Earth Alliance; John D. "Dev" Elmes of the Marine Spill Response Corporation; Phyllis Faber, biologist; Arthur Feinstein of Golden Gate Audubon; John Fitzgerald, kayaker; Nick Franco, superintendent, Angel Island State Park; Gregory Gartrell of the Contra Costa Water District; Zeke Grader of the Pacific Coast Federation of Fishermen's Associations; Ruth Gravanis of the Sierra Club; Deb Green of the San Francisco State Univesity Seals Project; Brenda Grewell of the University of California at Davis; Emma Grigg of the San Francisco State Univesity Seals Project; Robin M. Grossinger of the San Francisco Estuary Institute; Marcie Hammie of the Pacific International Yacht Association; Janet Hansen of the San Francisco Bay Bird Observatory; Daniel Harkels of the Port of Oakland; Myrna Hayes, Vallejo conservationist; Stana Hearne of Citizens for the Eastshore State Park; Joel Hedgpeth, biologist; Alfred Heller, planning gadfly; Bruce Herbold of the Interagency Ecological Program in bay-delta studies; Jack Heyman of the International Longshore and Warehouse Union; Kathie Hieb of the California Department of Fish and Game; Beth Huning of the San Francisco Bay Joint Venture; Huey Johnson, international environmentalist; Lori Johnson of Cargill Salt; Kevin Kan of Berkeley Boardsports; Jonathan Kaplan of WaterKeepers; Anna Kastner of the Feather River Hatchery, California Department of Fish and Game; Charlie Kennard, master tule boat builder; William J. Kimmerer of San Francisco State University's Romberg Tiburon Center; Amarette Ko of the Golden Gate Bridge, Highway, and Transportation District; Terry Koenig of Red and White Fleet; Commander David W. Kranking of the U.S. Coast Guard; Kenneth Lajoie, geologist; Steve Larsen of the San Luis and Delta-Mendota Water Authority; Shin-roei Lee of the San Francisco Bay Regional Water Quality Control Board; Steve McAdam of the Bay Conservation and Development Commission staff; Clyde Morris of the Don Edwards San Francisco Bay National Wildlife Refuge; Chuck Morton of CalTrans; Angela Moskow of The Bay Institute of San Francisco; Patricia M. Nelson, attorney; Mike Nerney of the Port of San Francisco; Frederick H. Nichols of the U.S. Geological Survey; Einer Nyborg of the San Francisco Bar Pilots; George Olson of *Sunset* magazine; Jack Olson of SSA Terminals; Ruth Ostroff of the Central Valley Joint Venture; Ronn Patterson of Dolphin Charters; Anitra Pawley of The Bay Institute of San Francisco; Chindi Peavey of the San Mateo County Mosquito Abatement District; Courtenay Peddle of the *San Francisco Chronicle;* Terence Philippe of Fish First; John Poimoroo of Poimoroo & Partners; Roberto Ponce of the Venice Island Club; Laurette Rogers of The Bay Institute of San Francisco; Chris Rupert of Cantoo Labs; Barbara Salzmann of the Marin Audubon; Anthony Sandberg of the Olympic Circle Sailing Club; Syrell Sapoznick of the Port of Oakland; Karen van der Schaft of the Netherlands Consulate; Pete Scheele of the California Department of Water Resources; Curtis Schmutte of the California Department of Water Resources; Michael Sellers of Audubon's San Francisco Bay Restoration Program; Stuart Siegel, wetland scientist; Charles Simenstad of the University of Washington; Robin Smith of Sequoia Audubon; George Snyder of The Bay Institute of San Francisco; John Thelen Steere of the San Francisco Bay Joint Venture; Nancy Streuch of Save the Bay; Trish Strong of the California Department of Water Resources; Joan Suzio of the Martin Luther King Jr. Shoreline; Brian Swedberg of the Port Sonoma Marina; John Takekawa of the U.S. Geological Survey; Chuck Taylor of Cargill Salt; Jan Thompson of the U.S. Geological Survey; Louise Vicencio of the San Pablo National Wildlife Refuge; Michael Casey Walker of Bay Access; Rob Warwick of Berkeley Boardsports; Jennie Watson of the Evelyn and Walter Haas Jr. Fund; Diana Watters of the California Department of Fish and Game; Curt Watts of the Port of San Francisco; Olin Webb of Bayview Hunters Point Community Advocates; Dan Westerlin of the Port of Oakland; and Tim Wilson, farmer on Dead Horse Island in the delta.

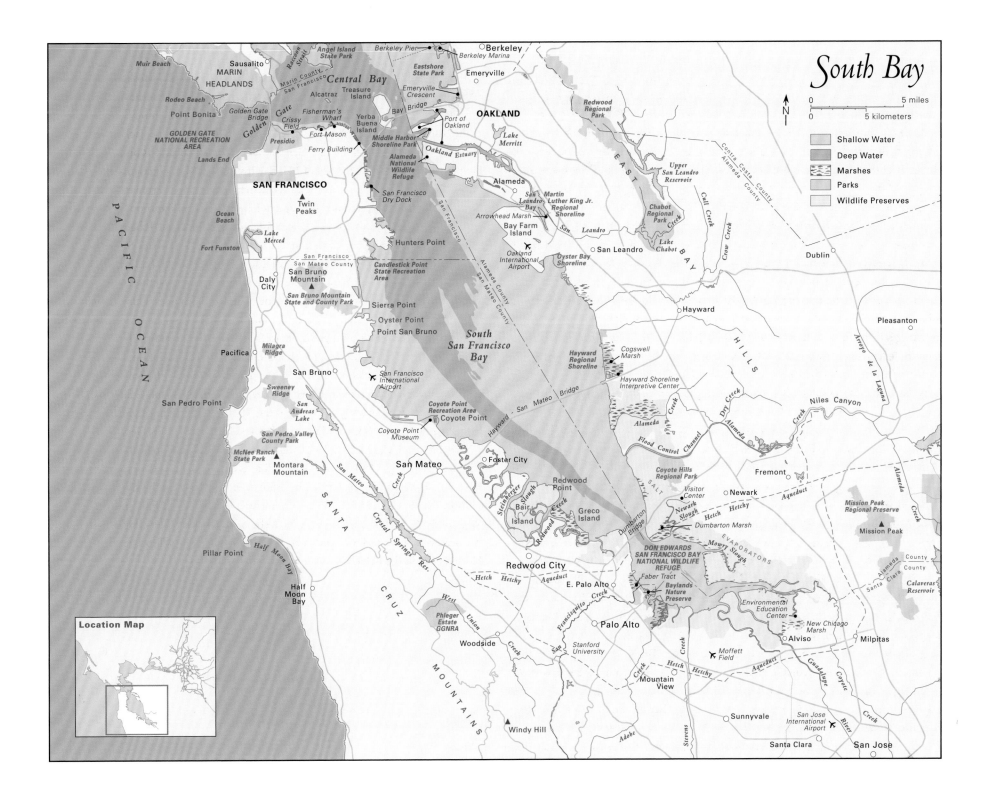

South Bay

Shallow Water
Deep Water
Marshes
Parks
Wildlife Preserves

0 5 miles
0 5 kilometers

N

Location Map

PACIFIC OCEAN

Muir Beach
Sausalito
MARIN HEADLANDS
Rodeo Beach
Point Bonita
GOLDEN GATE NATIONAL RECREATION AREA
Lands End
Ocean Beach
Fort Funston
Daly City
Pacifica
San Pedro Point
San Pedro Valley County Park
McNee Ranch State Park
Pillar Point
Half Moon Bay

Angel Island State Park
Berkeley Pier
Raccoon Strait
Marin County
San Francisco
Central Bay
Alcatraz
Treasure Island
Fisherman's Wharf
Crissy Field
Golden Gate Bridge
Fort Mason
Golden Gate
Ferry Building
Presidio
Yerba Buena Island
Bay Bridge
Middle Harbor Shoreline Park
SAN FRANCISCO
San Francisco Dry Dock
Twin Peaks
Lake Merced
Hunters Point
San Francisco San Mateo County
San Bruno Mountain
Candlestick Point State Recreation Area
San Bruno Mountain State and County Park
Sierra Point
Oyster Point
Point San Bruno
Milagra Ridge
San Bruno
Sweeney Ridge
San Andreas Lake
Montara Mountain
SANTA
San Mateo Creek
Crystal Springs Res.
CRUZ
MOUNTAINS

Berkeley
Berkeley Marina
Eastshore State Park
Emeryville
Emeryville Crescent
OAKLAND
Port of Oakland
Oakland Estuary
Alameda National Wildlife Refuge
Lake Merritt
Alameda
San Leandro Bay
Martin Luther King Jr. Regional Shoreline
Arrowhead Marsh
Bay Farm Island
Oakland International Airport
Oyster Bay Shoreline
San Leandro
San Leandro Creek

Redwood Regional Park
EAST
Upper San Leandro Reservoir
Contra Costa County Alameda County
Chabot Regional Park
Lake Chabot
BAY
Cull Creek
Crow Creek
Dublin
Hayward
Pleasanton

South San Francisco Bay
San Mateo County
Hayward Regional Shoreline
Cogswell Marsh
Hayward Shoreline Interpretive Center
Hayward – San Mateo Bridge
Coyote Point Recreation Area
Coyote Point
Coyote Point Museum
San Francisco International Airport
San Mateo
Foster City
Steinberger Slough
Bair Island
Redwood Creek
Redwood Point
Greco Island
Redwood City
E. Palo Alto
Palo Alto
Woodside
Phleger Estate GGNRA
Stanford University
Windy Hill
West Union Creek
Francisquito Creek
San
Hetch Hetchy Aqueduct
Hetch Hetchy Aqueduct

Coyote Hills Regional Park
Visitor Center
Newark
Newark Slough
Fremont
Niles Canyon
Alameda Creek
Dry Creek
Alameda Creek
Flood Control Channel
SALT EVAPORATORS
Dumbarton Bridge
Dumbarton Marsh
Hetch Hetchy
Mission Peak Regional Preserve
Mission Peak
Arroyo de la Laguna
DON EDWARDS SAN FRANCISCO BAY NATIONAL WILDLIFE REFUGE
Faber Tract
Baylands Nature Preserve
Mowry Slough
Environmental Education Center
New Chicago Marsh
Alviso
Milpitas
Calaveras Reservoir
Santa Clara County
Alameda County
Moffett Field
Mountain View
Adobe Creek
Stevens Creek
Sunnyvale
San Jose International Airport
Santa Clara
San Jose
Guadalupe River
Coyote Creek

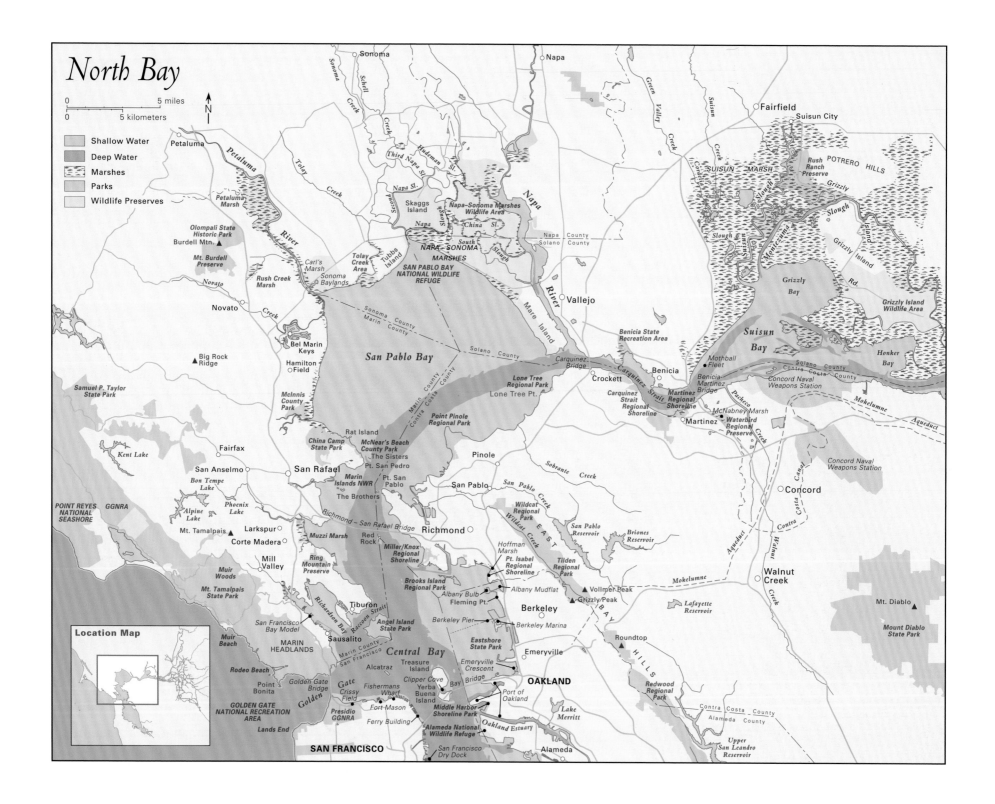

North Bay

Shallow Water
Deep Water
Marshes
Parks
Wildlife Preserves

0 5 miles
0 5 kilometers

N

Sonoma
Napa
Fairfield
Suisun City

Petaluma

SUISUN MARSH
Rush Ranch Preserve
POTRERO HILLS

Petaluma Marsh

Schell Creek
Sonoma Creek
Third Napa Sl.
Hudeman Sl.

Olompali State Historic Park
Burdell Mtn. ▲

Mt. Burdell Preserve

Carl's Marsh
Rush Creek Marsh
Sonoma Baylands

Skaggs Island
Napa–Sonoma Marshes Wildlife Area
China Sl.

Napa
South Napa
NAPA–SONOMA MARSHES

Tolay Creek Area
Tubbs Island

SAN PABLO BAY NATIONAL WILDLIFE REFUGE

Napa County
Solano County

Green Valley Creek
Suisun Creek

Suisun Slough
Montezuma Sl.
Grizzly Island
Grizzly Slough Rd.

Novato
Novato Creek

Big Rock Ridge
▲

Bel Marin Keys

Hamilton Field

Sonoma County
Marin County

San Pablo Bay

Solano County

Vallejo

Mare Island

Napa River

Grizzly Bay

Suisun Bay

Grizzly Island Wildlife Area

Samuel P. Taylor State Park

McInnis County Park

Benicia State Recreation Area

Carquinez Bridge
Carquinez Strait

Honker Bay

Solano County
Contra Costa County

Crockett
Benicia
Mothball Fleet
Benicia–Martinez Bridge

Concord Naval Weapons Station

Mokelumne
Aqueduct

Lone Tree Regional Park
Lone Tree Pt.

Carquinez Strait Regional Shoreline
Martinez Regional Shoreline

Martinez
McNabney Marsh
Waterbird Regional Preserve

Point Pinole Regional Park

Pacheco Creek

Fairfax

Kent Lake

China Camp State Park
Rat Island
McNear's Beach County Park
The Sisters
Pt. San Pedro

Pinole

Sobrante Creek

Concord Naval Weapons Station

San Anselmo
Bon Tempe Lake

San Rafael

Marin Islands NWR
Pt. San Pablo

San Pablo
San Pablo Creek

Concord

POINT REYES NATIONAL SEASHORE

GGNRA

Alpine Lake
Phoenix Lake

The Brothers

Richmond–San Rafael Bridge

Wildcat Regional Park
Wildcat Creek

San Pablo Reservoir

Briones Reservoir

Mt. Tamalpais ▲
Larkspur
Corte Madera

Richmond

EAST

Aqueduct
Contra Costa

Muir Woods

Mt. Tamalpais State Park

Muzzi Marsh
Red Rock

Miller/Knox Regional Shoreline

Hoffman Marsh
Pt. Isabel Regional Shoreline

Tilden Regional Park

Mokelumne

Walnut Creek

Mt. Diablo ▲

Ring Mountain Preserve

Brooks Island Regional Park

Albany Bulb
Fleming Pt.
Albany Mudflat

Vollmer Peak ▲
Grizzly Peak ▲

Lafayette Reservoir

Mill Valley

Richardson Bay
Tiburon
Raccoon Strait

San Francisco Bay Model

Berkeley Pier

Berkeley
Berkeley Marina

BAY HILLS

Mount Diablo State Park

Sausalito

Angel Island State Park

Eastshore State Park

Roundtop ▲

MARIN HEADLANDS

Marin County
San Francisco County

Central Bay

Emeryville

Muir Beach

Alcatraz
Treasure Island

Emeryville Crescent

Redwood Regional Park

Rodeo Beach

Clipper Cove
Yerba Buena Island

Bay Bridge

OAKLAND

Lake Merritt

Point Bonita

Golden Gate Bridge
Gate
Crissy Field
Fishermans Wharf

Port of Oakland

Contra Costa County
Alameda County

GOLDEN GATE NATIONAL RECREATION AREA

Golden

Fort Mason
Presidio GGNRA
Ferry Building

Middle Harbor Shoreline Park

Oakland Estuary

Upper San Leandro Reservoir

Lands End

SAN FRANCISCO

San Francisco Dry Dock

Alameda National Wildlife Refuge

Alameda

Location Map

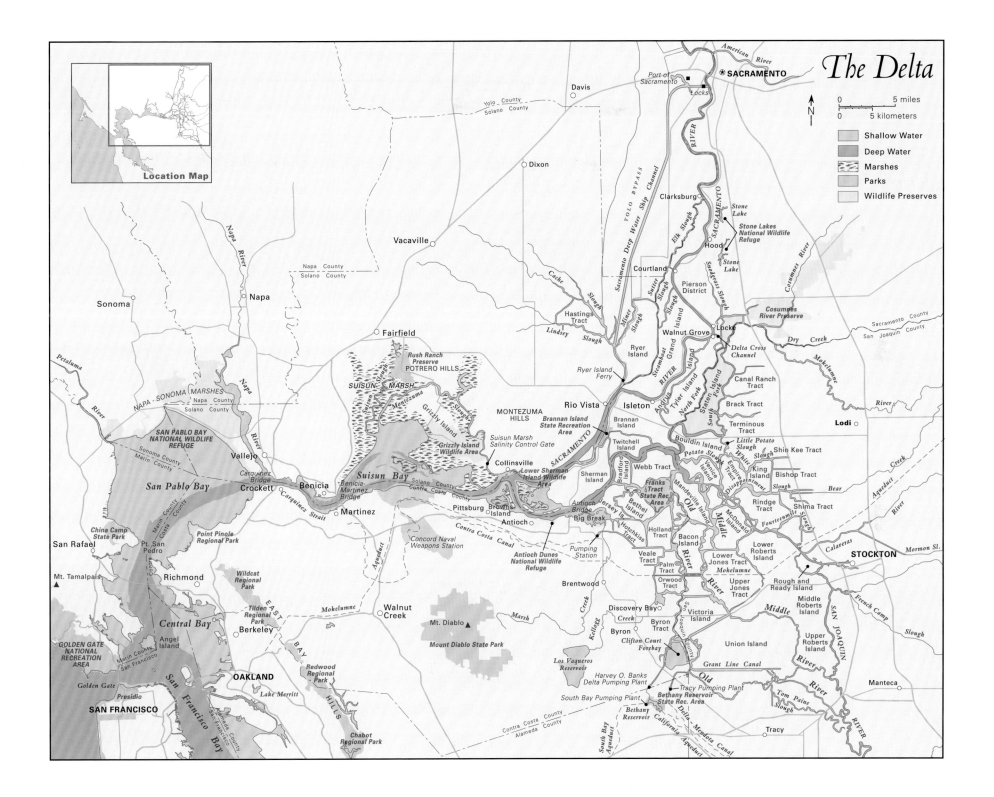

The Delta

Location Map

Shallow Water
Deep Water
Marshes
Parks
Wildlife Preserves

0 5 miles
0 5 kilometers

N

SACRAMENTO
Port of Sacramento
Locks
American River
Davis
Dixon
Vacaville
Napa County / Solano County
Yolo County / Solano County
Clarksburg
Stone Lake
Stone Lakes National Wildlife Refuge
Hood
Stone Lake
Courtland
Pierson District
Snodgrass Slough
Cosumnes River
Cosumnes River Preserve
Sacramento County / San Joaquin County
Dry Creek
Walnut Grove
Locke
Delta Cross Channel
Mokelumne River
Sonoma
Napa
Napa River
Fairfield
Napa County / Solano County
Cache Slough
Hastings Tract
Lindsey Slough
Miner Slough
Steamboat Slough
Sutter Slough
Elk Slough
Ryer Island
Grand Island
Andrus Island
Tyler Island
Canal Ranch Tract
Brack Tract
SACRAMENTO RIVER
YOLO BYPASS
Sacramento Deep Water Ship Channel
Rush Ranch Preserve
POTRERO HILLS
SUISUN MARSH
Montezuma Slough
Grizzly Island
Suisun Slough
Ryer Island Ferry
Ryer Island
North Fork
South Fork
Staten Island
Terminus Tract
Lodi
MONTEZUMA HILLS
Rio Vista
Isleton
Brannan Island State Recreation Area
Brannan Island
Little Potato Slough
Bouldin Island
Shin Kee Tract
Grizzly Island Wildlife Area
Suisun Marsh Salinity Control Gate
Collinsville
Lower Sherman Island Wildlife Area
Twitchell Island
Potato Slough
White Slough
King Island
Bishop Tract
Disappointment Slough
Bear Creek
Aqueduct
Napa-Sonoma Marshes
Napa County / Solano County
SAN PABLO BAY NATIONAL WILDLIFE REFUGE
Sonoma County / Marin County
Vallejo
Carquinez Bridge
San Pablo Bay
China Camp State Park
Pt. San Pedro
San Rafael
Mt. Tamalpais
Point Pinole Regional Park
Crockett
Benicia
Benicia-Martinez Bridge
Carquinez Strait
Martinez
Suisun Bay
Solano County / Contra Costa County
Pittsburg
Browns Island
Antioch
Webb Tract
Sherman Island
Bradford Island
Venice Island
Bethel Island
Franks Tract State Rec. Area
Mandeville Island
Empire Tract
Rindge Tract
Shima Tract
Richmond
Wildcat Regional Park
Mokelumne
Concord Naval Weapons Station
Contra Costa Canal
Antioch Bridge
Big Break
Jersey Is.
Hotchkiss Tract
Holland Tract
Bacon Island
McDonald Island
Lower Roberts Island
STOCKTON
Calaveras River
Mormon Sl.
EAST BAY
Tilden Regional Park
Aqueduct
Walnut Creek
Mt. Diablo
Mount Diablo State Park
Antioch Dunes National Wildlife Refuge
Pumping Station
Veale Tract
Palm Tract
Orwood Tract
Lower Jones Tract
Upper Jones Tract
Mokelumne River
Old River
Middle River
Lower Roberts Island
Middle Roberts Island
Upper Roberts Island
San Joaquin River
French Camp
Berkeley
Central Bay
Angel Island
Redwood Regional Park
HILLS
Brentwood
Kellogg Creek
Marsh
Discovery Bay
Byron Tract
Byron
Victoria Island
Union Island
Middle River
Grant Line Canal
GOLDEN GATE NATIONAL RECREATION AREA
Golden Gate
OAKLAND
Lake Merritt
Los Vaqueros Reservoir
Clifton Court Forebay
Old River
Rough and Ready Island
San Joaquin River
Manteca
Presidio
San Francisco Bay
Alameda County / San Francisco County
Chabot Regional Park
Harvey O. Banks Delta Pumping Plant
South Bay Pumping Plant
Bethany Reservoir
Tracy Pumping Plant
Bethany Reservoir State Rec. Area
California Aqueduct
Delta-Mendota Canal
Tom Paine Slough
Tracy
SAN JOAQUIN RIVER
SAN FRANCISCO
Contra Costa County / Alameda County
South Bay Aqueduct
Contra Costa Canal
Fourteenmile Slough

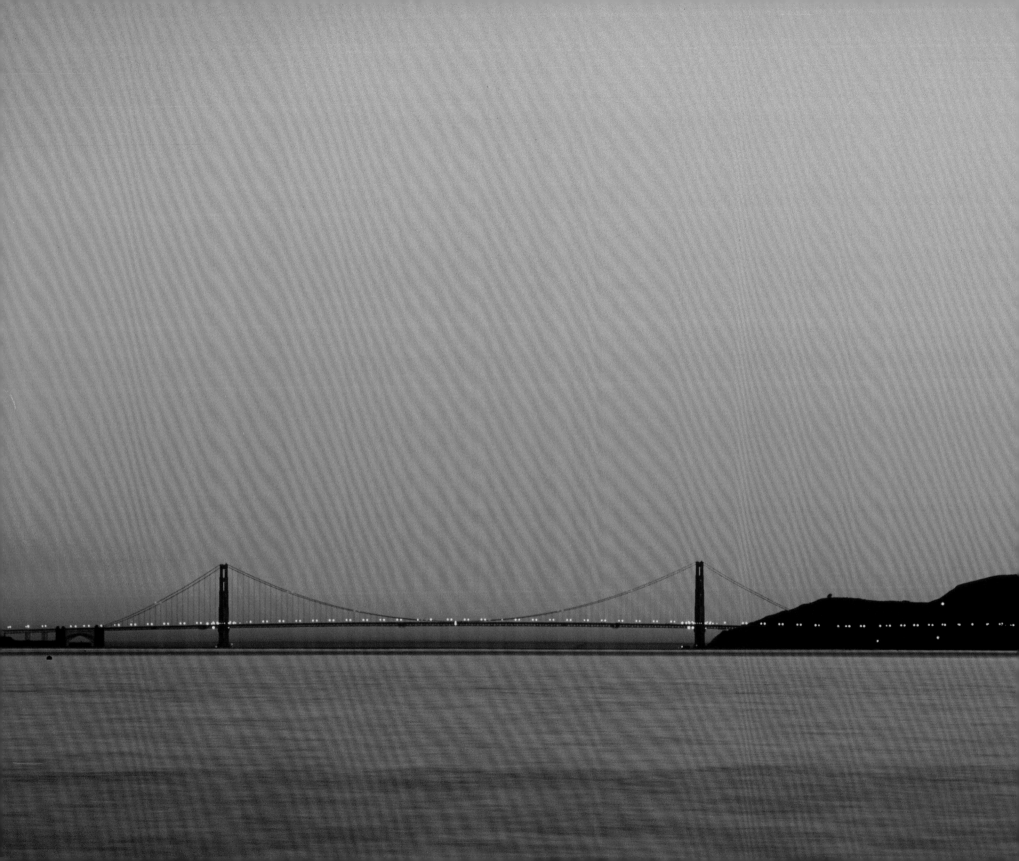

Inside the Golden Gate

Seen from the sea and through a mariner's eyes, the coast of California is a thousand miles of hills, a grim, gray barrier. At just one place in it is there a break, the narrowest of gaps, a doorway barely a mile wide. Approaching from the Pacific—even knowing the geography and watching for the profile of the modern bridge—you may squint into summer mist and find it no wonder that the first Europeans to explore these shores cruised right on by.

Inside that chink in the coastal armor lies the most important estuary on the western shores of the Americas; one of the world's grandest (and trickiest) harbors; the fifth-ranking metropolitan region in the United States; and a testing ground for the proposition that eight million people and a delicate natural system can after all share a landscape and mutually thrive.

San Francisco Bay proper, San Pablo Bay, the Carquinez Strait, Suisun Bay, the Sacramento–San Joaquin River Delta: these are the parts of what scientists now prefer to call the San Francisco Estuary.

The estuary is northern California's great meeting place, host to a mighty traffic of waters and weathers, of goods in transit and of migrant living things. Twice a day the ocean heaves in and out of the Golden Gate, and waters as far inland as Stockton responsively rise and fall. California's largest rivers pour fresh floods into salt in a balance ever changing, ever nourishing of life. Salmon and sturgeon and bass by the kiloton move from sea to spawning waters and back again. In the autumn, nearly half the migratory birds on the Pacific Flyway settle on these shores to feed. Ships from around the world shuttle cotton and fruit and molasses, petroleum and the automobiles it will fuel, salt and cement and supercooled ammonia, and plant and animal hitchhikers that can be the most troublesome cargo of all.

The bay-delta estuary is harbor and habitat, shipyard and playground, linker and divider, fishing hole and communal cloaca. Bridges straddle it; tunnels burrow under it; airplanes bank across it, lifting from their shadows on the water top. Sailors and windsurfers

In English, the Golden Gate; in Greek, Chrysopylae. John Charles Fremont proposed the latter name in 1846, recalling Byzantium's Golden Horn, Chrysoceras. His idea stuck, if only in translation.

lean against its winds; rowers and swimmers pull on its waters. Water diverted from its inland delta flows to much of the state's population and irrigates half of its farms.

Estuaries are inlets where rivers reach and mix with the sea. San Francisco Bay, at about sixteen hundred square miles, is one of the grandest such minglings of fresh and salt in the United States. No mere drowned river mouth, the bay sprawls clear through several chains of coastal mountains, widening and narrowing as it works among the ranges to lap into the heart of the Great Central Valley of California, ninety miles from the sea.

The bay-delta estuary has six distinct chambers. Just inside the Golden Gate is the Central Bay, the deep-water heart of the system; it is bounded, more or less, by the Golden Gate Bridge, the San Francisco–Oakland Bay Bridge, and the Richmond–San Rafael Bridge, each of which takes advantage of a natural narrows. Its shores are urban, and except where hillsides come down to deep water, they are artificial, consisting of bay fill protected by seawalls and stony riprap.

Southward toward San José extends the long appendix of South San Francisco Bay, the largest single segment, called by the Spanish explorers "an immense arm of the sea." Because only small streams feed it, its water tends to get very salty; because of the shape of its basin, its tides are very high. Metropolis wraps around this lobe of the estuary but at the southern end loosens its grip. Here the immediate shoreline is made up mostly of salt ponds—diked wetlands used now or formerly to make salt from bay water; the Don Edwards San Francisco Bay National Wildlife Refuge incorporates many of these ponds.

The remaining chambers of the estuary lie to the north and east of the Central Bay, upstream toward interior California and the influx of the major rivers. First to the north is the big, round expanse of San Pablo Bay, shallow but for a narrow channel scoured by river outflows and further maintained by dredges; it is bordered on the east by cities and on the west and north mostly by low-lying, dike-protected fields, formerly marshlands.

To the east of San Pablo Bay the broad waters clamp down into a second, interior Golden Gate, the steep-walled Carquinez Strait, a drowned canyon six miles long. Its shores are partly industrial but in parts almost wild, suggesting the scene of two centuries ago.

Eastward again the horizon opens out into Suisun Bay. Here the water begins to be fresher, brackish most of the time rather than salty. It is bordered on the south by industrial towns and on the north by the largest single expanse of wetlands in California: Suisun Marsh.

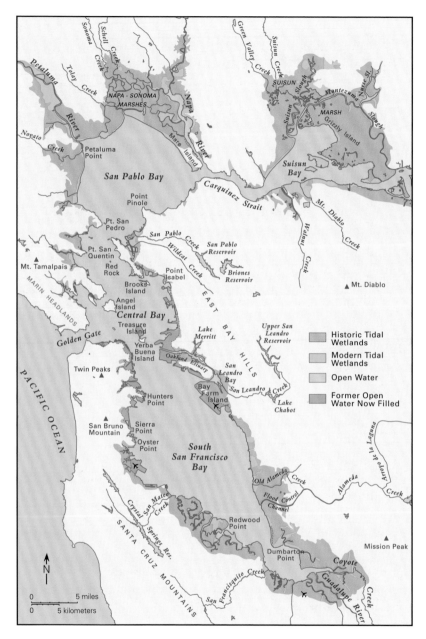

TIDAL WETLANDS AROUND SAN FRANCISCO BAY *Only about 20 percent of the marshland that once surrounded San Francisco Bay is still intact and open to the tide, but restoration projects may bring back as much as half of the original wetland rim.*

(Data courtesy of The Bay Institute of San Francisco and the San Francisco Estuary Institute, 1998)

At the east end of Suisun Bay the thick rope of the estuary splits apart into raveled strands: a fan of waterways, widening out to the east, called the Sacramento–San Joaquin River Delta. Here the Sacramento and San Joaquin Rivers, as well as the Mokelumne and the Cosumnes, combine their flows and lose their identities in a web of flatwater sloughs. The water curving between these diked banks, though normally fresh, still shifts with the tides, and seagoing vessels still move here, passing between the farms like apparitions of a distant, briny world. It is from this region that much of the potable water that used to feed the estuary is diverted south to cities and to farms.

The linked lowlands now filled by the San Francisco Estuary have existed for half a million years, but the water body we know is a recent phenomenon. Twenty-two thousand years ago, sea level was four hundred feet lower, and the coastline lay twenty-five miles off the Golden Gate. The Sacramento River, master stream of northern California, shouldered its way out through the canyon now known as the Carquinez Strait, collected tributaries north and south from valleys among the coastal ranges, swung around a knoll now called Angel Island, traversed the notch that would later be the Golden Gate, and finally reached the sea near some rocky hills whose craggy tips you can now just see from the mainland on a clear winter day, the Farallon Islands.

Then the most recent melting of the glaciers began, and the sea swelled up and in. By ten thousand years ago, it had reached the Golden Gate; a finger of salt water poked in past Angel Island. By eight thousand years ago, the water had penetrated the Carquinez Strait, and a southern arm of bay reached about to Palo Alto. About six thousand years ago, sea level rise slowed down, and a wide zone of mudflats and marshes formed around the open waters. By the year 1800, the estuary had attained what is so far its maximum extent.

Then a bustling people from the east arrived and began diking and filling its extensive shallow margins to make fields, salt evaporation ponds, and cities. Under these efforts the flooded area has shrunk, returning roughly to its outline of four thousand years before the present.

There was a time, around 1960, when the growing region seemed ready to turn its back once and for all on the living water that had shaped it. The bay had become a receptacle of sewage and toxic waste; a handy place to dump garbage; and, as landfills spread over marshes and mudflats, a source of new real estate. If the dreams of those days had all been realized, the bay shallows could have been filled to the point where only a polluted shipping channel remained. But a regional public outcry brought a halt to the filling and produced a watchdog agency, the Bay Conservation and Development Commission, to guard the remaining open water and tidelands.

Since then, decade by decade, the bay has been coming back into focus at the center of its region. Pollution has been substantially cleaned up. Many more miles of shoreline

are open to the public. Ferries once again are linking shoreline cities. Meanwhile, the obvious alarms of the 1960s have given way to subtler, hardly less troubling, concerns.

The San Francisco Estuary is, scientists tell us, the most profoundly altered system of its kind and size in the world. No comparable estuary is so enwrapped in cities as this one. Few have been so reduced in area by diking and filling. Few have had their fresh-water input so tampered with. In few estuaries has the web of life been so altered by the introduction of exotic species from around the planet.

But through it all the living estuary has shown a quite remarkable resilience. Greatly though it has suffered, it is greatly rich and greatly restorable; and today it is the subject of the grandest experiment ever conceived for the repair of a biologically degraded system. The most visible change will be the restoration of vast swathes of marshes. Plans are afoot to breach miles of dikes—especially in the South Bay, along San Pablo Bay, in Suisun Bay, and even in the delta—and let the estuary swell again.

One thing is becoming pretty clear: that in restoring these wetlands we are making a virtue of necessity. After decades of worrying about a shrinking, shallowing bay, we learn that the estuary is in fact now in a deepening phase. Muds washed down from hydraulic and placer mining in the Sierra Nevada once clogged and shoaled it, but these are on their way out the Golden Gate. Meanwhile the sea is imperceptibly, inexorably rising, at a rate of about two millimeters a year—a pace that global warming may very well increase.

The bay of 1950 was vastly different from the bay of 1850; by 2050 it will surely be another place again. We have set processes in motion in the estuary and its watershed, and in the world, whose effects are only beginning to be seen. Among these processes is the growth of our own conscience and our own knowledge. The bay will almost certainly be larger fifty years from now, its outlines fuzzier, its perimeter much longer. With any luck at all, the estuary of tomorrow will be still lovelier and richer and more serviceable to us than the place we know today.

In a long-ago sports season, when San Francisco teams were doing badly and Oakland teams were doing well, a sportscaster rechristened the metropolitan region the Oakland Bay Area. But the bay and the region were never named for the city of San Francisco; the naming went in the other direction, starting with the bay. The estuary was San Francisco Bay when its first city was still the village of Yerba Buena. The region takes its title from something all its people share, its central natural feature. This is a resonant fact.

There is much to be struggled with, much to be solved, in our relationship to the San Francisco Estuary. But the first step is simply to see, to marvel even: to value, ever more keenly, the luminous, priceless, vulnerable puddle of water around which we have chosen to live.

A work in progress: the estuary and its people.

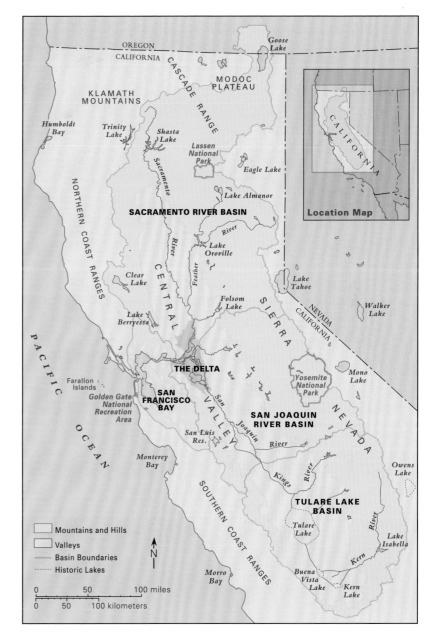

THE WATERSHED OF SAN FRANCISCO BAY *The water that feeds the San Francisco Estuary flows from 40 percent of the California landscape. Tulare Lake in the southern Central Valley, now dry in most years, once also spilled into rivers bound for the Golden Gate.* (Data courtesy of The Bay Institute of San Francisco and the San Francisco Estuary Institute, 1998)

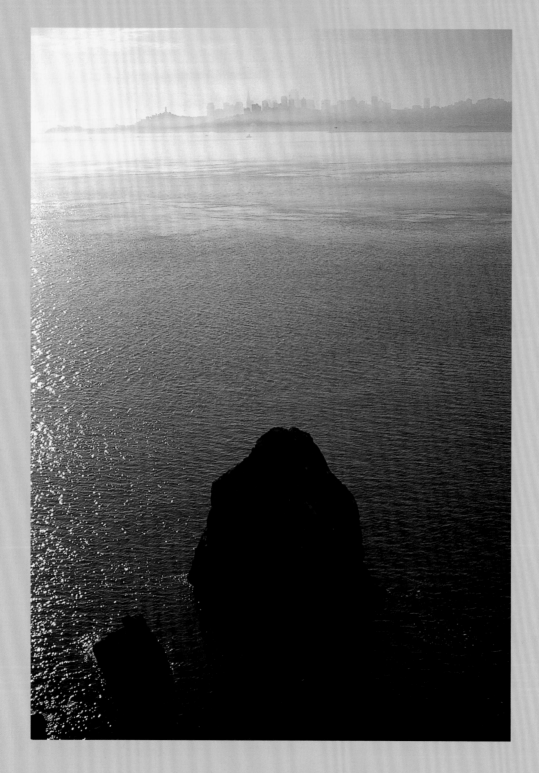

LEFT: *Sheltered waters.*
San Francisco seen from Fort Baker
on the north shore of the Golden Gate.
OPPOSITE: *Fog in the Gate.*
Only the bridge suggests the presence
of the strait and the city beyond.

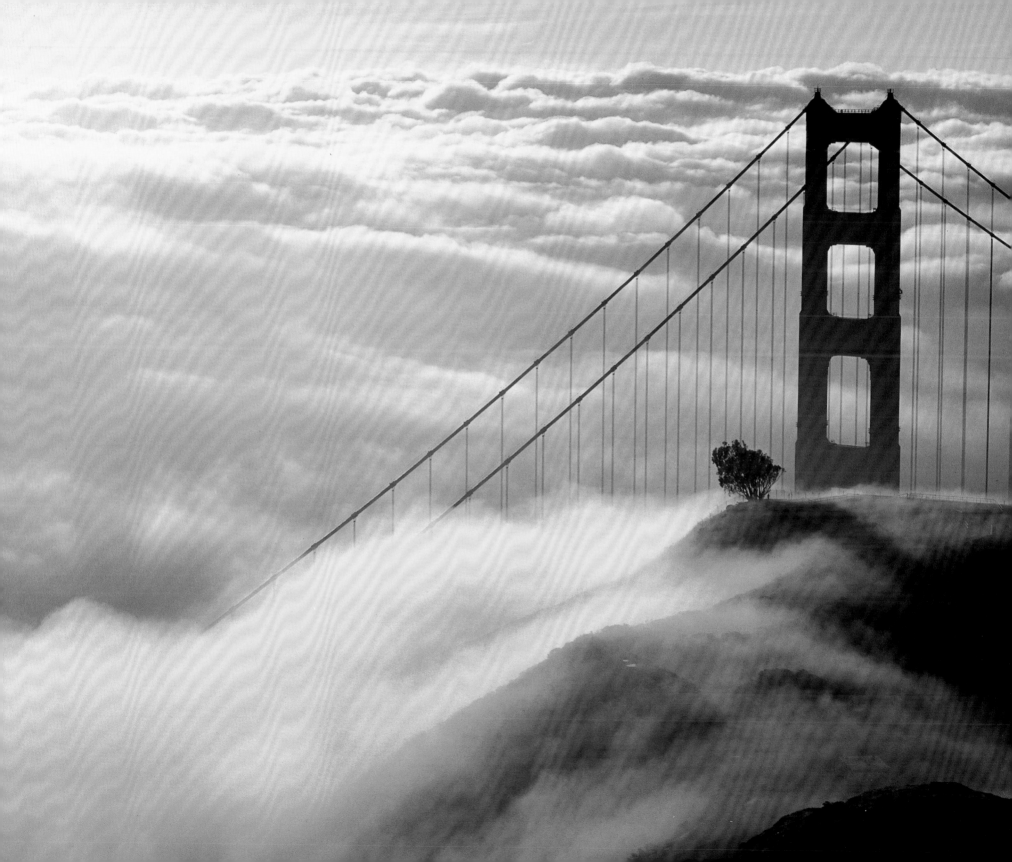

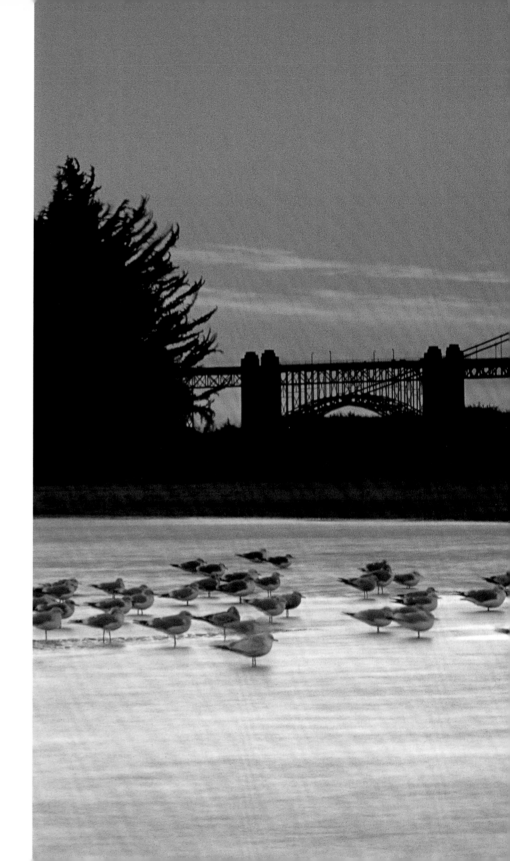

ABOVE: *Gull on piling.*
RIGHT: *Tidal lagoon at Crissy Field in San Francisco, just inside the Golden Gate.*

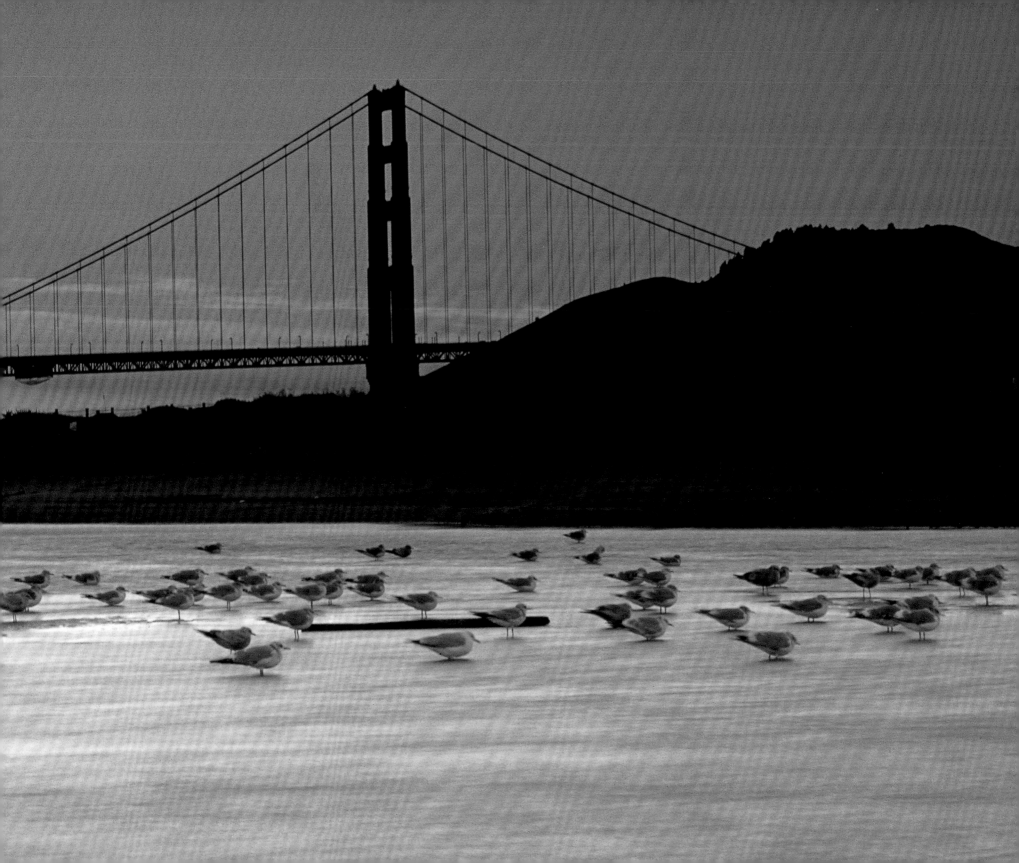

OPPOSITE: *Clearing storm over Berkeley's Municipal Pier.*
RIGHT: *Dusk over the Golden Gate from Point Isabel Regional Park, Richmond.*

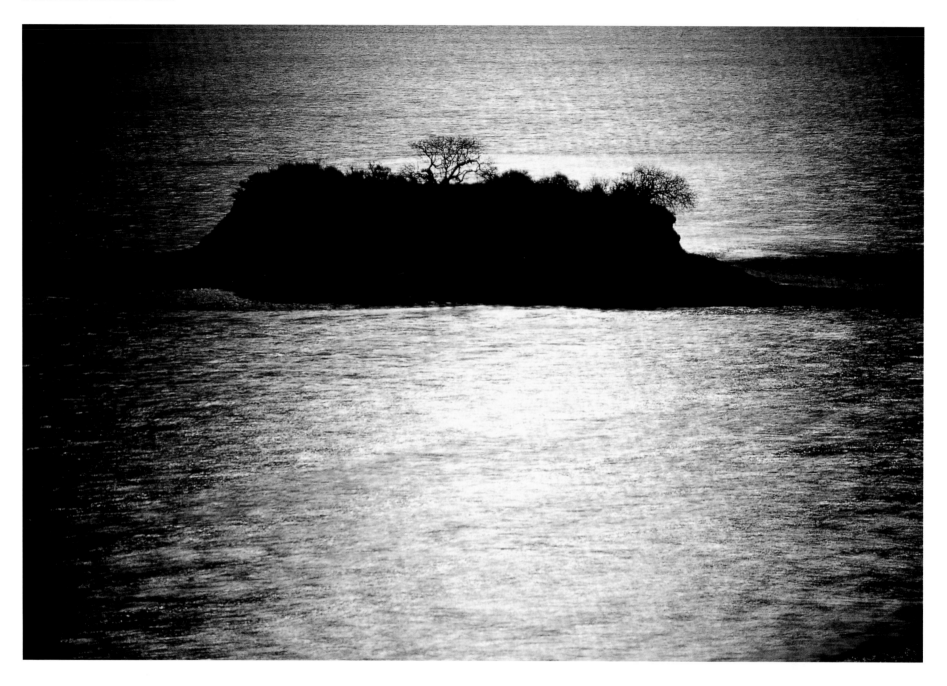

ABOVE: *Rat Island in San Pablo Bay. The islet lies just off the shore of China Camp State Park, near San Rafael.*
OPPOSITE: *East Brother and West Brother Islands off Richmond.*

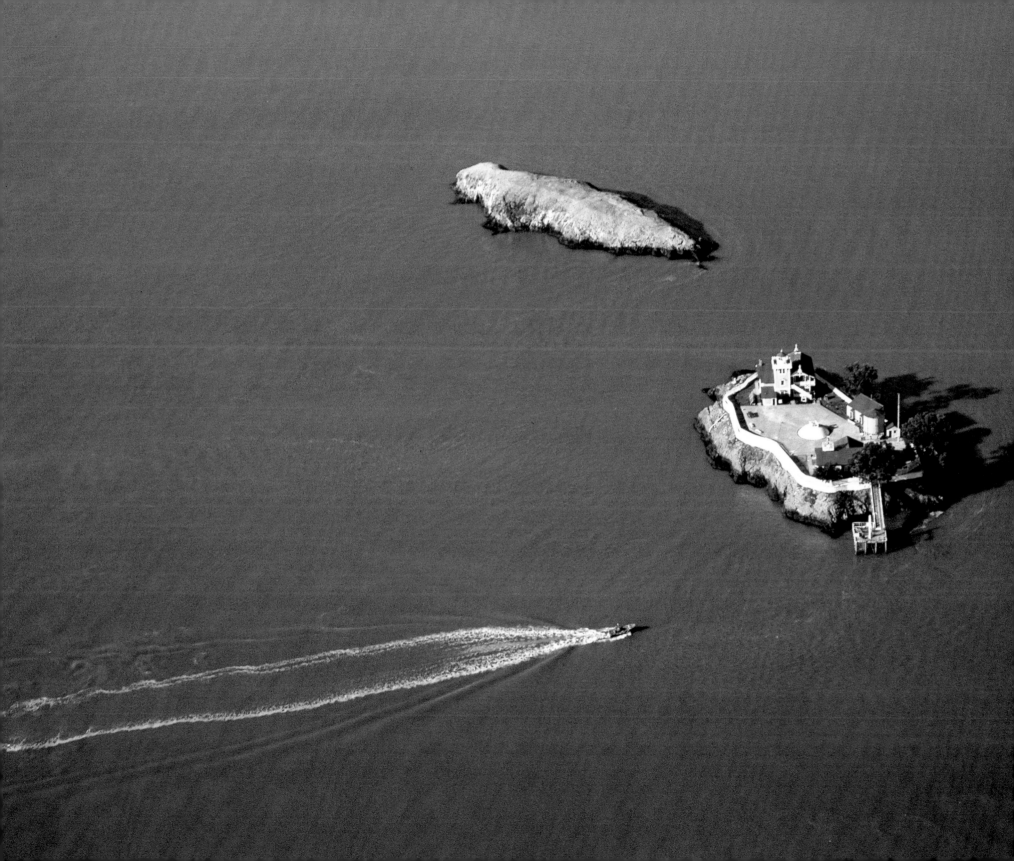

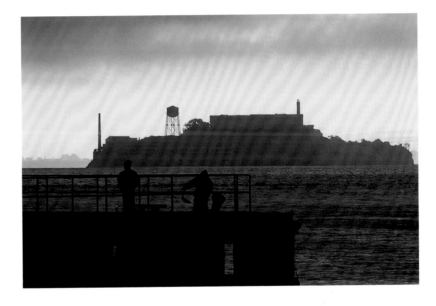

LEFT: *Winter storm clouds over Mount Tamalpais and Angel Island off the Marin County shore.* ABOVE: *Fishing at Fort Baker in the Marin Headlands; Alcatraz Island beyond.*

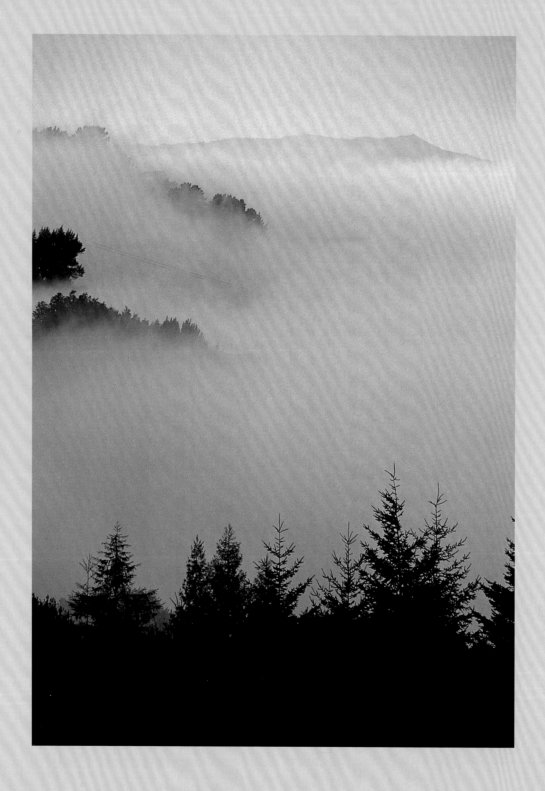

LEFT: *Morning fog on San Francisco Bay, seen from Grizzly Peak in the Berkeley Hills.* OPPOSITE: *Ayala Cove, Angel Island. The Spanish exploration of San Francisco Bay in 1775 was based at this central spot.*

On the east shore of South San Francisco Bay, at the Alameda County end of the Dumbarton Bridge, an odd little range of hills pokes from the soggy plain. Not so little, a geologist would tell you; the roots of the Coyote Hills lie two thousand feet deep, buried in bay sediments and the outwash from Alameda Creek, which enters the bay nearby. Bayward from the hills are salt ponds; landward it's largely marshes, fresh or brackish. The southern part of the range, south of the bridge approaches, belongs to the Don Edwards San Francisco Bay National Wildlife Refuge; the north part is Coyote Hills Regional Park.

This Coyote Hills greenbelt preserves many things. Among them is the best-known and best-protected village site of the people who inhabited the shores of the San Francisco Estuary before the Europeans came.

The site, known to archaeologists as Alameda 328, is easy to overlook. It is away from the road in the regional park, nestled among willow trees and further guarded by a gated chain-link fence, necessary to defend it from vandals and souvenir hunters. Once inside the fence, you'll notice the part aboveground—the hemispherical frameworks of dwellings, the bigger skeleton of a pit house suitable for gatherings—but these are only modern reconstructions. The real village, the genuine artifact, is the rounded ground itself. For more than two millennia, this spot was a home of the Tuibun group of the Ohlone Indians.

On this autumn day, by appointment, the gate to the past is open. The metal barrier is swung aside, and half a dozen curious visitors are sitting in a circle, making tule boats. More accurately, we are making tule boat toys. Our instructors are two very distant relatives of the old inhabitants, Ohlone descendants named Mary and Lisa Carrier. They show us how to work with foot-long lengths of round bulrush stalk, harvested from a slough near Byron in the Sacramento–San Joaquin River Delta. These we bind together with kite string into bundles of four. Several such bundles, sewn together and tied fore and aft, make a miniature craft. Sure enough, tossed into a barrel of water, it floats, buoyed up by the air contained in the hollow stems.

If we were Ohlone making a real boat in the old ways, we would be working much harder. Our boat would be ten to twenty feet long and weigh a few hundred pounds,

*Coyote Hills near Fremont on South San Francisco Bay. Ohlone
villages at the base of this range were inhabited for two thousand years.*

dry. Instead of cotton sewing thread we would be using ropes carefully twisted from cattail leaves; long, flexible willow shoots; or grapevines. The finished boat—there is one at the nearby visitor center—would be a structure of four or five massive tule bundles, bent upward at both ends to resemble a crescent. It would have been used in gathering food and in trading across the bay to groups on the Palo Alto side. Carefully dried between uses, tule boats might last for many months. Once they became too sodden, the bindings could be salvaged and a new boat constructed.

This much we know, but many details are guesswork. The replica boat at the visitor center is based on common methods from the West Coast and drawings from the mission era but may or may not reflect the methods used by this particular tribe.

Gaps like this are typical when we talk about the ancient Indian communities around the estuary. Being among the first California native groups to encounter Europeans, at the end of the eighteenth century, the bayside peoples lost their traditions earlier and more completely than most. The last native speakers were dying by the early 1900s. People of partial Indian descent (there are none of unmixed blood) long preferred to be considered Hispanic. But recently there has been a prideful movement to recover the forgotten: to rediscover, which in some cases means to reinvent, the old identities and ways.

The two Carriers, our instructors today, are part of that movement. In the background sits one of its inspirers, a self-effacing ethnologist named Beverly Ortiz. Another mentor, former park naturalist Norm Kidder, directed construction of the buildings we see. They are unfinished, lacking the layers of reeds and earth that should make up their roofs, for a reason. In the old days, fires were kept burning constantly within such dwellings to keep the thatches dry in the rainy season; lacking that warmth, the materials would rot.

In talking about the ancient peoples and their descendants, we seem to have a choice of misnomers. "Indians," of course, is a comical historical accident. Even the language-based group names applied to the bayside dwellers—Ohlone or Costanoan around most of the estuary; Coast Miwok in Marin County; Patwin around Suisun Marsh; Plains Miwok, Bay Miwok, and Yokuts in the delta—are modern abstractions. The locals did not group themselves by speech. Identity lay in the tribelet or local nation. Around the shores of the bay, it is thought, there were some forty of these groups, each controlling enough land to feed its population.

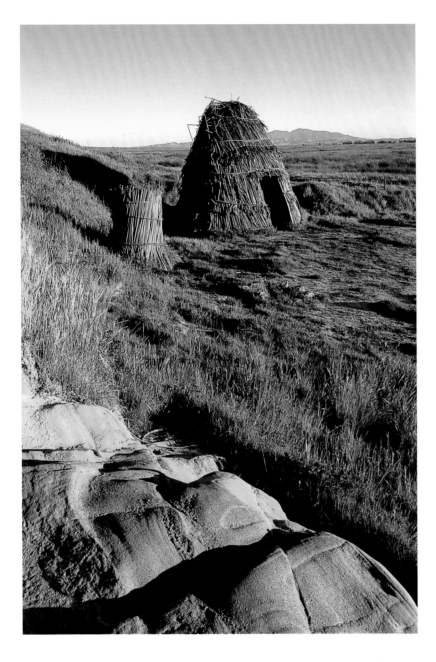

ABOVE: *Replica of a Patwin Indian tule hut at Rush Ranch in Suisun Marsh, near Fairfield.* OPPOSITE: *Tule reeds. The stems were used by Indians all around the San Francisco Estuary to build boats and thatch dwellings.*

The Tuibun, numbering perhaps three hundred, held a rather large territory, running about fifteen miles north to south along the East Bay plains. It included the delta of Alameda Creek, the largest stream to enter the South Bay. Westward it was bounded by the water, eastward by the tall ridge containing prominent Mission Peak, a place of ceremonial importance to the tribe.

Like other Indian groups, the Tuibun had a few major settlements and numerous outlying camps where seasonal foodstuffs were harvested: the seeds and lilylike brodiaea bulbs, the deer in the grizzly-haunted hills, the acorns in the oak groves. In many tribal areas the big winter villages would be left nearly empty in the dry season as people dispersed in pursuit of food. But those tribes that held strips of bay shoreline were unusually favored and, it seems, somewhat more sedentary, for they had a food source that never failed: shellfish. They ate mussels and clams and native oysters and gooseneck barnacles. They discarded shells and other debris in quantities that eventually formed mounds rising as much as thirty feet above the surrounding land. The height and volume of each such mound is a rough guide to its age.

Ala-328 and its close neighbor Ala-329 occupied what one researcher calls "the ideal winter village type of site." They had three key resources in abundance: food from marsh and mudflat and open bay; fresh water from artesian springs in the alluvial fan of Alameda Creek; and, more surprisingly, firewood. The Coyote Hills were all but treeless, then as now, but logs washed down from the delta eddied into the South Bay and drifted with the prevailing winds to these shores. The most numerous tools found in these mounds are wedges made of tule elk antler, which—Norm Kidder surmises—were used to split these logs.

The twin villages were occupied for twenty-four hundred years, perhaps in alternation. Alameda 328 was excavated between 1935 and 1970. Researchers found five thousand artifacts: shell beads, pipes, harpoon spears, serrated arrowheads, pestles, birdbone beads, and those antler wedges. They also found over five hundred sets of human bones. It is not unusual to find burials at village sites, but the number here is unusually large. Also very numerous here are shamanistic ceremonial artifacts. These finds have led one anthropologist to speculate that the spot was not a true settlement but a dedicated cemetery, a "cry site." Others doubt this idea but agree that the place seems to have had some special significance. Kidder thinks it may have been a sort of Old City in the minds of the Tuibun, a place where they too felt the presence of a long history.

Twenty-four hundred years of occupancy is very respectable for an Ohlone site but is by no means unique. A mound in Berkeley, among the oldest known, has been dated to fifty-six hundred years before the present. It is suspected that many still older

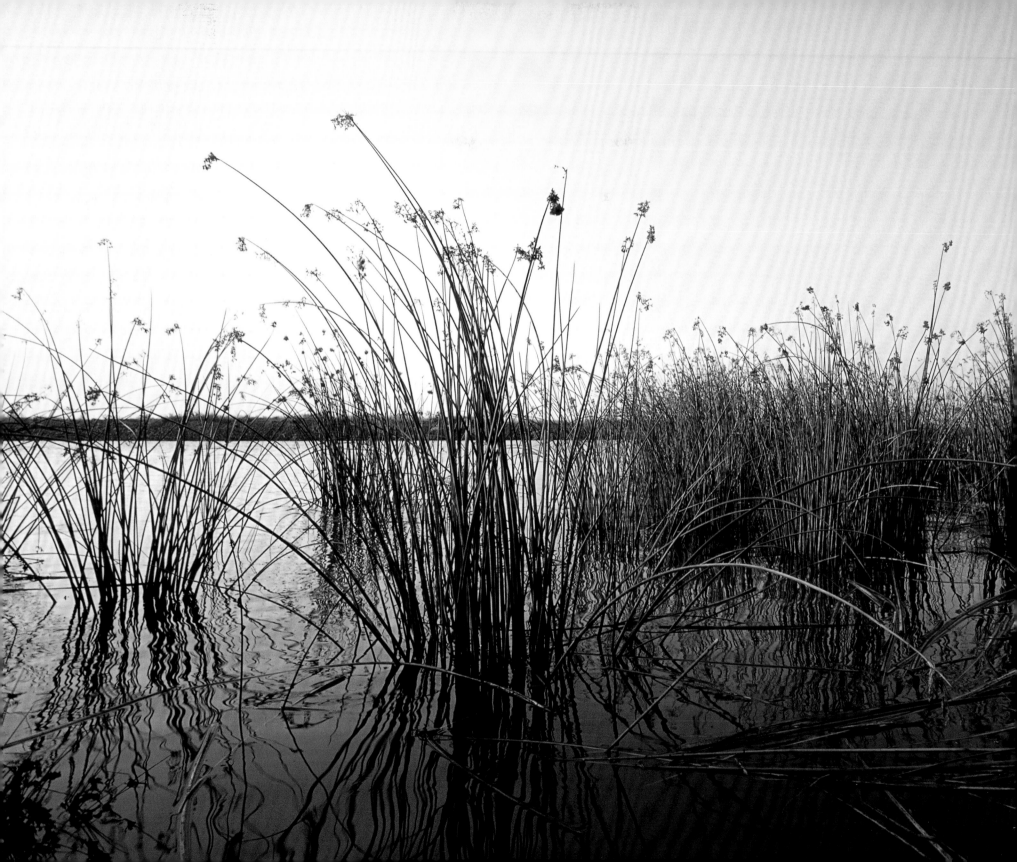

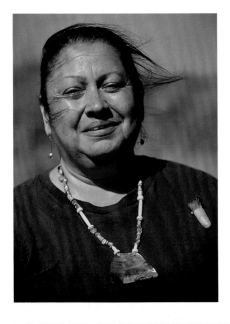

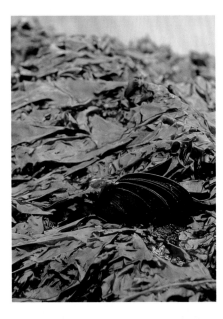

TOP LEFT: *Ramona Garibay, an Ohlone descendant who teaches traditional living skills and consults on the protection of aboriginal remains.* TOP RIGHT: *Mussels, an important native food, on kelp.* BOTTOM: *Shell fragments, the remnants of ancient meals.* OPPOSITE: *Native American shell mound.*

settlements—which may not have belonged to exactly the same peoples—are drowned now under the waters of the bay and the nearby ocean.

A rise in cultural sensitivity stopped the digging at Ala-328, which nonetheless provided much of the information for today's cultural rediscovery. A little freshwater marsh now occupies the hollow that the diggers made.

Ravaged though it may seem to some Ohlone activists, Ala-328 is also a rare survival. Worse for the Indian heritage around the bay than archaeology or vandalism or pot hunting has been simple construction, the building of the continuous modern city that fills the bay plain. Until recently the Native American sites were bulldozed not only without protest but also frequently without examination. One of the largest of them was the Emeryville shell mound, a settlement of the Huchiun group.

Another very large site, possibly the biggest in the region, was a village of the Carquin people at present-day Crockett on the Carquinez Strait, a waterway whose name preserves the tribal one. The special wealth of the place was chinook salmon, running the gauntlet of the strait toward interior spawning grounds. Like the inhabitants of Ala-328, the denizens of the Crockett village would have had less reason than most to move around on land—and they would have had even more cause to move around by water. All the early Spanish explorers commented on the number of tule boats in the strait, fishing and linking the related settlements on both shores. In 1776 one Juan Crespi came to this spot and reported: "On the banks of the other side we made out many villages, whose Indians called to us and invited us to go to their country, but we were prevented by a stretch of water about a quarter of a league wide; and many of them, seeing that we were going away, came to this side, crossing over on rafts, and gave us some of their wild food."

In exchange the conquerors brought the Indians Christianity, novel diseases, a new way of life both seductive and destructive, and, in the end, the near cultural extinction that descendants and anthropologists alike are now working to overcome.

One byproduct of the modern exploration of old Indian ways has been a modest shipbuilding industry of tule boats. People who have made them have learned great respect for the craft, in both senses. Reads one account: "The tule boat really showed its 'sweetness' when in the water; it rode just high enough to keep its occupants dry, straightened its 'twist' out so was easy to steer, was incredibly comfortable and stable to ride in, and . . . had a wonderful scent." Jan Southworth, a staffer at Coyote Hills Regional Park, has supervised the building of several boats here. In 1984 one of her fleet, a very large thirty-foot creation, was hauled up to Antioch at the edge of the delta and piloted back home down the estuary—a journey of eighty-four miles and nine days.

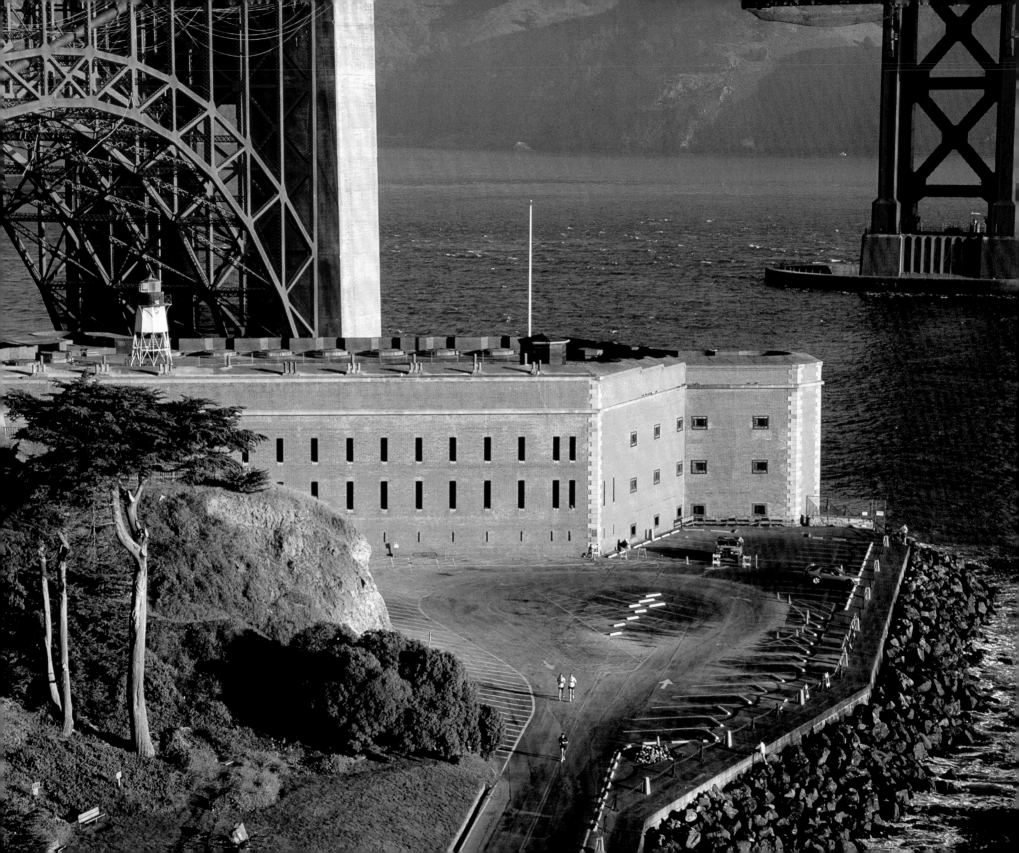

Guardian of the Golden Gate. Rushed to completion on the eve of the Civil War, the Fort Point blockhouse was the keystone of early harbor defense. Almost torn down in the 1930s to ease construction of the bridge, it is now preserved as a national historic site.

*T*here was a city, and there was a harbor.

The city, at first, was nothing much: a gaggle of huts, an impoverished pueblo on the ill-supplied northern limit of the Spanish Empire in the New World. But San Francisco Bay was something marvelous: huge and sheltered, easily guarded, big enough to float all the warships of the world. Military men saw in the bay the key to the West Coast. "There is not another *good* harbor," one observer wrote, "between Cape Horn and the Bering Straits."

Who could doubt that it needed defending?

The Spanish started it. In 1776 they laid out, on the south shore of the Golden Gate, their last California military center, or *presidio*. In 1794 they built, on a steep white bluff commanding the strait, a fortress called the Castillo de San Joaquín. Two miles to the east, at the point we now know as Fort Mason, they installed another nest of cannon, the Batería de Yerba Buena.

But the Spanish hold on upper California was never very firm. Neither the Spanish nor their successors, the governors sent after 1821 by independent Mexico, did much to maintain the bay defenses. When California passed to the United States in 1848, the new owners vowed to do better. In 1850, President Millard Fillmore signed an executive order setting aside for military purposes strategic lands around the Golden Gate: the old San Francisco Presidio; its eastern satellite, Fort Mason; Alcatraz Island; Angel Island; Yerba Buena Island; and the northern wall of the Golden Gate, the steep-fronted Marin Headlands. Cannon on each of these shores would deny the passage of the strait to hostile vessels.

Engineers got to work. Soon ninety guns had been put on Alcatraz; but the focus was on the site of the Spanish Castillo, now called Fort Point. The original vertical white cliff was leveled almost to waterline. On the new low platform the engineers built the elegant brick and granite blockhouse that you see today under the humming deck of the Golden Gate Bridge. With its three long tiers of gunports, its rooftop barbettes, and its seven-foot-thick walls, the fort was thought to be a formidable guardian.

The military also reached deeper into the bay. In 1853, the U.S. Navy acquired Mare Island, at Vallejo, for its first shipyard in the west. The location was deemed "safe from attack by wind, wave, enemies, and marine worms." In those days the waters near Vallejo tended to remain quite fresh, fatal to the saltwater organisms that bore into

wooden hulls. Still farther east, the army took over a hilltop at Benicia, commanding the inner end of the Carquinez Strait, for its Benicia Arsenal.

So was the bay now invasion-proof? Not to the satisfaction of the planners. They wanted more strongpoints, more guns. And, inconveniently, the means of possible attack kept evolving, overtaking the means of defense. When Millard Fillmore set the forts aside, the standard cannon used round shot and could carry about two miles—and could certainly not penetrate brick walls. By the end of the Civil War, new guns with rifled barrels could propel cylindrical shells much farther and faster, and no brick wall, however thick, was a defense against them. In a duel between Fort Point and an up-to-date, well-armed ship, Fort Point might lose.

The answering defensive innovation was armor plating. Plans were drafted at this time that would have made the harbor entrance an almost medieval landscape. Imagine two enormous revolving armored turrets, one replacing the Fort Point blockhouse and a twin at Lime Point in Marin, with a third such tower rising from the water between them . . . Imagine, strung across the Gate, lifted by winches to let friendly traffic through, a stupendous iron chain. Fortunately, little had been done to realize this vision when metal armor, too, was rendered obsolete by growing firepower.

The next wave of fortification around the Golden Gate began in the 1890s. Most of the massive emplacements you see today near the mouth of the bay belong to this generation. Guns now crouched in huge revetments of beveled concrete; they rose from the pit to fire and sank out of harm's way between rounds. The stark gray nests are everywhere: on Angel Island, at Fort Mason, on the bay and ocean shores of the Presidio, and throughout the Marin Headlands. By 1914 this system was considered complete. Almost needless to say, it was also out of date.

The approach of World War II brought one final generation of guns to the Golden Gate, five-hundred-ton monsters, sixteen inches in the bore. These were installed at coastal sites outside the harbor entrance, facing west to the sea. They would have no successors. The edge of the continent, from a military point of view, had moved up, and out, and away. For a time the Nike antiairplane missiles and their humped white radar domes succeeded the guns in the Marin Headlands and on Angel Island and appeared on many bayside hills. Then these too were gone.

Yet even as the old coastal defenses turned into archaeology, San Francisco Bay had become the center of another kind of military power, not defensive but offensive, essentially naval, generated here for projection overseas.

The process started with the Spanish-American War of 1898 and hit its stride with World War II. As that conflict approached, the military holdings around the San Francisco Estuary swelled. Notably, the navy acquired Hunters Point, an important private shipyard in the southeast corner of San Francisco, and it also took over a piece of land that had existed for only two years: Treasure Island.

The site of Treasure Island, just north of Yerba Buena Island, had been a shoal, a spot where beds of eelgrass waved beneath the surface and Pacific herring spawned. It was a navigation hazard and (the ecological value of such shallows being then undreamed of) "waste territory." In the middle 1930s, the city of San Francisco was looking for land for a new international airport. It also wanted a site for a huge party, a world's fair, to celebrate the completion of two great building projects, the Golden Gate Bridge and the San Francisco–Oakland Bay Bridge. To meet both needs, civic leaders fell on the idea of creating new land at Yerba Buena Shoals.

Two hundred and eighty-six thousand tons of rock went into seawalls enclosing four hundred acres of bay floor. Dredges deposited twenty-one million cubic yards of bay-bottom sands and muds within the walls. To top it off, eighty thousand cubic yards of rich peat soil were barged down from the Sacramento–San Joaquin Delta. The result was an octagonal expanse a mile long, linked to Yerba Buena Island by a causeway. It was celebrated as the largest artificial island in the world. Looked at another way, it was also the largest single landfill project yet to take a bite out of San Francisco Bay.

The fair of 1939–1940 was a "Pageant of the Pacific," a celebration of commerce and friendship around the rim of the western ocean. Among its landmarks was a seventy-foot statue of the goddess Pacifica, palms raised in blessing. But she was the wrong deity for the times.

Instead of becoming an airport, Treasure Island became a center of operations for World War II. It was a kind of Grand Central Station for sailors, pulling them in from across the country, training them, and shipping them out to the far-flung ocean battlefields. Building One, the curvilinear Art Deco structure designed for use as an airport terminal, became instead the headquarters of Admiral Chester Nimitz. The admiral went home across the causeway to a white-columned Georgian house on Yerba Buena Island, on the steps of which you still can read his stenciled name.

The world war ended but morphed into the Cold War, and the military presence did not wane. At its height the constellation of bases covered one hundred square miles around the San Francisco Estuary and occupied forty miles of its shoreline.

The largest single site was the Concord Naval Weapons Station on the south shore of Suisun Bay; it was the major munitions shipment point in the western United States. The most strategic was Mare Island Naval Shipyard, which was now the West Coast headquarters for the nuclear submarine fleet (and—much more than any local city—a certain target in a nuclear war). Reporting to Mare was the enigmatic Skaggs Island

Naval Station, occupying one of the diked-off former marsh islands north of San Pablo Bay, where sensitive antennae listened for transmissions from enemy submarines. The strangest property was and is the Suisun Bay Reserve Fleet at Benicia, a ghostly convoy of mothballed ships moored at this point in the estuary for the same reason that the shipyard had been sited at Vallejo: because the water is somewhat fresher and discouraging to "float-fouling" organisms.

But even before the end of the Cold War, all this military presence began to seem expensive and exaggerated, and a slow divestment process began. The army bases at the Golden Gate, having long outlasted their harbor defense role, were the first to go. Angel Island had gone from fort to state park by 1962, and a decade later the army's headland forts were incorporated into the Golden Gate National Recreation Area.

The navy held out longer, but even its role was clouded. For a service that now did almost all its work overseas, rather than in continental defense, the midcoast location of this bay was a drawback, not an advantage. It was farther from Asia than Hawaii and Guam, farther from the Arctic than Seattle, farther from South America than Long Beach or San Diego. Then, too, public opinion in the liberal Bay Area was not quite so friendly to the military as in the rival ports.

In the 1980s, as part of a plan to expand and decentralize the American fleet, President Reagan proposed to home-port the historic World War II battleship *Missouri* and the attendant vessels in its "battle group" at Hunters Point. Local activists helped to scuttle the idea, and by 1990 the die was cast. Base after base was abandoned in the multiphased Base Realignment and Closure process. In 1993, Treasure Island, the navy's nerve center, was shut down, to become again the property of the city of San Francisco.

The opponents of home porting had more in mind than a metaphorical sticking of flower stems down gun barrels. They saw little future in the military use of these lands, and much future in the real estate that would be opened up if the army and navy departed. They saw parks, new and refurbished housing, different and cleaner industries, accessible shorelines, wetlands restored. Lost jobs, they argued, would be replaced many times over.

What they did not foresee was the length and trickiness of the base conversion process. The biggest obstacle has been contamination of the military sites, in use since long before the dawn of environmental concern. There were hundreds of acres of ground where petroleum products had spilled (Treasure Island was likened to an oil-soaked sponge). There were PCB hot spots around electrical transformers. There were lingering pesticides and herbicides. There were splotches of heavy metal contamination. Cleaning up these old messes was and is onerous, with many debates about how much should be done and about who should pay.

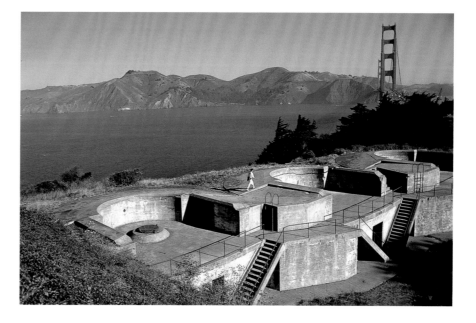

Nevertheless, the old bases are starting to realize their promise. New waterside neighborhoods are rising. Businesses are moving into refurbished airplane hangars. Several former military parcels are serving to expand the Port of Oakland. And large chunks of military territory are going to the birds. The arid pavement of the former naval air station on the island of Alameda has proved an ideal nesting ground for the graceful and endangered California least tern; the area is now the Alameda National Wildlife Refuge. Skaggs Island north of San Pablo Bay will be wildlife land as well. At Hamilton Army Airfield in Marin County, the old runways are to disappear under reestablished marshes. Airports traditionally take land from the bay; this may be the only case on record of land once used for aviation being given back to the tides.

In the end the biggest legacy of the military presence around the bay is going be the shoreline open space it has preserved. No power in the country besides the military could have secured these lands. No power besides the military would have troubled to keep them free of private housing and commerce in this burgeoning urban region.

When President Fillmore reserved the first Golden Gate forts, he did not actually specify "defense" as the reason, but only "public purposes." It is tempting to read his ambiguity as a promise, now fulfilled. Public purposes can change, and have.

Concrete gun emplacement on the south shore of the Golden Gate, built in 1895.

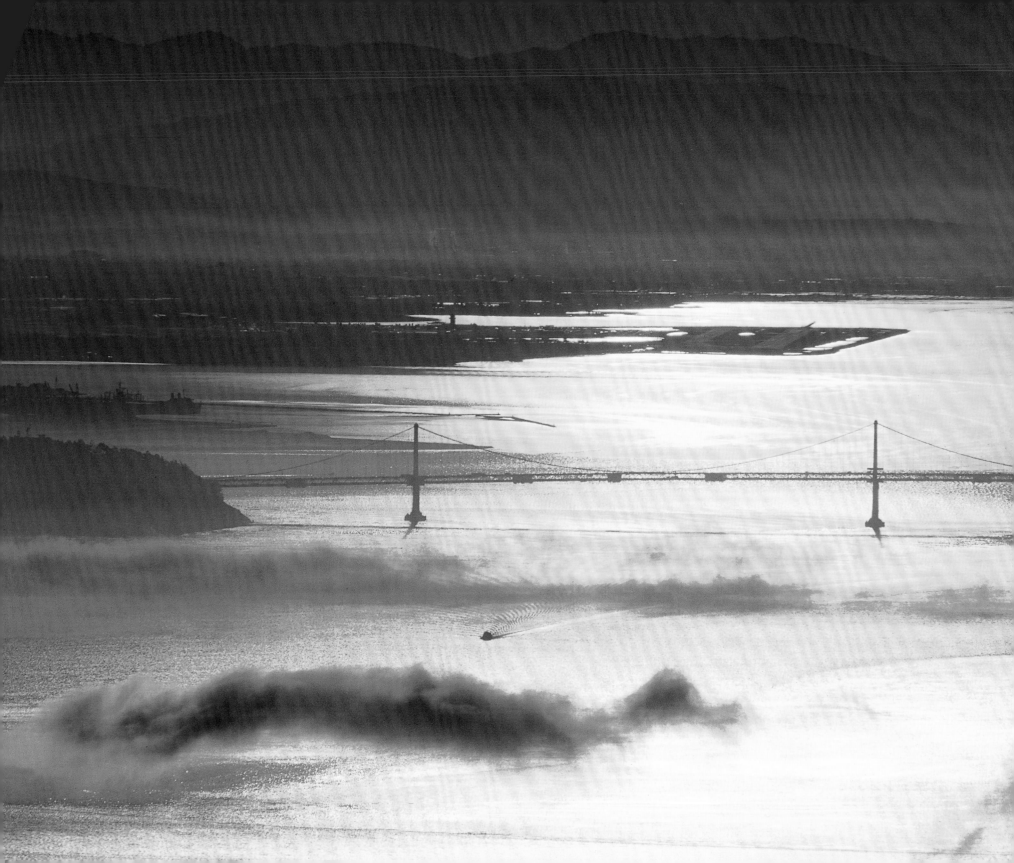

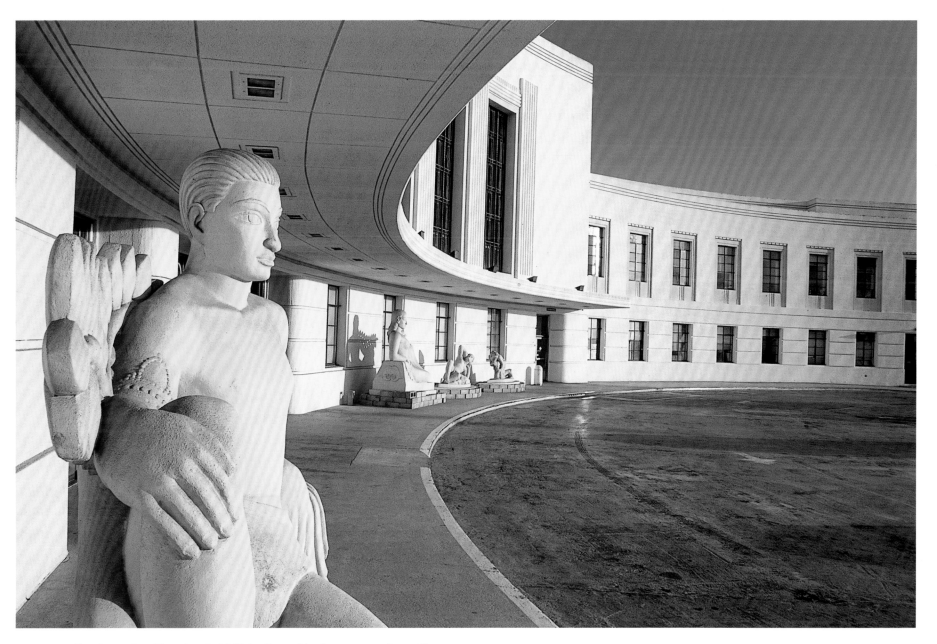

OPPOSITE: *Sunrise on the military bay. Left is Yerba Buena Island, once a navy base, still half controlled by the Coast Guard. Beyond the San Francisco–Oakland Bay Bridge extends the former Alameda Naval Air Station, now partly a wildlife refuge.* ABOVE: *Building One on Treasure Island, headquarters of the 1939 Golden Gate International Exposition.*

OPPOSITE: *Avenue of the Palms, Treasure Island. The trees are as old as the island, planted on its western waterfront for the 1939 fair.* RIGHT: *Yerba Buena Island, Clipper Cove, and the eastern span of the Bay Bridge. The cantilever structure is being replaced with a dramatic suspension span.*

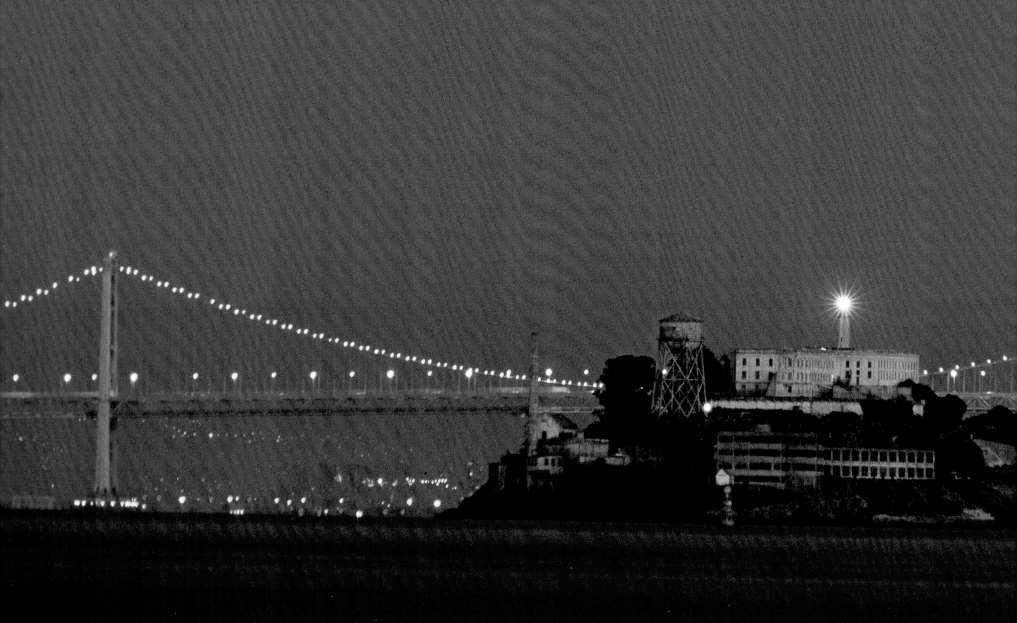

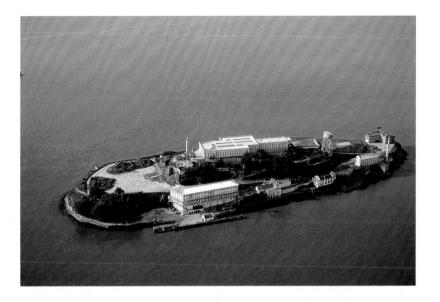

LEFT AND TOP: *Alcatraz Island has been, successively, an uninhabited rock, a harbor defense fort, a military lockup, a federal prison, a rallying point for Native Americans who occupied it in 1969, and a tourist attraction within the Golden Gate National Recreation Area. Its lighthouse, seen at left above the Bay Bridge, has been guiding ships since 1854.* BOTTOM: *East Brother Light Station off Richmond. With lighthouse automation, the historic keeper's house has been preserved as a bed-and-breakfast inn.*

The First Saving of San Francisco Bay

At "Paradise Park" in Any Bay City you may notice the following:

A rounded hill, perhaps one hundred feet high, with a viewpoint overlooking the water and several rather unimpressive sculptures on top.

Concealed in a draw, a small brown-painted building that oddly thrums.

A bit of salt marsh, with an exhibit explaining what lives there and how it nourishes San Francisco Bay.

A larger area of open water, surrounded by dikes, with a salty crust on its banks and quite a few feeding birds.

A shoreline path identified as a segment of the San Francisco Bay Trail.

An inconspicuous, rather musty-smelling building that, on closer inspection, turns out to belong to a local sewer district.

Put them together, and these elements make up the archetypal urban bayshore of the era since people stopped filling the bay and stemmed the amount of waste they dump into it. It is an earnest and partly successful attempt to put some public value back into a degraded shore.

The hill is a former garbage dump. Decaying waste within it is producing methane gas, which the small building pumps out. In some places the methane is burned to make energy; in others, just vented to the atmosphere.

The open water is a salt pond, part of a sprawling system that each year turns seven billion gallons of bay water into seven hundred thousand tons of salable salt.

The utility district building is a sewage treatment plant; it discharges treated effluent of a very nearly drinkable quality into deeper water several hundred yards offshore.

The salt marsh is just a salt marsh, a reminder, barely large enough to be symbolic, of the marshy world that was.

Cleaned up, tidied up, interpreted, accessible, this spot is not perhaps the best of all

Sunset on the mudflats north of Point Isabel in Richmond. Threatened with fill in the 1960s, this valuable habitat is now part of Eastshore State Park.

possible bays. But it represents a victory of sorts, for things were pretty ugly here once—and seemed on an inexorable downhill trend.

In 1960, most of the bay's shoreline was closed to the public, shut away behind buildings and (not seldom) behind barbed wire. Often for good reason. "Anything that stank or was dangerous," one observer notes, "wound up on the bayshore." That strictly utilitarian shoreline was a place of refineries, military bases, explosives factories, firing ranges, ports and airports, sewage outfalls, and dumps. It was not a place for enjoyment. Of the entire 276-mile circumference of the bay below the entrance of the Sacramento–San Joaquin River Delta, only 4 miles were open to public access.

Pollution was extreme. Sewage treatment methods and facilities, though improved since the days when Oakland used its tidal Lake Merritt as a sewage holding basin, had not kept up with population growth. Raw or barely treated effluent entered the bay in eighty-three places. Remnant wetlands like the Hoffman Marsh in Richmond reeked. At Alviso near San José, the sloughs were anoxic with waste from fruit canneries in the Santa Clara Valley. In San Francisco, the inlet called Islais Creek bubbled with sulfides from nearby industry.

Except near the Golden Gate, the bayshore was not an attractive place to live. Accordingly, poor people lived there. Ironic, that an address close to the region's great natural treasure should have come to suggest poverty. West Oakland, East Palo Alto, the Bayview–Hunters Point region in San Francisco, the Canal district in San Rafael: these were areas favored by geography but devalued by society.

As for the bay itself, the parts of it not involved in navigation were seen simply as real estate. The state, which held the original title to submerged lands, had disposed of them to cities and private interests with the freest of hands. Vast sections of bay floor were plotted out into fictitious streets and lots. Bayside cities were gleefully expanding their tax base by building new land. Often they built it of garbage, simultaneously solving the refuse disposal problem. Twenty major landfills were pushing into the bay like deltas from rivers of consumption and waste.

The biggest fill projects required much more material than garbage could provide. They utilized bay mud (easy to get but not very stable) or imported rock and earth. No postwar fill had yet matched the size of the one that earlier transformed Yerba Buena

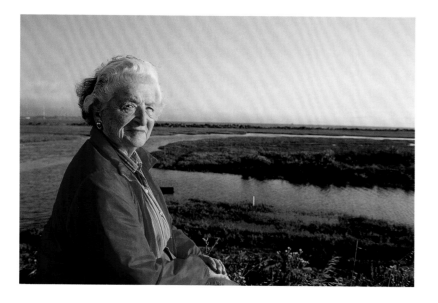

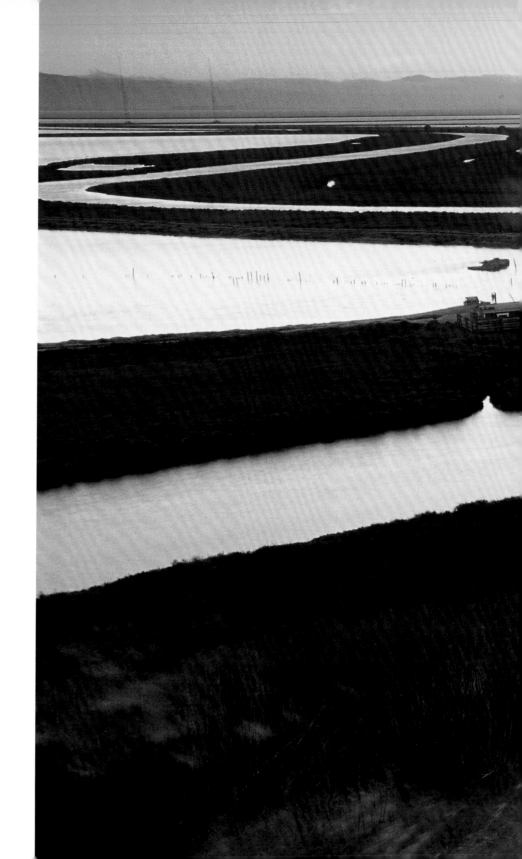

ABOVE: *Sylvia McLaughlin, bay fill opponent and co-founder of Save the Bay.* RIGHT: *Newark Slough in the Don Edwards San Francisco Bay National Wildlife Refuge. In the distance the channel traverses the Dumbarton Marsh, a rare intact remnant of the South Bay's wetland rim.*

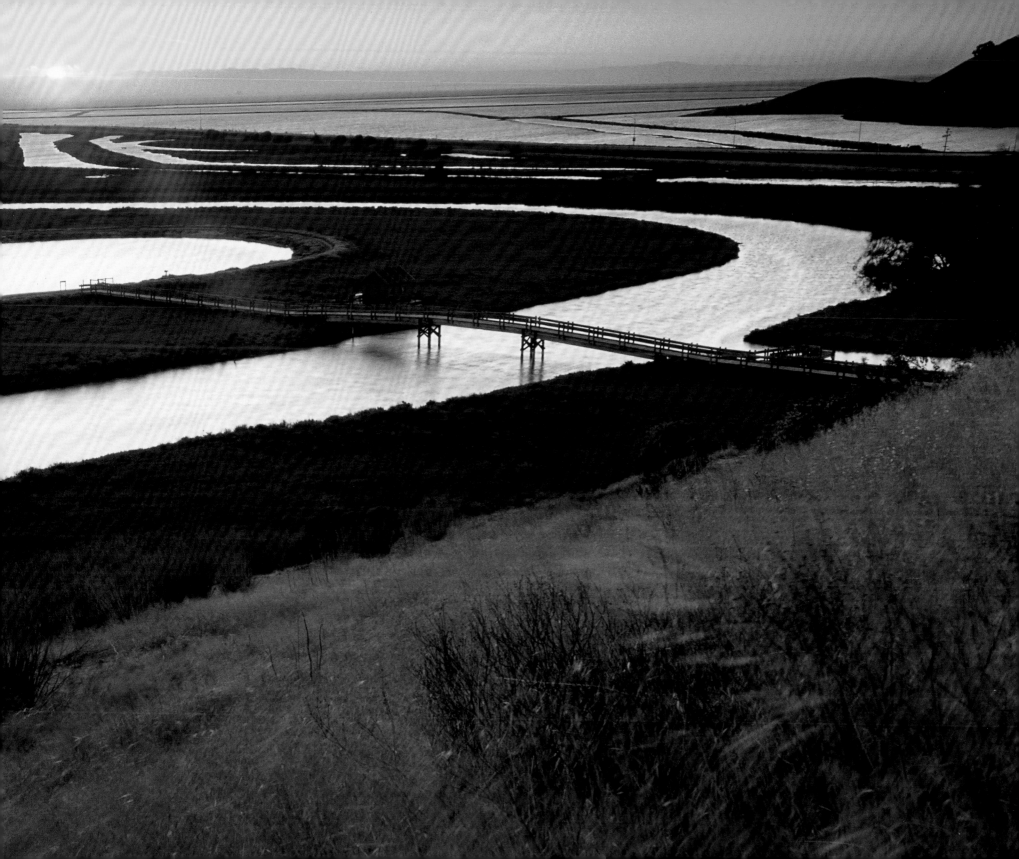

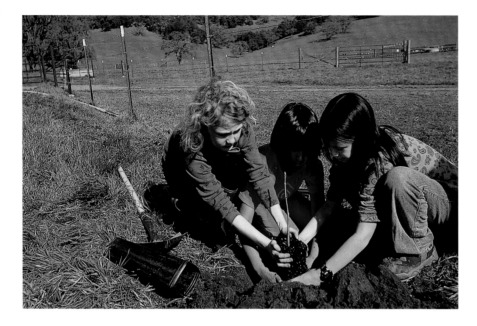

Shoals in the middle of the bay into Treasure Island, but much grander land grabs, or bay grabs, were pending. Richardson Bay, the inlet north of the Golden Gate between Sausalito and Tiburon, was on the block. The city of Berkeley planned to double its land area by filling to the middle of the bay. In San Mateo there was talk of reclaiming another twenty-three square miles of shallows, pulling down much of San Bruno Mountain to get the necessary material. And so it went. Possibly because each project was looked at separately from the others, nobody seemed much worried. At public meetings on the San Mateo plan, residents raised their voices about one thing only: the possible noise from the trucks.

Did nobody care about what was happening, or was it just that nobody felt another way was possible? What happened next, and how quickly it happened, suggests the latter.

The countermovement started in Palo Alto and Berkeley, and its leaders were all women.

Kids from the STRAW (Students and Teachers Restoring a Watershed) project plant native vegetation on a creekside near San Pablo Bay. The movement to "save the bay" preserved a future in which such restoration efforts are possible.

One day in 1958, an Audubon Society member named Harriet Munday tripped on a cracked sidewalk in Palo Alto and broke her leg. In aid of her recuperation, she limped along the bayside levees, admiring the birds. (Palo Alto even then owned its waterfront and offered an unusual degree of public access.) Presently she went before the city council to press a claim for compensation. Her friend Florence LaRiviere recalls: "And while she was there, lo and behold, the Utah Construction Company came and made a great presentation about the baylands. And they had grandiose, wonderful plans for a hotel, a conference center, tennis courts, restaurants. And Miss Munday rose in righteous indignation, rapped with her cane on the podium, and said, 'What do you people think you are doing here?'

"And that was really the beginning, to my mind.

"Harriet knew that there was something good about those lands, but she didn't know what," LaRiviere remembers. Munday and her ally Lucy Evans went to the California Academy of Sciences and to San José State College to arm themselves with information on the biological role of marshes. "She got all the materials, and they did her this wonderful display board that she took everywhere." Though mocked at first in the press, the campaign made steady headway. In 1965, the voters of Palo Alto amended the charter to provide that the city's baylands would not be filled.

Meanwhile, a further-reaching effort was getting under way in Berkeley. The protagonists here were three faculty spouses: Kay Kerr, wife of University of California chancellor Clark Kerr; Esther Gulick, married to an economics professor; and Sylvia McLaughlin, whose husband was a geologist and a member of the university's board of regents. All longtime Berkeley residents, they worried about changes they saw. As Gulick put it: "Crossing the bay, and seeing what was happening to it, and also smelling it when you went down the shoreline, made me realize that something I loved and had grown up thinking was always going to be here . . . maybe wasn't going to be."

In December 1959, the U.S. Army Corps of Engineers released a report on the projected growth of the Bay Area. It included without comment a map showing that the vast majority of the bay was shallow enough to be filled. Reprinted in newspapers, the map alarmed a lot of people. Kerr, McLaughlin, and Gulick were the three who decided to see what could be done about it.

In January 1961, they invited the most eminent conservationists in the Bay Area to a meeting at Esther Gulick's house. In Kay Kerr's account: "I remember Dave Brower saying, 'Well, it's just exceedingly important, but the Sierra Club is principally interested in wilderness and in trails.' The next guy, Newton Drury, said, 'This is very important, but we're saving the redwoods, and we can't save the bay.' It went around the room to

the point where there was dead silence. So we said, 'Well, the bay is going to go down the drain.' Dave Brower said, 'There's only one thing to do: Start a new organization, and we'll give you all of our mailing lists.' They all wished us a great deal of luck, and they went out the door."

So began the Save San Francisco Bay Association, usually just known as Save the Bay. It went from being a hobbyhorse to being an unstoppable force in regional politics in about a year and a half.

Its first target was the founders' fill-happy hometown. Using the promised mailing lists, they sent a thousand letters to arouse concern and solicit memberships at a dollar apiece. They got over nine hundred responses. Unheard of. Armed with such public support and their own excellent connections, they made rather short work of this first campaign. By the end of 1963, Berkeley had drastically scaled back its ambitious fill plan, and the Save the Bay network had spread all over the region, linking up the previously isolated clusters of people who had ineffectually and mostly silently deplored what was happening to the San Francisco Estuary.

The same year saw the publication at the University of California of a report entitled *The Future of San Francisco Bay,* by Mel Scott. Scholarly in tone but alarming in content, it showed just how far the destruction of the bay was poised to go. Local city and county governments, Scott suggested, could not be trusted to stem it. There must be a special regional authority to control fill and guide immediate shoreline development.

Almost immediately, local state senator Nicholas Petris introduced a bill to create such an agency. In 1964, Eugene McAteer, a state senate eminence (and a personal friend of the Kerrs), picked up the idea. In 1965, the McAteer-Petris Act established a temporary Bay Conservation and Development Commission and told it to write a San Francisco Bay Plan and report back to the legislature. In the meantime the commission had the authority to stop fills in open water and tidal marshes (though not the filling of former bay wetlands now isolated by dikes). In 1969, an amended McAteer-Petris Act made the commission permanent. Though much testing of the process was to come— though "grandfathered" fills would continue for years, leading some to wonder what had really changed—the era of the shrinking bay was over. The San Francisco Bay Conservation and Development Commission was the first body set up to protect submerged lands and wetlands—in the world.

Nineteen seventy-two was another turning point for San Francisco Bay. In that year Congress passed the Clean Water Act, setting national rules for pollution control. The federal program reinforced a recent state water pollution law, the Porter-Cologne

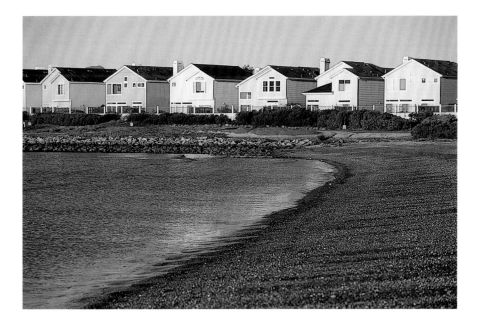

Act of 1969, and added a key new ingredient: lots of money, for the improvement of municipal sewage treatment plants. To make a complicated story simple, the campaign worked. Samples taken by the U.S. Geological Survey since that time—the longest run of such data for any estuary in the world—show, pollutant by pollutant, just how dramatic the improvement has been. Although pollution is still a serious problem in the San Francisco Estuary, coming now mostly from diffuse, nonpoint, sources like automobiles and agriculture, the change that has been wrought since 1972 is a triumph.

In the game of chess there is a phenomenon called discovered check. One threat to the king is removed—only to reveal another lurking behind it. So it is with the estuary, still under pressure from multiple angles. At the same time, our ambitions are growing. "Saving the Bay" won't do any longer; we want it substantially restored.

But let us not forget—troubled by current problems, exhilarated by current opportunities—just how much, against what seeming odds, has already been attained.

Housing on bay fill, Richmond.

OPPOSITE: *Egret in flight.*
RIGHT: *Reeds and reflections.*

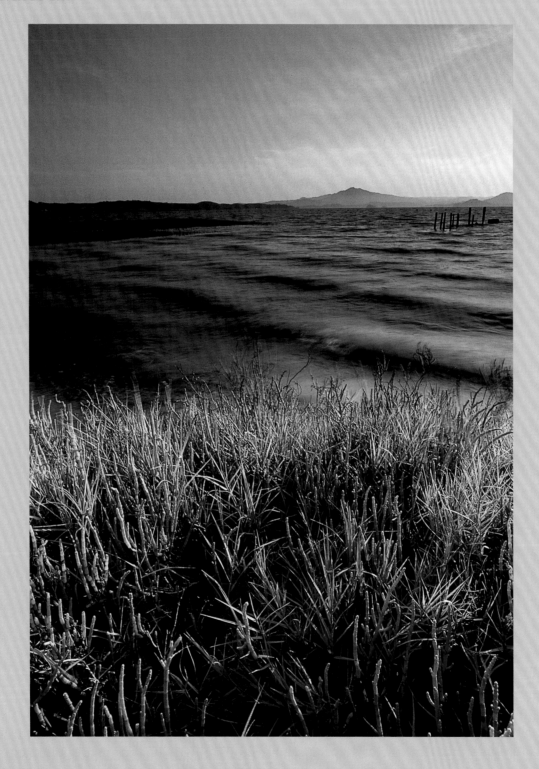

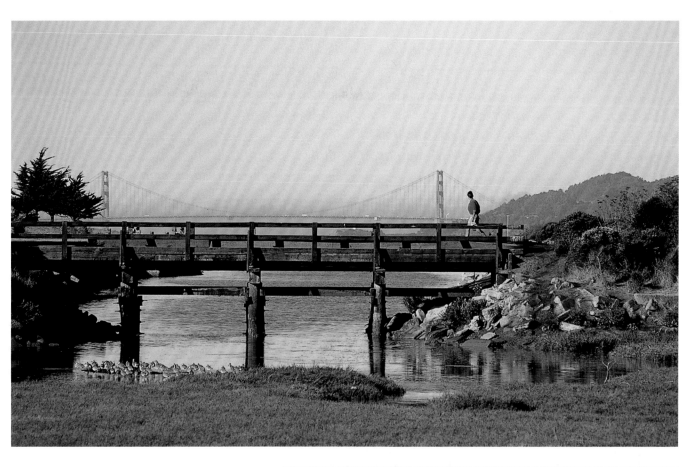

OPPOSITE: *Point Pinole Regional Shoreline, Richmond. San Pablo Bay stretches toward Mount Tamalpais in Marin. The point was once slated for a steel mill.* ABOVE: *Point Isabel Regional Shoreline, Richmond. A former railway trestle bridges the slough feeding Hoffman Marsh (foreground), one of the best saltmarsh remnants on the Central Bay.* RIGHT: *California least tern with chick. Terns nest on barren sites near the water, like this former navy runway on Alameda Island.*

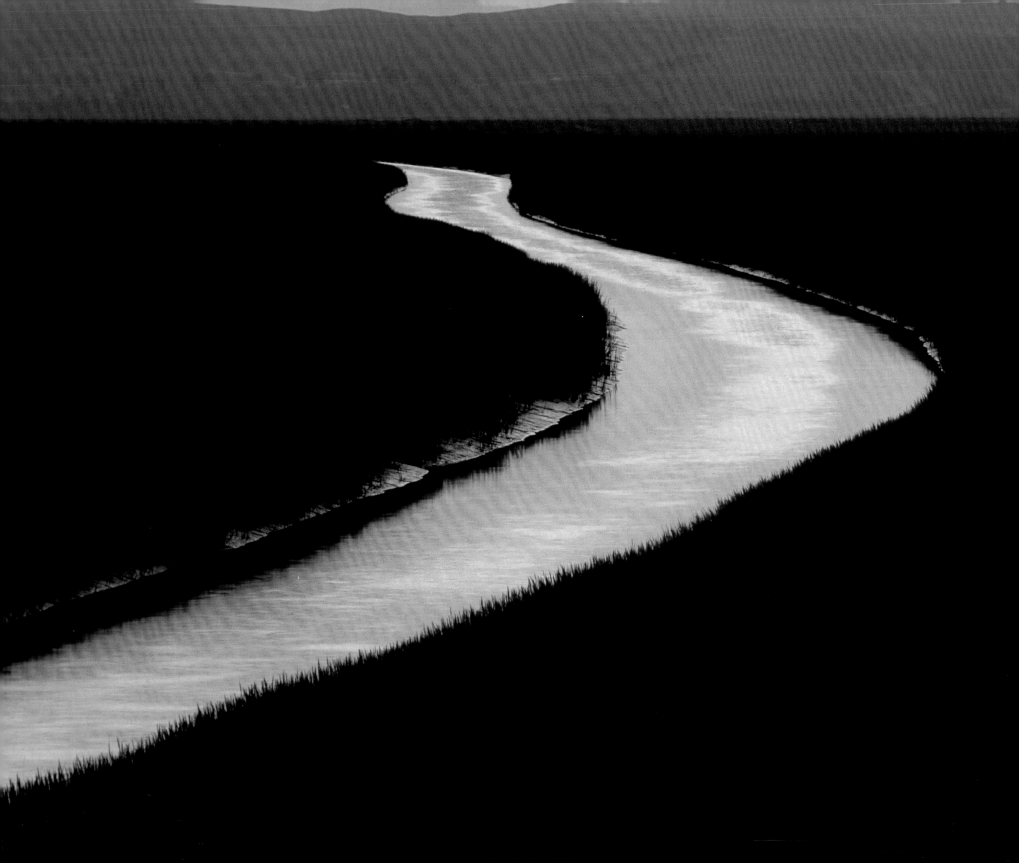

If you were listening to the radio somewhere near San Francisco in 1988, you might have heard an unusual public service spot. An ignorant man and a savvy woman are discussing the word *estuary*. No, she tells him, it is not a fancy garment; it is not a Middle Eastern condiment. It is the proper name and nature of those bodies of water commonly known as San Francisco Bay and the Sacramento–San Joaquin River Delta.

The word estuary comes from the Latin root for *tide*. The classic definition reads: "An estuary is a semienclosed coastal body of water that has a free connection with the open sea and within which sea water is measurably diluted with fresh water derived from land drainage." As a rule, estuaries are not just fresher than the sea but also better supplied with nutrients, washed off the land, than is the open ocean.

Bay and delta have been an estuary for at least ten thousand years, but they have only recently begun getting credit for it. When the Spanish explorers used the word *estero,* they just meant "bay." The conservationists who launched the Save the Bay movement didn't use the *E* word. Even scientists were slow to catch on to the specialness of estuaries in general and of this remarkable estuary in particular.

The revelation of this treasure hidden in plain sight began in 1967 when geochemist David Peterson took a job with the U.S. Geological Survey in Menlo Park. He was hired to map earthquake faults under the bay floor sediments, but it turned out that the technology didn't exist to do that. (It still doesn't.) So he turned to studying bay water—its chemistry, the nutrients it contains, and the fundamentals of the life it nourishes. Soon Peterson was joined by geologist John Conomos, a specialist in sediment transport (mud). Recruiting additional young colleagues, they formed the San Francisco Bay Group and began chipping away at "our enormous ignorance" of the bay and its most basic functions.

Conomos started tracking currents in the bay by setting loose "drifters" weighted to ride on the surface or at different depths. He proved that objects floating on the surface tend to make their way out the Golden Gate, but that sunken objects encounter a reverse flow and tend to make their way back in—a fact of immediate practical

Napa Slough in the Napa-Sonoma Marshes. Skaggs Island (right), *a former navy base, will be part of the San Pablo Bay National Wildlife Refuge.*

interest to murderers and coroners. A dead body begins as a bottom drifter and, with decomposition, becomes a surface drifter. Depending on its state and its location when it's taken out of the water, you can make a pretty good guess as to when and where it was dumped. Engineers scoffed at these findings at first. "Water doesn't run uphill," they said. But such two-way currents are in fact typical of estuaries, and living things in estuaries make use of them to get where they need to be.

The team learned a second fundamental fact about the bay: where most of its food comes from. The food chain begins with tiny floating algae called phytoplankton. These pinpricks of green turn inorganic nutrients, washed in by streams, into particles that other organisms can eat. Because phytoplankton must have sunlight for photosynthesis, they are found near the surface and grow best when the water is clear.

The phytoplankton hot spot in the estuary, research revealed, is the South Bay, the long branch of the system extending to San José. For several weeks in the spring, phytoplankton in this area proliferate, or bloom. For all the animals that live on phytoplankton, including clams and mussels and other mud-dwelling invertebrates, spring is the annual mealtime. It is now that they grow and reproduce. And the animals that eat these invertebrates—including fish like sturgeon, halibut, and English sole and diving ducks like scoters—similarly flourish.

Why is the bloom in the spring? For most of the year, the waters of the South Bay are well stirred by winds and tides. Phytoplankton get moved downward, out of the sunlit layer called the photic zone. They also get moved within reach of the bottom-dwelling organisms that consume them. Thus, no bloom. But when river outflows are high in the spring and the Central Bay to the north grows fresher, fresh water moves into the South Bay on the surface, above the heavier salt-laden water that was there before. The layers remain distinct for a while, a phenomenon known as stratification. When the South Bay is stratified, phytoplankton stay in the productive surface zone and float above the reach of grazers. Their population explodes. When stratification ends, they sink again, and bottom-dwellers reap the harvest.

Until this mechanism was understood, the South Bay had been thought of as an independent tidal lagoon, quite separate ecologically from the river-fed bays to the north. But the new research showed an intimate connection. It revealed that this reach of the estuary, too, depended on the rivers for its ecological function.

In the early 1970s, the scientists went on the road with their message of interconnection and complexity. Talking to anyone who would listen—to water bureaucrats, to farm groups, to environmentalists, to forums like the Commonwealth Club of San Francisco—they explained their new view of the bay: an estuarine system, inseparably connected to its delta, to its rivers, to its watershed.

This view involved the team in some rather hot exchanges with the engineers who ran the water projects tapping the bay-delta watershed. The California Department of Water Resources and the U.S. Bureau of Reclamation preferred to see the bay as just a bay, for a very practical reason: while a mere ocean inlet does not depend on an input of fresh water, an estuary, by definition, does. But the water an estuarine bay might need for its health was water already promised to cities and farms. It was only in the 1980s that the state of California formally accepted the estuarine nature of San Francisco Bay.

As late as the middle of that decade, the Geological Survey team (a changing roster) still accounted for most of the basic scientific research on the bay and delta. It was this team that first described the tremendous influx of exotic species into the system. It was this team that began tracking pollution levels in the waters and muds, and watched the dramatic improvement in water quality brought about by pollution control.

Peterson and his colleagues now have plenty of company in the field, but they retain the distinction of having founded it. They caused the scientific world to see the estuary for what it is.

Meanwhile, a newly retired bureaucrat named Bill Davoren was trying to open the eyes of citizens and policymakers to the same reality. During a long career with the U.S. Department of the Interior, he'd learned to think of the world as a collection of river basins, or watersheds, and he'd grappled with the costs to wildlife when rivers are dammed and diverted. People around the bay should be worrying much more, he argued now, about water diversions and other mischief that was going on upstream. "Save a river for the bay," he liked to say. In 1981, he launched a new organization, the Bay Institute, to tackle the bay's problems from a watershed point of view. Part advocate, part educator, and part think tank, the institute has six scientists on staff.

During the 1980s the growth of awareness continued. In 1987, Congress directed its attention to the problems of estuaries in general and of this one in particular, establishing the San Francisco Estuary Project. This working group of government agencies was charged with nothing less than planning the environmental future of the bay and delta. This exercise could have been as empty as it was vast, but the participants, led by the federal Environmental Protection Agency, were determined to give it some content

and some force. They got down to work. In the meantime, they attempted to prepare the ground by launching a "What is an estuary?" ad campaign.

In 1993, the estuary project published its *Comprehensive Conservation and Management Plan*. Of the many actions proposed therein, two stand out. One of these suggestions—that upstream water diversions must be limited for the estuary's sake—was controversial but by now familiar. The second major proposal, though not so sensitive, started a whole new conversation. Lost tidal wetlands all around the estuary's margin, the plan asserted, could be, and should be, restored on a massive scale.

In 1993 the Estuary Project hived off a daughter body, the San Francisco Estuary Institute, a scientific organization charged with monitoring and research. The institute helped to pull together a group of one hundred bay managers and scientists, the San Francisco Bay Area Wetlands Ecosystems Goals Project, to refine the restoration idea. The result, in 1999, was a landmark document dryly titled *Baylands Ecosystem Habitat Goals*. This bold and detailed blueprint calls for some one hundred square miles of former marshes, about one-third of the total that once existed west of the delta, to be reconnected to the tides. Another forty-five to sixty square miles are to be restored as nontidal wetlands.

The claim was staked. At the center of the effort to carry it out is another made-to-order umbrella body, the San Francisco Bay Joint Venture. This sprawling partnership links nearly all the public agencies and private organizations with an interest in restoration projects around the bay.

So the word is out: San Francisco Bay is an estuary. What's so special about that? And among estuaries, what's so special about this one?

In recent years we've come to realize that Nature is not just Nature, a green, flower-studded fabric spread across the world. We've learned that its texture is uneven. The ecological body of the world has some vital organs and some zones that are pretty much connective tissue; some spots where life reaches a peak, in mass or in diversity or in both, and others where the pickings are comparatively thin. Tropical rainforests, originally covering some 5 percent of the earth's surface, have become an emblem of special value and vulnerability. So have coral reefs. So too have estuarine environments, and these make up less than 1 percent of the area of the globe. "Everything in nature," notes National Audubon Society president John Flicker, "is attracted to estuaries and to rich coastlines."

Let's be obvious: to have an estuary you need a stream and an ocean (or a sea or a salt lake) for it to flow into. You also need a certain flatness of terrain. A river that plunges precipitously into salt water won't have much of an estuary; Canada's mighty Fraser River, for instance, is considered to have none.

At 1,600 square miles, the bay-delta estuary is the second or third largest in the United States (Chesapeake Bay being number one by far); it might also rank high on a planetary list, though no one seems to be keeping one. More importantly, the bay lies in a part of the world that is poor in such environments. From Tierra del Fuego at the southern tip of South America, up the entire length of the Pacific coast to just south of the Golden Gate, there is not a single big estuary. To the north, the Columbia River estuary is a quarter the size of the one at San Francisco. Washington's Puget Sound, though classed as an estuary by some, is not really comparable. You have to keep on all the way to Cook Inlet in Alaska to find a peer for San Francisco Bay.

Location, location, location. It makes the San Francisco Estuary the key destination or midway stop for birds on the move from northern summer nesting grounds to warmer winter habitats; as many as half the shorebirds and waterfowl on the Pacific Flyway spend time here. The shorebirds are the flocks you see on mudflats, shifting in groups as if obeying a single brain, probing for worms and crabs with cylindrical beaks of the most varied lengths and curvatures; they include the western sandpipers, dowitchers, marbled godwits, willets, and American avocets. In the fall, winter, and spring, a million of these busy birds, comprising some thirty species, are here. The region is classed as a site of highest importance in what is called the Western Hemisphere Shorebird Reserve Network.

Waterfowl—geese and swans, but especially ducks—also appear here in winter in thirty-odd species and in numbers approaching a million. The sea ducks, such as the surf scoter, use the maritime Central Bay; the diving ducks, like the canvasback and the pintail, favor deep but calmer waters; the dabbling ducks, like the mallard, feed in the shallows. More than half of the diving ducks on the Pacific Flyway spend the winter here, and the concentration of canvasbacks is one of the continent's greatest.

Though most of these birds breed in regions farther north, the bay shores are nesting grounds for some. Among the most notable are the terns: Forster's, Caspian, and least. These graceful, gull-like birds eat fish and nest on barren, open spaces near the water. The California least tern, an endangered species, has colonies at the former Alameda Naval Air Station and on the grounds of a power plant in Pittsburg. In marshes live henlike, almost flightless birds called rails. The California clapper rail, found only around the bay, was once abundant enough to be restaurant fare; it went to the edge of extinction before beginning a tenuous recovery. Its cousin the black rail, found in the Petaluma Marsh and elsewhere on San Pablo Bay, is doing just a little better. Three local subspecies of song sparrow are also salt-marsh nesters.

Birds tend to move north and south through the San Francisco Estuary; fish tend to move through it east and west. About 130 species of fish are found. Some, like delta smelt, live their entire lives within the system. Others, like herring, come into it from the sea to spawn or, like the starry flounder and northern anchovy, to grow to maturity here. Still others, like steelhead and chinook salmon, pass through on their way to mountain spawning grounds. For the young of many species, the branching sloughs that penetrate the few intact marshes are vital refuges and nursery sites. Streamside areas that flood in the winter—where this is still permitted to happen—have a similar nursery role.

The list of common fish in the estuary has changed a lot in the last 150 years. Many game fishes, like the American shad, have been introduced for sport; many nongame fishes, like the shimofuri goby, have arrived in the ballast water discharged by ships. In general, the seaward part of the bay has mostly natives; the delta is full of introduced species; and Suisun Bay and Suisun Marsh, midway between, are about half and half. The exotics, which seem to better tolerate the changes that human beings have made in the system, are gaining ground.

For many years, the species watched as an indicator of system health was the striped bass, a tasty Atlantic fish that flourished after its introduction to these waters around 1880. Lately attention has shifted to the chinook salmon and the delta smelt. Some four million salmon used to pass annually through the Golden Gate, moving in four distinct seasonal runs from ocean to inland spawning gravels. Numbers are down by 90 percent, and only one of the four runs, the one that takes place in the fall, at the beginning of the wet season, remains comparatively strong.

The delta smelt, found only in the inner reaches of this estuary, is a small, silvery fish that smells like cucumbers. Since it evolved with natural conditions and lives one year only, making it especially vulnerable, it is the favored canary for this particular coal mine.

Aquatic mammals have been scarce in the bay for so many generations that we no longer know what we're missing. In the old days, whales sometimes crowded the waters inside the Golden Gate, and local sea otters supported a major fur trade; hard to imagine today. Yet a modest resurgence seems to be underway. Harbor seals are here and holding their own; they breed on the Castro Rocks under the east end of the Richmond–San Rafael Bridge and at Mowry Slough near the Coyote Hills, and haul out also on Yerba Buena Island. In 1988, a gang of sea lions took up residence on the dock at Pier 39 in San Francisco and became an instant tourist attraction. Beaver are once more seen east of the Carquinez Strait, and river otter are common in the delta. Gray whales, too, are reappearing inside the Golden Gate.

The little native rodents that live in the salt marshes—the salt marsh wandering shrew, the Suisun shrew, the salt marsh harvest mouse—have dwindled with their habitat, and the last is officially endangered. It is the one of the few mammals that can drink salt water.

Of the thousand animal species the region supports, half are invertebrates. To mention these last and quickly is to read the book of the ecosystem backwards, for they support the rest of the food chain. The muds of the bay and delta area are a no-vacancy community of worms, clams, crabs, shrimp, cockles, and snails. Exotic species have changed this "mud town" community more than any other; a single new species, the Asian clam *Potamocorbula amurensis,* has become the most numerous creature on vast stretches of the estuary's floor.

The estuary is not one environment but many, modulated by tides, freshwater inflow, elevation, and local weather. Deep water is different from shallow, mudflat from marsh, the South Bay from the North. There are endless niches. Of special value, wherever it still exists, is the border, or ecotone, between wetlands and adjacent woods and grasslands.

The richness of the bay-delta system is both undeniable and somewhat paradoxical. Biologically speaking, it appears to rest on a rather small base. Compared with many others, this estuary is unusually turbid, its waters admitting little sunlight. Its "primary productivity"—the rate at which carbon from the air is made into plant tissues—is actually on the low side. The system seems to depend ultimately on nutrients brought down the rivers, washed in from the ocean, or (in recent decades) introduced via sewage outfalls. Marshes used to be a major nutrient source and may be again. Many estuaries can suffer when too much organic matter gets into them; overfertilized, they can undergo stinky eutrophication. Not here, as a rule. You might say that this bay is a hungry one: rather than choking on the influx of organic matter, it readily swallows it all.

But what most distinguishes this estuary from its peers around the world is the depth of the human imprint.

Typically, big cities form at the inland margins of estuaries, up near the limits of tidal action, leaving the seaward shores relatively wild. London is well up the Thames; Washington, D.C., is well up the Potomac. The analogous cities in California would be Sacramento and Stockton. The San Francisco Bay metropolis, almost engulfing its namesake body of water, is unique. No wonder that the Geological Survey researchers titled one of their first big reports *The Urbanized Estuary.*

Again, there may be no estuary on earth—with the exception of a vanished one, the now desiccated delta at the mouth of the Colorado River—that has had its freshwater influx so altered and reduced as this one.

Nor is there any estuary on earth that has been so thoroughly invaded and profoundly altered by species from other parts of the world. Biodiversity here, in the sense of species count, may have actually increased, even as the ecosystem suffers from the change and many valued native species dwindle.

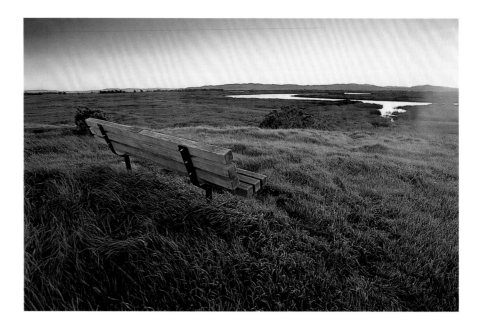

These human pressures combine to give the bay-delta system its least welcome distinction. For all its present wealth, it is probably the most diminished, the most impoverished, the most stressed system of its kind in the world. With increasing population on its shores and in its watershed, with greater demand for the fresh water that sustains it, the pressures are only going to mount.

Extraordinary challenge—and extraordinary response. Energies are pouring into the restoration of San Francisco Bay. The San Francisco Estuary Project and its associated bodies are working away. The Save San Francisco Bay Association and the Bay Institute, their missions now convergent, are on the job. The Audubon national organization, supplementing the work of the affiliated local Audubon chapters, has made this project one of its top priorities. Governments and private foundations are contributing the first of many needed millions. Fred Nichols, a scientist of the original Geological Survey group, sees the bay as a flagship experiment in large-scale ecosystem restoration—deserving, if it works, of world renown.

Check back in a hundred years.

ABOVE: *Overlooking Suisun Slough at Rush Ranch in the Suisun Marsh.*
OPPOSITE: *Low tide in San Pablo Bay National Wildlife Refuge. The glistening muds are packed with life; a cubic inch of tidal mud will contain forty thousand organisms.*

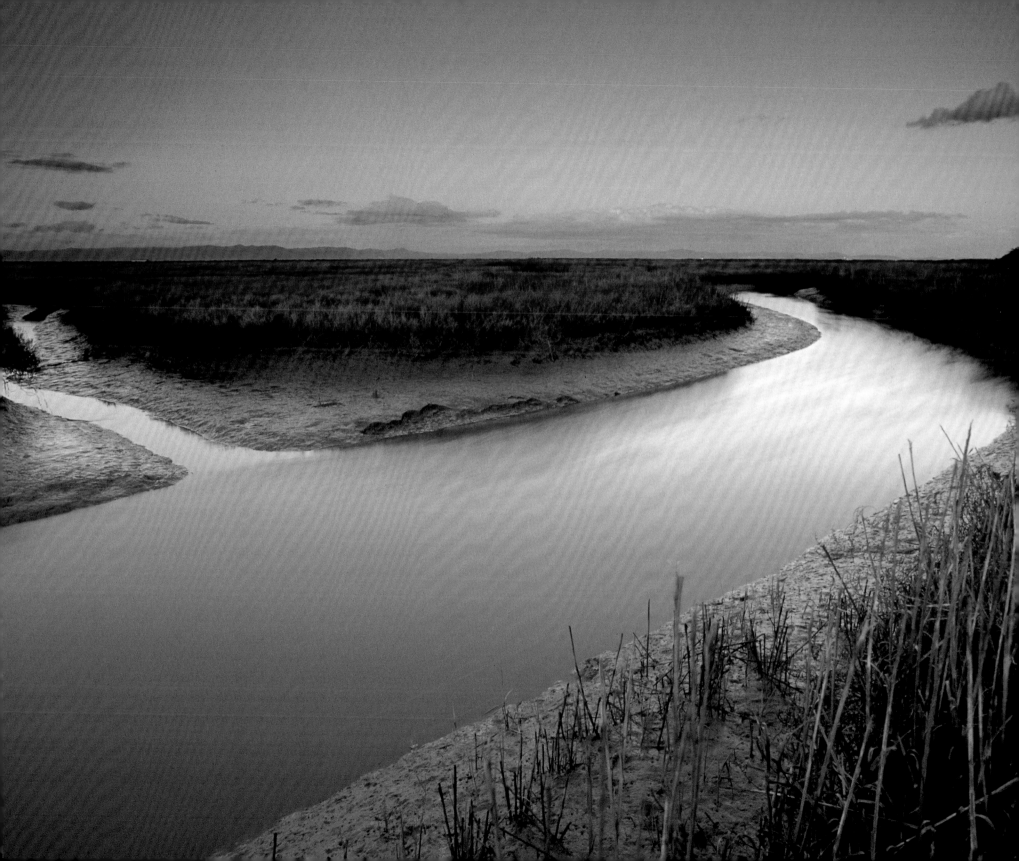

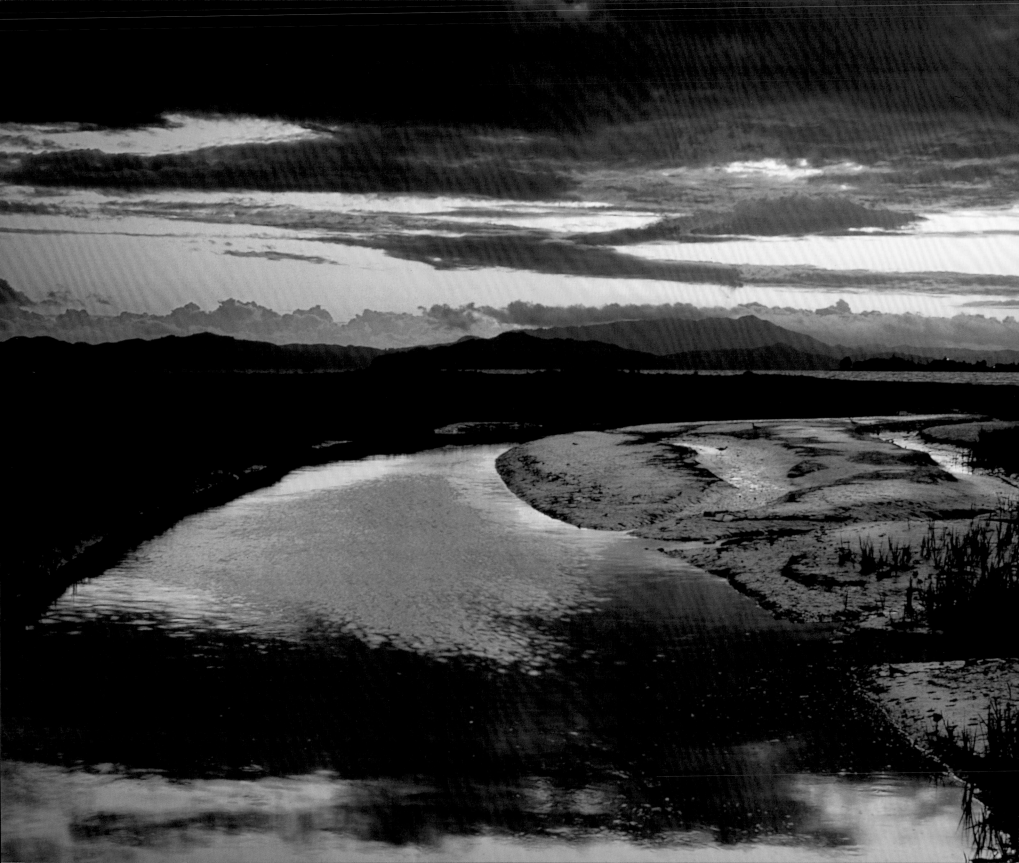

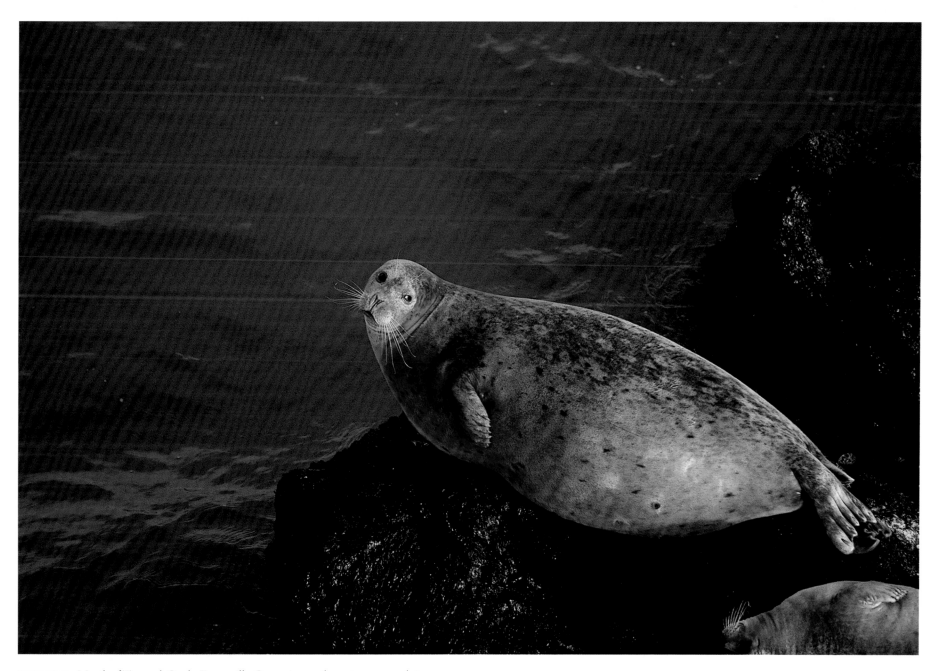

OPPOSITE: *Mouth of Temescal Creek, Emeryville Crescent, near the eastern approach to the San Francisco–Oakland Bay Bridge. Citizens are working to restore this urban, largely buried stream.* ABOVE: *Harbor seal resting at the Castro Rocks under the Richmond–San Rafael Bridge. Biologists from San Francisco State University are monitoring the seals.*

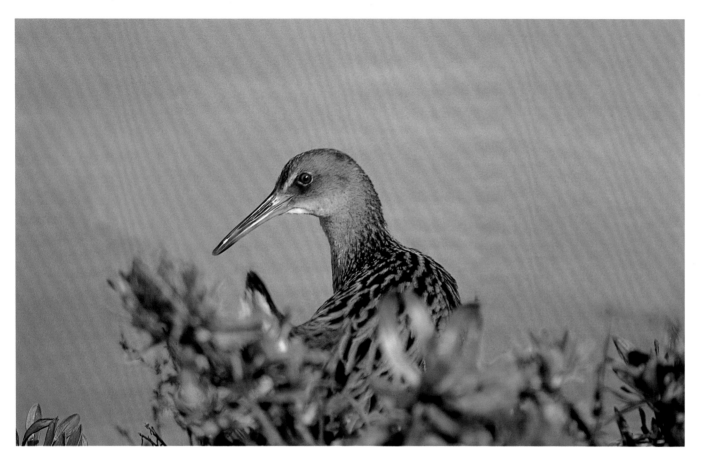

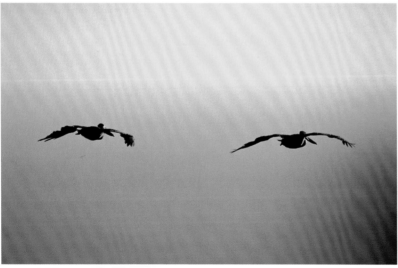

ABOVE: *Endangered California clapper rail at Arrowhead Marsh in Oakland. Usually hidden deep in the marsh, the birds are best spotted when tides are very high and they must move to higher ground.* LEFT: *Brown pelicans.* OPPOSITE: *Red fox. This exotic species preys on the rail, whose populations rebound where the foxes are controlled.* OVERLEAF: *Tidal lagoon at Crissy Field, San Francisco.*

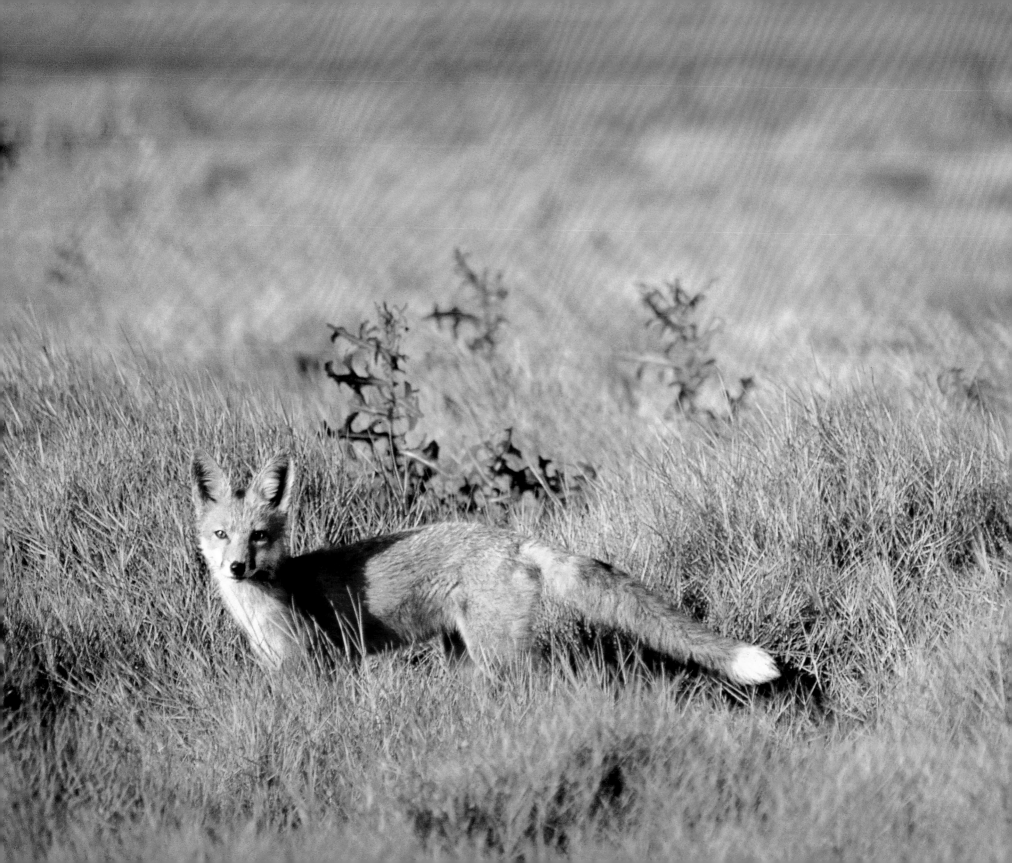

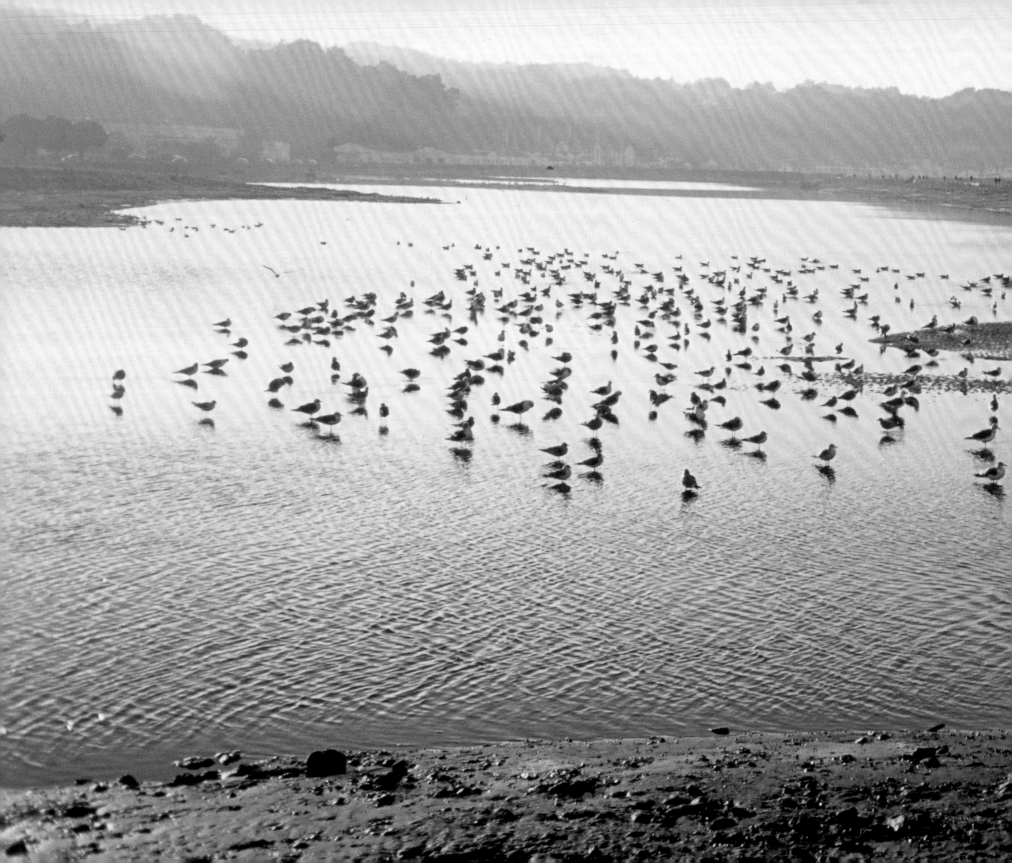

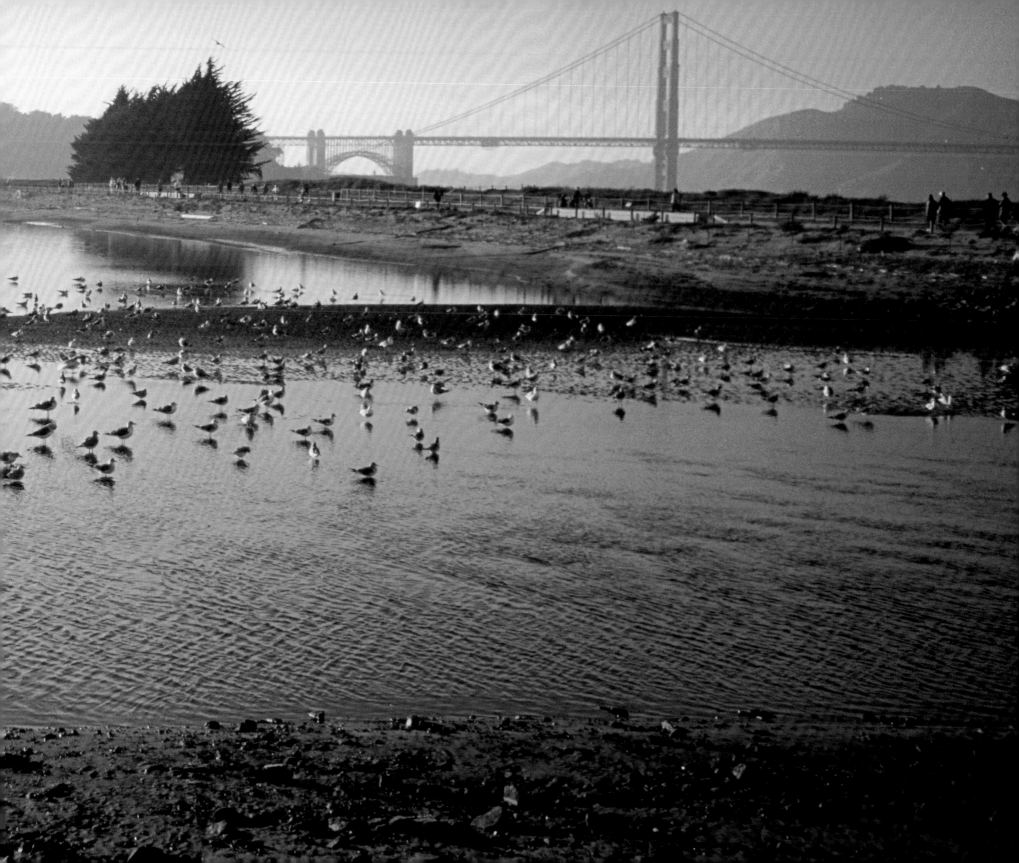

*E*very day, on average, 407 billion gallons of salt water rock in and out of the Golden Gate with the tides. Compared with that volume, the amount of fresh water that enters San Francisco Bay from inland rivers isn't much: about 16 billion gallons, on average, per day. Just 4 percent of the tidal exchange. Yet it is that 4 percent that makes the bay-delta system what it is: a mixing ground of fresh water and salt, an estuary, something more and richer than a bay.

Because its character depends so much on its freshwater inflow, the San Francisco Estuary can't be understood apart from its watershed. It is part of a system of waters that begins at distant mountain passes with the smallest tributaries of the tributaries of its rivers and embraces 40 percent of the landmass of California. Greatly though we have changed the bay itself, we have altered that upstream water system still more profoundly.

The process started small in the nineteenth century, as miners and farmers tapped nearby streams. Then the diversions became more ambitious. Early in the twentieth century, San Francisco and the East Bay cities built aqueducts from the Tuolumne and Mokelumne Rivers in the Sierra, moving mountain water directly to the coastal regions for urban use. In 1951, the federal Central Valley Project stuck a straw into the Sacramento–San Joaquin River Delta, sucking water south to farms in the San Joaquin Valley. In 1968, the California State Water Project tapped the delta too, sending much of its water even farther south, to urban southern California: clear out of the watershed that historically drained to the Golden Gate.

Some of the water removed from the rivers does eventually make its way to the estuary, after passage through farmers' fields or urban sewage treatment plants—entering at unnatural places, at unnatural times, and sometimes rather the worse for wear. Some of the water is gone for good. Each dam, each aqueduct, each new withdrawal from the Central Valley water bank has weakened the rivers that feed the bay. Estimates vary—often the most basic facts are the most disputed—but it appears that total freshwater runoff to the system has been reduced by at least one-third. In most years the reduction

The Central Valley Project water intake near Tracy. Several sets of pumps like this one draw fresh water out of the Sacramento–San Joaquin Delta, reducing the natural flow toward the Golden Gate.

varies from 30 percent to 60 percent; in dry years, when the water can least be spared, the proportion is much greater.

More important than the absolute reduction, it appears, is the change in the timing of flows. In the natural regime, streams surged with winter rains, subsided a bit in early spring, surged again in late spring when the Sierra snowpack melted, and trailed off through summer and fall. Now water is held back in mountain reservoirs during winter and spring for release in the second half of the year. These less variable flows, convenient in general for human purposes, are bad in general for living things and natural systems that evolved with higher highs (and perhaps lower lows). The winter peak still happens, but in most years the May–June runoff serves to swell the pools behind reservoirs and isn't allowed to pass downstream.

The downstream part of the estuary is now saltier in spring. Between February and June, scientists track the shifting of a point they call X2, at which the salinity near the bay floor is two parts per thousand. This point shifts constantly; it can be as far west as the Golden Gate and as far east as the delta channels. Most fish species that live in the estuary, especially the native ones, seem to flourish when X2 is well to the west, in Suisun Bay or in San Pablo Bay. This is true even of pelagic, ocean-dwelling fish that are just visiting the bay and would not be expected to respond.

Just why animals do better when the estuary is fresher is clear in some cases, less so in others. We do know that immature chinook salmon need high spring flows to guide them from their mountain origins out through the delta to the sea. We know that the Sacramento splittail, a large native minnow, spawns in the flooded riparian zones that form only in wetter years. We also know that the South Bay, which has less circulation, needs an annual dose of fresher water from the north; lacking this, it tends to go into a sort of suspended animation, producing little phytoplankton, accumulating pollution from its shores, and becoming even saltier than the sea.

How much water is diverted matters to the estuary; so, we see, does the *when*. An additional challenge lies in the *where*. Three of the biggest withdrawals happen almost side by side at the southern edge of the delta, near the community of Tracy. Here three sets of powerful pumps—a rather large set belonging to the Contra Costa Water District, a huge array belonging to the federal Central Valley Project, and a colossal one belonging to the State Water Project—draw from the delta channel known as Old

River. Together, the three installations sometimes remove from the delta an amount of water equal to two-thirds of what the watershed is pouring into it. And they have the horsepower to remove much more.

It would take a kind of blindness not to be impressed by the sheer scale of the engineering at these sites. Some of the world's largest electrical engines turn shafts four stories high. At the business end of the shafts, in the water-filled tunnels below, great screws called impellers turn, forcing the liquid southward and uphill. When we visited the Central Valley Project pumps, a dial on a wall showed a current energy draw of fourteen megawatts for just one of six pumps. It is the consumption of a fair-sized city, happening under a single roof. There are more pumping stations down the line. The State Water Project, which sends water farther and over mountains, uses vastly more power.

Besides doing their share to reduce the bay's freshwater income, the pumps have some more local troubling effects. Their pull is felt in nearby channels, setting up illogical currents that deceive many thousands of fish into heading the wrong way. "They think we're the bay," a federal biologist says ruefully. Some twenty million fish, counting immature forms, are drawn into the state and federal orifices every year.

There are devices called fish screens at the intakes. What they really are is fish catchers. They somewhat resemble tall metal picket fences, aligned in V formation in the intake channel, with the wide end "upstream" toward the Old River water source. The narrow end is not quite closed. As the current rushes into the V, most of it falls out along the sides and is taken on to the pumps. But the fences create vibrations unpleasant to fish, so they keep to the dwindling stream in the middle. The fish and the remaining water then drop out the narrow lower end into a conduit that leads not to the pumps but to a separate salvage building. Here the fish are counted (a sampling process) and finally returned to the river.

The system, if better than nothing, is not that good. Quite a few of the fish drawn from the river aren't diverted at all but go on into the pumps (some survive to take up residence in the long aqueducts beyond). Many of the fish that do make it to salvage are injured, and many die; species that are classed as threatened, like the delta smelt, seem especially fragile. The salvage process also crowds fish together, giving big ones a good chance to devour the little. This problem is worse at the State Water Project intake, where the fish spend time in a predator-friendly holding basin called the Clifton Court Forebay before they get their chance at salvage. No wonder that scientists compare the delta pumps themselves to "big, deadly predators."

The native fishes of the delta, like the delta smelt, have plenty of problems besides these pumps. Biologists differ on how much to worry about this particular hazard; many young of a given species can die here without reducing the number of adults. But the pump intake problem adds to all the other pressures—pollution, habitat loss, the competition of exotic species, and the drastic changes in natural river flows—that beset these fishes.

Just as the waters of the estuary are tugged in different directions by gravity and tides and spinning impellers, its future has been in suspense between three powerful and passionate interests.

On one side of the triangle are the demands of San Joaquin Valley agriculture, which seeks always to have as much water as possible pumped south. For decades, irrigated farming was expanding, opening new fields as fast as imported water became available—and even before it became available (a trick accomplished by overpumping and depleting local groundwater). That expansion has stopped in most places, but agriculture is fighting to hold on to the water it has (it uses about four-fifths of the state's developed supply); to keep that water coming as cheaply as possible; and above all to keep its ditches running predictably, even in times of drought.

On the second side of the triangle are the state's burgeoning urban regions. They need water, too, and in the past have often lined up alongside farmers in support of more dams and diversions. But the cities are also, increasingly, learning to conserve, to stockpile water during wet years in the natural underground gravel fields called aquifers, and to make good use of water recycled from sewage.

On the triangle's third side are people whose interests somehow lie with a healthier bay-delta estuary. These include various environmental groups, some scientists, some bureaucrats, recreationists, hunters, and (very notably) sport and commercial fishermen. Often aligned with this party are delta farmers who tap into delta channels at points seaward of the pumps. These various people want more water, or anyway not one drop less, to flow westward toward the sea. They want diversions out of the watershed in general—and out of the delta in particular—to be curtailed.

Until the 1990s, urban interests and agricultural interests typically worked together, and pretty much got their way. In decades of controversy, the environmental or "downstream" advocates gained some points, but very little water. Exports climbed through the 1980s, even in the face of a lengthy drought, and reached a peak in 1989. Four more pumps were added to the State Water Project array. The news from the fish biologists only got worse.

In the century's last decade, the downstream party essentially called in the feds. Going to court, they got the delta smelt and the winter-run chinook salmon, two species in undeniable trouble, declared Threatened under federal law. That official

capital *T* gave federal wildlife agencies some power over water project operations. To the disgust of agriculture, the biologists could now actually shut down the pumps to prevent harm to protected fish. The campaigners also secured big changes in the laws governing the federal Central Valley Project. In 1992, Congress passed the Central Valley Project Improvement Act, sponsored by local representative George Miller and Senator Bill Bradley of New York. For the first time, the project managers were directed to release some of its water for the needs of fish and wildlife. To old-line water bureaucrats who felt empowered, in principle, to control all the state's liquid assets—who regarded releases for ecological purposes as a kind of charity—this seemed like highway robbery.

To Gary Bobker of the Bay Institute, who fought for all these changes, this revolution recalls the civil rights movement of the 1960s in the segregated South. Then, too, only federal intervention could unlock what looked like a permanently frozen situation.

The pieces kept moving. To oversimplify—and for sanity's sake we had better—the cities forsook their old alliance with agriculture and took up a mediating role. They agreed to support greater freshwater flows to the bay. They offered some money for habitat restoration. And they also interceded for the farmers from time to time.

In 1994, the parties signed an agreement called the Bay-Delta Accord. (The Bay Institute was one of the three nongovernmental signatories.) The accord required greater flows and reduced pumping out of the delta in the spring. To wrestle with longer-term problems, a joint planning forum was set up, known inelegantly as CALFED. Every interest is present, and the state and federal governments jointly preside.

CALFED's action plan appeared in 2000. It boils down to a great bargain, based on a great gamble.

The bargain is that billions of new dollars will be spent to protect and restore the natural systems of the estuary, in every way but one: the amount of water taken from the watershed will not be curtailed—and may even modestly increase.

The gamble is that this will work: that if everything else is done right—wetlands rebuilt, riparian habitats restored, pollution cleaned up, levees adjusted, fish screens improved, and water dribbled out the delta at just the moments when fish need it most—the estuary can flourish on something like half its natural freshwater income. As fish scientist Peter Moyle puts it, "We want to have our cake and drink it, too."

The results of this experiment won't be known for many years. Certain explosive questions—whether and at whose expense to build some new reservoirs, for instance—have been deferred, rather like the status of Jerusalem. But for a while, at least, the knives of the water warriors are in their sheaths, or only flashed occasionally, by way of reminder. CALFED is the only game in town.

One of the many things CALFED is seeking is better fish protection at the pump intakes at the Old River. The existing fish catchers, misnamed screens, will be replaced with true screens, fine enough so that fish can't pass through them at all and will simply stay in the river. Water moves slowly through such a mesh, so the screens must be very large in area (and must also be frequently cleaned of debris so they don't clog). At the State Water Project intake, the new screens will also be next to the river, sparing fish the passage of the Clifton Court Forebay. There will be other refinements.

The "taking" of fish at the pumps is only a small part of the problem water exports pose; the fancier fish screens are at best a tiny part of the solution. But they are evidence, tangible and expensive, of a newly serious effort to deal with the consequences of our thirst.

Transmission lines bringing power to the pumps at the Central Valley Project and the State Water Project. The state project is California's largest electricity consumer. In the distance, Clifton Court Forebay.

OPPOSITE: *Fish screens at the intake of the California Aqueduct.*
ABOVE: *The aqueduct near Tracy. This 450-mile-long ditch carries water from the delta to Central Valley farms and Southern California cities. Windmills nearby harvest energy from prevailing west winds.*
RIGHT: *Steelhead fingerlings at a state hatchery on the Feather River north of Sacramento. To offset fish losses due to water development, millions of hatchery-raised salmon and trout are released yearly into the delta.*

The Hollow Lands

*T*o walk a dike on the shore of San Francisco Bay is to enter into the strangeness of a system half natural and half artificial, seen at one unstable moment of an eventful history.

The Netherlands, the nation so famous for its dikes, has eighteen hundred miles of raised earthen barriers defending it from the sea. In the San Francisco Bay and Sacramento–San Joaquin Delta region, there are probably two thousand miles. These dikes—you can also call them levees—constrict the bay, restrain stream and river floodwaters most of the time, and in fact make up most of what we today perceive as the San Francisco Estuary's shoreline. Behind the dikes lie the "baylands," a broad, debatable band of country wrested from the bay, much of it actually below sea level. The future of the baylands is still being determined by nature and by us.

The typical dike was built at the outer edge of a marsh—an expanse of saltwater vegetation like pickleweed and cordgrass, of freshwater plants like tules and cattails, or of brackish-water mixtures of the two. In a few places, the lands cut off behind the dikes remain wetlands, their water levels artificially controlled for the benefit of ducks and the people who hunt them. In other places what lies behind the dike is the quiet, pastel-tinged water of a salt evaporation pond. In still others the former marsh has been filled with garbage or other debris, raised above sea level, and irrevocably annexed to the mainland. But the commonest use of diked-off lands, especially along San Pablo Bay and in the Sacramento–San Joaquin Delta, is for farming.

It was in the delta, around 1870, that the diking process began in earnest. The region then was a ten-thousand-square-mile tule marsh, divided by rivers and sloughs into blocks of relatively higher ground called, rather hopefully, islands. The peat soil that accumulated in the marshes over millennia, in some places to depths of ninety feet, was very fertile, and this far inland it was free of salt. If it could be dried out and farmed, the neighboring rivers would provide both a guaranteed water source in a naturally dry region and a toll-free highway for the transport of crops.

The first dikes were built of peat dug from the "islands" themselves; the first labor force was Chinese discharged by the Central Pacific Railroad when the transcontinental line was completed in 1869. But the resulting barriers were pretty fragile. Only a yard or two high, they might hold against normal tides and modest surges of spring runoff, but not against Nature's very common extremes. Peat, moreover, shrank as it

A levee on the north shore of San Pablo Bay, Sonoma County.
The tidal marsh at right, once drained for farmland, is now managed
as part of the San Pablo Bay National Wildlife Refuge.

dried out, and actually rose and fell in response to the tides, leading to cracking, leaks, and breaches.

Bigger, stronger barriers were needed, and engineers soon figured out how to make them. The next generation of levees was built, not from the organic island soils, but from bottom muds in the adjacent rivers—mineral soil washed down from the mountains. A particular type of dredging machine, already in service maintaining shipping channels, was modified for levee building. The result was the California specialty known as the long-boom clamshell dredge, still seen at work in estuary waters. Look for the stout timber or metal structure, like a lopsided teepee, that supports the cable that works the swinging boom. Although other kinds of dredges would join the fleet, this historic design has never been supplanted for levee work.

The dredges moved along rivers or tidal channels, scooping up bucketfuls of mud, swinging them to the island side, and dropping a row of loads. A dike would be built in two or more passes, with pauses in between while the sediments drained and consolidated. Once the barrier was complete, remaining water within the walls would be pumped out, and farming could begin.

The tools perfected in the delta were soon being applied around Suisun, San Pablo, and San Francisco Bays. Soils along more seaward shores were saltier and less fertile than those in the delta, and the reclaimed fields tended to be used not for asparagus and tomatoes, say, but for pasture and oat hay; yet "reclamation" still made economic sense. The dredgermen (as the operators are always called) transformed the great marshland north of Suisun Bay, tamed the arc of wetlands along San Pablo Bay from Vallejo to San Rafael, and worked their way around the South Bay from San Francisco to Alviso and back up to Alameda on the eastern shore. Decade by decade the diking rolled on. It shrank the bay to the outline familiar from road maps; it turned the delta into the modern patchwork of named and more or less habitable islands.

Diking caused changes in the open-water channels that remained. Because there was less waterlogged area for the tides to fill and drain—because the tidal prism was lessened, a hydrologist would say—the currents in the channels weakened. More sediments settled; channels shoaled and narrowed; vegetation closed in. Open water became mudflat, mudflat became marsh, marsh became dry land. This shrinkage of channels and slackening of currents has impeded navigation in shallower parts of the bay: with less tidal scouring in the diminished sloughs, there are fewer places where boats can get in and out without frequent, expensive dredging. It is astonishing to read of the places that sailing ships could once reach in natural channels: up Newark Slough to Mayhew's Landing in Newark, up San Rafael Creek to the present San Rafael city hall.

Profound changes also began in the "reclaimed" lands behind the dikes.

It was noticed from the earliest days that the new-made land was sinking. It subsided partly because it compressed, but chiefly because the plant matter in it, accumulated during centuries underwater, oxidized when exposed to the open air, a kind of slow fire promoted by microorganisms. The early farmers also quite literally burned the peat surface, a practice that killed weeds and released nutrients for crops but also hastened the land's decline. Wind, too, did its part, removing powdery soil.

Some of the land surface drops have been enormous. The fields north of San Pablo Bay are six to eight feet below mean sea level. The south end of Staten Island, deep in the delta, is seventeen feet below sea level. In a few spots the drop exceeds thirty feet. In the far southern reaches of San Francisco Bay, another process has accelerated the sinking: overpumping of groundwater in the Santa Clara Valley caused the whole region to sag like a leaking waterbed. Even some of the nearby salt ponds, whose beds were never exposed to the air, are now many feet below the level of the adjacent bay. The old port of Alviso, the waterfront part of San José, has been called "a hole surrounded by dikes."

There are many such holes, whole ranks and honeycombs of holes. All in all, about 730 square miles of land around the estuary now lies below sea level. If the dikes disappeared and the bay and delta reoccupied all these vacancies, the open-water area would more than double, and the amount of water the system holds at mean tide would increase by half.

The situation cannot last. We simply cannot defend, everywhere and forever, the hollow lands that ring the bay and almost constitute the delta (and which, remember, are still subsiding by the year). We have to make choices. Some real estate, already built on or otherwise of special value, we certainly have to protect. Flood control is now a permanent duty. Even our mistakes, if we have sunk enough money into them, must be defended. But where land can be given back to the waters, with preparation and on our schedule, not Nature's, it looks as though we had better do it.

Fortunately, that retreat may be just what the ecosystem needs.

Rush Creek wetlands in Novato, Marin County. Once a diked pasture, the area now serves as a flood control basin—and bird habitat.

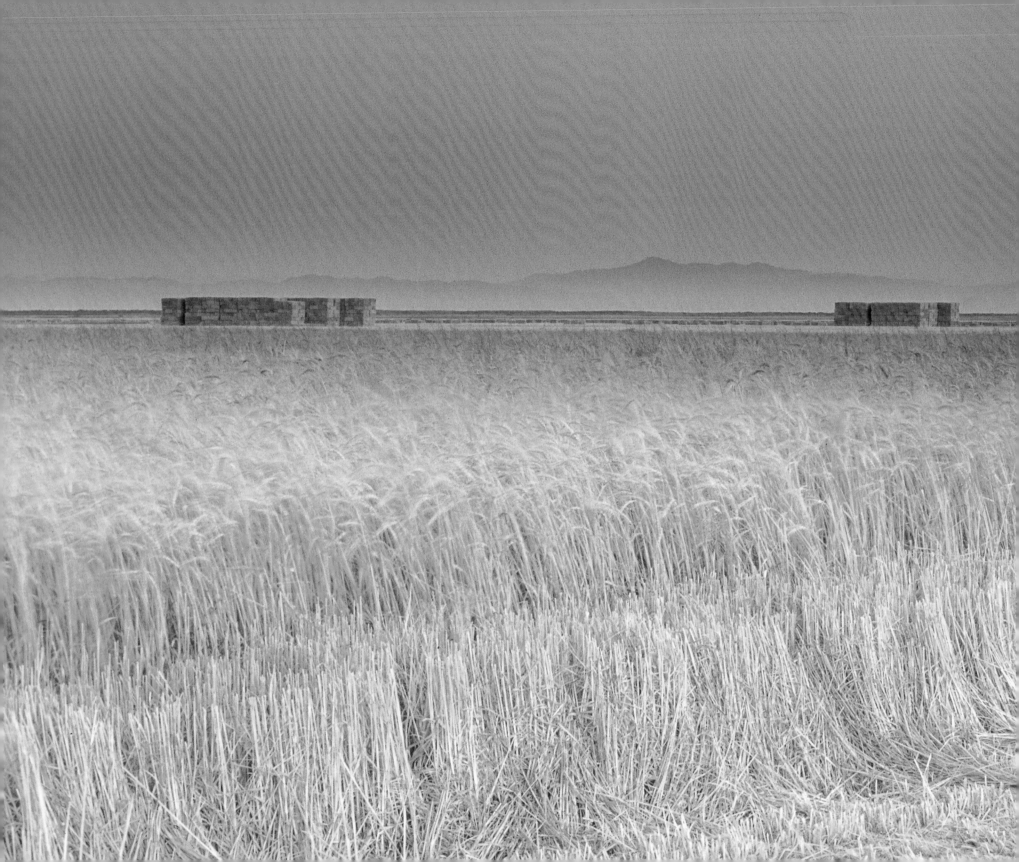

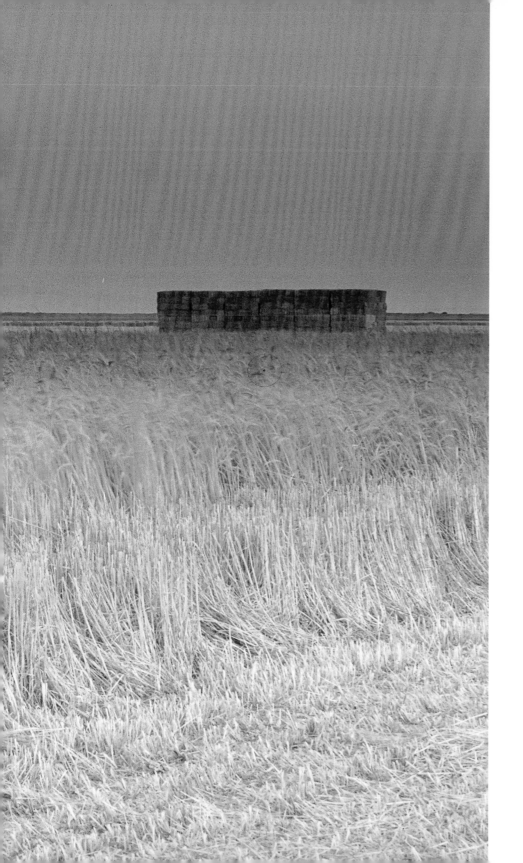

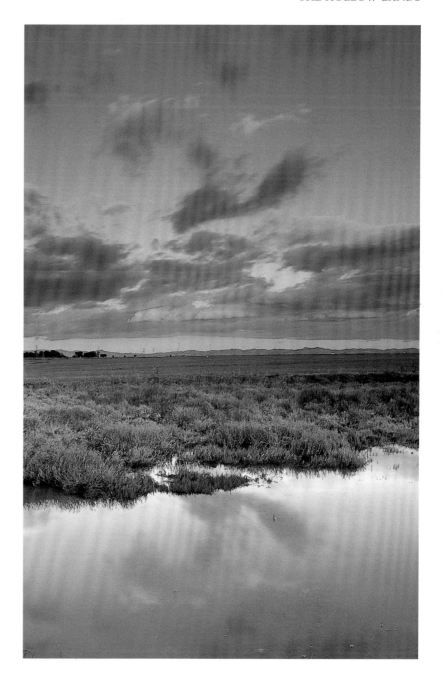

LEFT: *Hay farming on diked former marshlands along San Pablo Bay.*
ABOVE: *Marshy strip alongside fields on Tubbs Island, Sonoma County.*

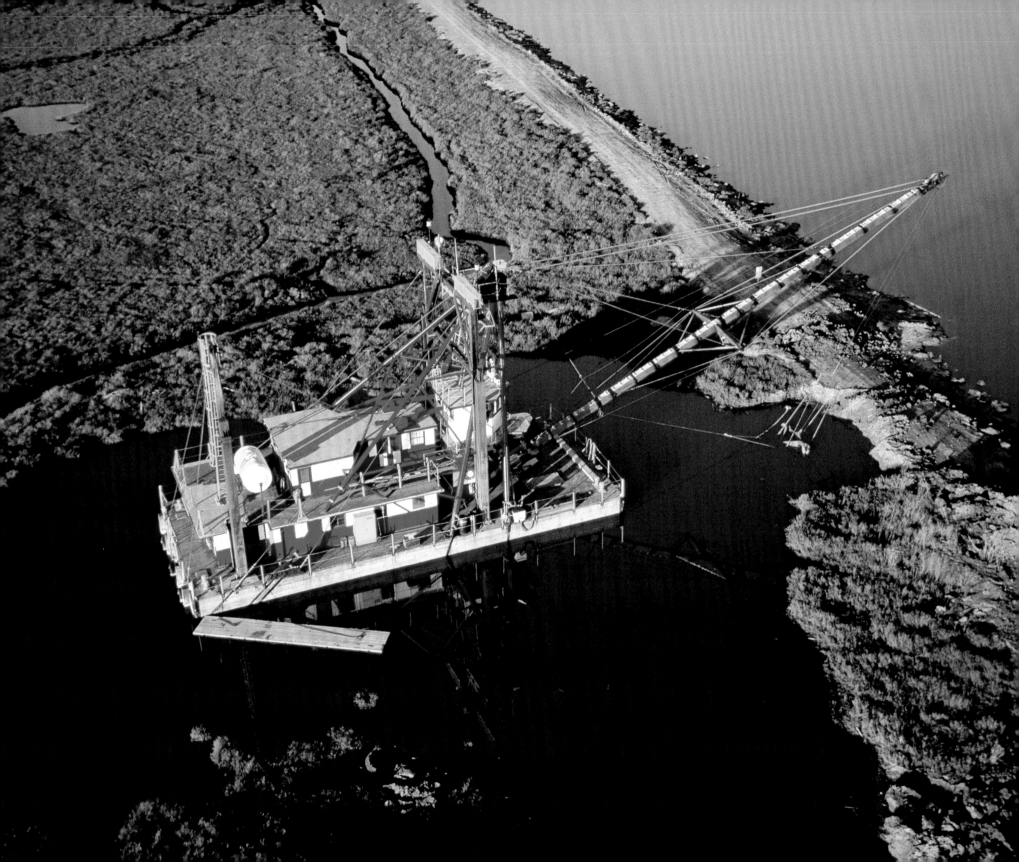

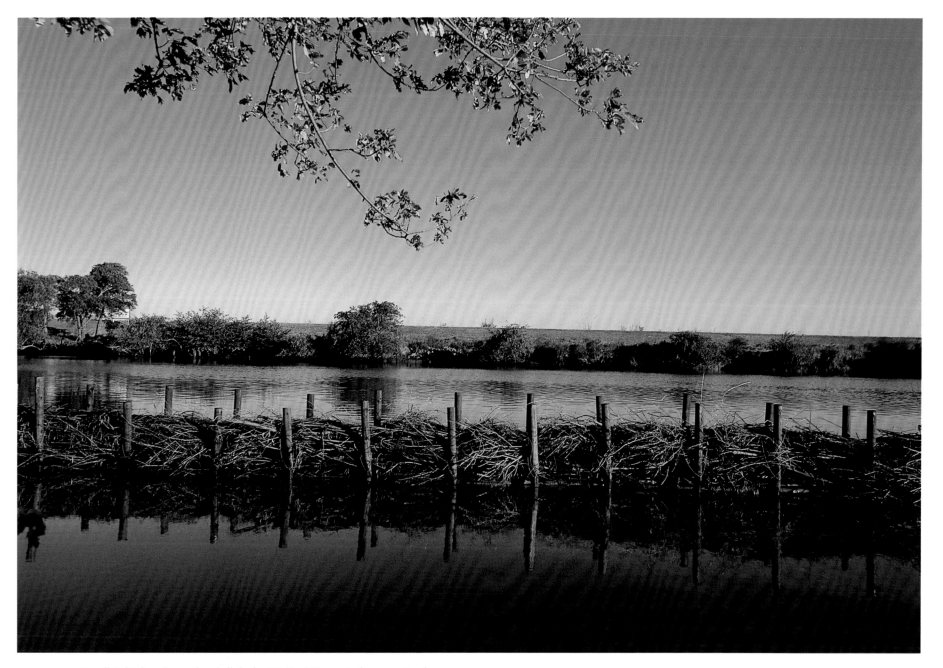

OPPOSITE: *Cargill Salt's long-boom clamshell dredge,* Mallard II, *repairs levees on South San Francisco Bay.* ABOVE: *Brushy breakwater in the Sacramento–San Joaquin Delta. Such barriers protect levees from wave erosion and create habitat as silt fills in the protected waters and vegetation grows.*

Second-Growth Wetlands

*I*n 1769, when the first Spanish expedition reached its shores, the San Francisco Estuary was a world of tidal marshes. Three hundred square miles of cordgrass and pickleweed and tules bordered San Francisco, San Pablo, and Suisun Bays, equaling the area of open water. Inland, the Sacramento–San Joaquin River Delta was a veritable sea of reeds covering five hundred square miles, interrupted at intervals by tidal sloughs and rivers.

Early accounts are full of the glory of bay and delta wildlife. The metaphors are those we know from other pioneer regions: the straits so thick with salmon or smelt or sturgeon you felt you could walk across on their backs; the sunlight dimming with flocks of ducks. That living wealth had many supports, but the local marshes contributed a good share. They did it by living; they did it by dying. Pouring bits of themselves into adjoining waters, they nourished a proletariat of invertebrates and small fish and, through them, all the animals higher up the feeding chain. Within themselves the marshes contained a special habitat of wandering, branching, mud-floored sloughs. These provided shelter and food for young fish like chinook salmon, steelhead, and the big native minnow called the Sacramento splittail; for shellfish like Dungeness crab; and for numerous birds, including the then abundant California clapper rail. The upland parts of the marshes, "the marsh plain," had their own communities of marsh-dependent animals, like the Suisun song sparrow and the salt marsh harvest mouse.

These functions, of course, were neither understood nor valued by the Spanish or their Mexican and finally American successors. By the time diking and filling were brought to a halt in 1966, in the entire system only about sixty square miles of more or less natural marshes remained, a loss of over 80 percent. The significant remnants could be counted on one hand. These were the Petaluma Marsh on the Petaluma River in Sonoma County; China Camp Marsh on the San Pedro peninsula in Marin County; Greco Island on the San Mateo County shore of the South Bay; and Dumbarton and Mowry Marshes on the opposite Alameda County shore near the Coyote Hills. There were lesser scraps here and there. In the delta, just a few strips of streamside wetland remained.

Sunrise in the San Pablo Bay National Wildlife Refuge.

Most of the reclaimed lands remained, at least, open spaces. (The areas actually filled in with garbage and rubble, and then built on, are smaller than people imagine.) The South Bay with its salt ponds, Suisun Marsh with its duck clubs, the San Pablo Baylands and the delta with their farms: these artificial landscapes had and have their own ecological values. But until the 1970s it was believed that a tidal marsh once gone was gone for good. These subtle natural systems, scientists believed, could only be destroyed, not restored.

Then a few people tried rewatering former marshland areas, just to see what might happen. To their surprise, the characteristic plants grew back. After some beginner's luck came some setbacks and renewed doubts. Since then, optimism and pessimism about marsh restoration have alternated, leading to a sobered but hopeful consensus: the thing can be done, but not always rapidly, and the complexities and obstacles are real.

It was in 1972 that the first deliberate breach was made. The eighty-acre Faber Tract at the mouth of San Francisquito Creek in Palo Alto was reopened to the tides. Biologist and wetland advocate Tom Harvey of San José State University planted some native California cordgrass at the site. The transplant took; a marsh began to form. A first, tentative lesson was drawn: *restoration can work.*

The second bay restoration was the site known as Pond 3, a former salt pond at the mouth of Alameda Creek on the Union City shoreline, near the Coyote Hills and the old Tuibun Indian villages. Here the restorationists made their first big misstep. Instead of planting California cordgrass, *Spartina foliosa,* the Army Corps of Engineers introduced a different species, native to Atlantic shores, called smooth cordgrass, *Spartina alterniflora.* No one thought it would matter. But in fact smooth cordgrass turned out to be a dangerous imperialist.

California cordgrass is a fairly minor member of a community made up mostly of pickleweed, merely fringing the pickleweed marsh at the edge of open water and along the interior sloughs. The eastern cordgrass, by contrast, is aggressive. It takes over most of the pickleweed zone; it buries all but the widest of the valuable internal sloughs; it also colonizes mudflats that the pickleweed leaves open. The result is a kind of cordgrass prairie, with a much more limited range of habitats.

By the time the scientists realized what they had unleashed, it was too late. The invader not only had established itself permanently on the Alameda shores but had also begun marching up and down adjacent coasts and hybridizing with the native species,

creating a permanent weed control problem. Several additional exotic cordgrasses, only comparatively less troublesome, had also reached the region. A second lesson of restoration was learned: *if you are planting something, be careful what it is.*

The third restoration, in 1976, was 130 acres in Corte Madera, in Marin County, called the Muzzi Marsh. Here cordgrass (the right kind) and pickleweed were planted, but there was disappointment. Most of the plants died. A large section of the hoped-for marsh remained an expanse of open, shallow water. It turned out that the bed was slightly too low, the water slightly too deep to allow plants to root. The Muzzi Marsh was chalked up as a cautionary tale. Then, when nobody was looking, the recalcitrant tract began to flourish. The tides had deposited enough sediment to raise its floor to the necessary level, and a new batch of plants had established itself from seeds swept in from the bay or already present in the soil.

The Muzzi Marsh taught at least three lessons. First, that in marsh restoration, you often have to prepare the ground, raising it to a point just below the proper rooting level—better a tad too low than a tad too high—so that sedimentation can finish the job. Second, that you shouldn't really have to do any gardening: if you create the right conditions, the marsh will plant itself. Third, that success should not be expected, nor failure declared, too soon.

The learning process continued. By the end of the 1980s, experimenters agreed that channels linking the sites to the open bay must be generous, permitting tidal currents to import needed mud; that marshes should be designed to take care of themselves once established, not requiring maintenance or structures like tidal control gates; and that, in general, the best approach was to get the initial conditions right, and then step out of the way. Restorationists had also learned not to be overspecific in predicting just what the new marshes would look like or when they would appear.

The first marsh restorations were small in scale, and they were part of a small-scale vision. They were thought of as "mitigations," offsetting new damage done. Fill for a road widening, for example, might be "mitigated" by a marsh project nearby. A new form of real estate enterprise appeared, the "mitigation bank," which acquired restorable properties and sold acreage as needed to agencies that had to compensate for habitat destroyed. Mitigation came out of the first impulse of the bay conservation movement: "Let's stop things from getting any worse."

In the 1990s, with the San Francisco Estuary Project, this modest program evolved into an incomparably grander plan for the wholesale restoration and rewatering of the bay's lost wetland rim.

Bringing back the marshes, it seems, will benefit much more than wildlife. Navigation, for instance: by giving the tides more room to move—increasing the "tidal prism"—marsh augmentation will strengthen currents, so that natural scouring will do more of the job of maintaining boating channels. Flood control: by giving streams room to spread where they meet the tide, expanded marshes will reduce flood risk in nearby communities. Pollution control: marsh organisms have a remarkable ability to clean polluted water and even air, capturing nitrous oxides from car exhausts and transforming them into harmless compounds. Ironically, it appears that marshes have even more functions in an urban region than in a rural or wild one.

At the end of the millennium, the momentum was mounting. In 1999, the major cooperative study called *Baylands Ecosystem Habitat Goals* set a marshland restoration target of about one hundred square miles, to be achieved more or less equally in the South Bay, San Pablo Bay, and Suisun Bay. In addition, sixty square miles of salt ponds and seasonal freshwater wetlands—perhaps unnatural but undeniably valuable habitats— would be retained behind unbroken dikes and managed for the needs of wildlife.

This deeply exciting vision has a price tag, just now being estimated. The purchase price of the needed land is only the down payment. The long-range costs will certainly be in the billions of dollars. Such an effort needs a national constituency to match its national importance. In 2000, the Audubon environmental group stepped forward to proclaim the effort one of its national priorities. The bay, says Audubon president John Flicker, deserves the iconic status of the Florida Everglades.

Other challenges than money lie ahead on this road. Exotic species like eastern smooth cordgrass threaten to colonize restored marshes; means of control must be found. And then there is the problem of mud: not the familiar problem of its superabundance but the unexpected problem of its lack.

The issue was brought into focus in 2001 by hydrologist Phillip Williams, whose firm has worked in many of the early marsh projects and stands to be involved in many more. It had long been clear that many candidate areas for early restoration are sunken well below sea level. Williams did some addition, calculating the volume of soil that would have to be placed or to accumulate in these tracts to raise the level to a point where marsh plants could put down their roots. The results were staggering: 350 million cubic yards would be required. The amount of sediment brought in by the rivers each year, by contrast, is at most 8 million cubic yards.

It used to be very much more. The American occupancy of the watershed began with an epochal burst of mud production. Between 1852 and 1884, when the courts stopped the practice, miners in the Sierra used high-pressure hoses to knock down whole mountains in search of gold-bearing ores. This hydraulic mining sent at least 1.5 billion cubic yards of material down the rivers and into the bay. Dramatic shoaling occurred. Most of the South Bay's native oyster beds, heavily harvested until then, were

buried and destroyed. Open waters shoaled into mudflats, exposed at low tide. Marshes actually expanded outward into San Pablo Bay and elsewhere, though not nearly far enough to offset the area they were losing to diking at the inland edge. Ironically, it is only thanks to hydraulic mining that parts of the bayshore have any marshes now at all.

The effects of what Williams calls the "Sierra mud wave" lingered long after mining stopped. Sediment that makes it into the bay tends to stay there a long time, settling to the bottom, lifting in the current, redepositing, resuspending, moving throughout the lower estuary, and shifting only slowly and on average toward the Golden Gate. But the exit is there, and in a century much of the "mud wave" has reached the sea. Today, in fact, the estuary is losing more sediment than it takes in. Rather than building more mudflats and marshes, it is starting to nibble away at the ones it has. The effect is particularly noticeable in San Pablo Bay, where the flats have shrunk back to what they were in 1850.

If we're now losing wetlands to open water, that's all the more reason to bring back some of the ones dried out by our levees. But the same shortage of new sediment may make that restoration a slow business. For every site, like the Muzzi Marsh, where the mud supply is adequate to do the restoration job, there is another where it seems to fall short. There is simply not enough to go around.

Where to get the precious goop? One commonsensical step is to use the spoils brought up by channel dredging for navigation, traditionally regarded as a great disposal problem. Why not divert some of them to marsh restoration? Why not divert them all? "A marriage made in mud," enthusiasts proclaimed.

There are a few flies in this muddy ointment. Any polluting substance that makes its way into the bay, from agricultural pesticides to industrial waste to the runoff from oil-spotted streets, is reflected somewhere in its muds. Of greatest concern is mercury. Elemental mercury, a potent toxin, was used during the Gold Rush and after in extracting gold from river sand and ore. Not only was the stuff applied in the bay's watershed, in the Sierra Nevada goldfields, but it was also produced here, mostly at the huge New Almaden mine complex near San José. From both sources it escaped to settle in bay-bottom sediments; New Almaden, though long shut down, still dribbles poison. In the presence of decomposing plant matter, it changes to a form called methyl mercury, which animals can readily absorb. Invertebrates in the mud take it in, and from these it gets into fish, growing more concentrated and lethal with each step up the food chain. In human beings, it attacks the kidneys, nerves, and brain.

Signs around the bayshore warn anglers not to eat more than one or two servings per month of locally caught game fish, including striped bass. For some fish and parts of fish, the limits are lower. The warnings are posted in half a dozen languages. Recent immigrants often bring with them the habit of fishing for sustenance, not only for sport.

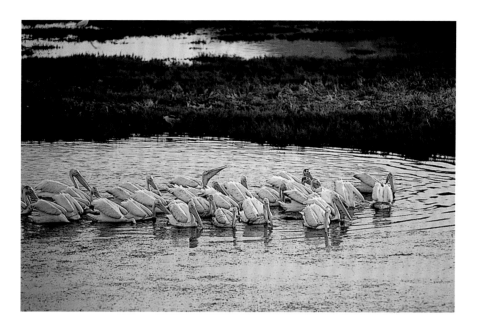

The cleanliness of mud, so to speak, depends on its age and depth. Pre-1850 muds, the deepest layers, are predictably very clean. Gold Rush muds are contaminated. Recent and superficial muds, laid down since the dawn of pollution control, are often okay—but you can't count on it.

So dredge muds have to be assessed case by case and, if used in wetland restorations, handled accordingly. Most are clean enough to use without concern; others are so contaminated that they must be taken to special toxics isolation dumps. In between are some muds that, the authorities believe, can and should be used, but only as a lower layer, under protective caps of cleaner material. Critics question whether the caps will do the job.

The project called Sonoma Baylands illustrates some other complexities. In 1994, with much fanfare, a dike at the mouth of the Petaluma River was breached. Several things were special about the project. It was the largest yet undertaken. It was the first intended to develop new habitat, rather than "mitigating" a loss somewhere else. It was also the first site where dredge spoils were used to build up a subsided field. But the struggle behind the scenes had been exemplary as well. Several ponderous institutions,

American white pelicans in a diked wetland at San Rafael. Among the largest North American birds, white pelicans are seen in quiet bay waters and on dikes from June to December.

TOP: Cordgrass taking hold at Crissy Field in San Francisco. Restored in 2001 with major foundation support, the site is designed to evolve into a marsh. BOTTOM: *Sandpiper in winter plumage.* OPPOSITE: *Native bunchgrasses in the restored Crissy Field dunes, planted by volunteers from the Golden Gate National Parks Association.* OVERLEAF: *Forster's tern (left) and snowy egret (right).*

notably the Port of Oakland and the Army Corps of Engineers, had had to alter policies to help the project happen. Most startling to backers was the attitude of the U.S. Fish and Wildlife Service, which almost scuttled the plan with a demand that the restoration itself be considered an "impact" to be "mitigated for."

The Fish and Wildlife Service had a point, however; and it's one that will keep on arising for a while. Habitats for many creatures are now so reduced around the bay that no disturbance can be taken lightly. Species like the salt marsh harvest mouse and the California clapper rail, "endangered" in law and in fact, need all their remaining living space. No present loss, even in service of a future gain, is trivial.

Among other things, the Fish and Wildlife Service demanded that the strip of existing marsh outside the Sonoma Baylands be disturbed as little as possible by the restoration process next door. As a result, the channel funneling water across this strip into the Sonoma Baylands was built small—at a price. For one of the clearest lessons of earlier marsh restorations has been this: the more water you have sloshing in and out, the faster mud will come in and plants will appear. Predictably, the modest channel has meant slow progress toward the magical point at which cordgrass takes hold.

Similar choices and arguments face the restorationists at every turn. There is much we do not know. There are many mistakes waiting to be made. The restorers are planning to make haste slowly, taking careful notes, counting on surprises, and changing tactics as the system tells them what it will and will not do. There is a fancy phrase for this commonsensical process: adaptive management.

Large-scale wetland restoration will plainly take a while. Even in the best cases, marshes don't simply reappear with all the productivity and ecological function that the originals had. "Second-growth wetlands," Williams calls them. Like second-growth forests, they may look pretty feeble for a while, even for a human lifetime. But the great thing is to set them on the path.

In the long run, the recent strange perturbation of the bay's wetland fringe—its decimation by diking, its brief augmentation by hydraulic mining waste, its hollowing-out by subsidence, its problematic reflooding and restoration—may look like a single, melodramatic chapter in a longer, calmer story.

What is clear to all now is that all interests—practical, aesthetic, ecological, economic—are served by helping this natural system get back to doing what comes naturally.

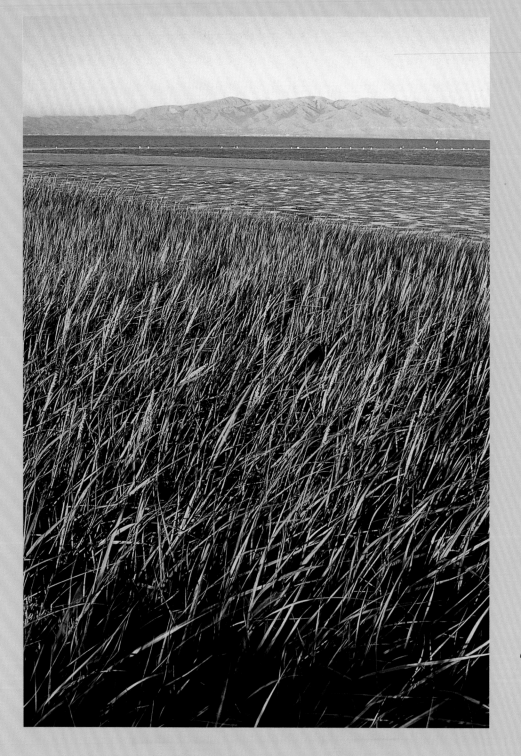

LEFT: *Native Pacific cordgrass in the Palo Alto Baylands. Across South San Francisco Bay, Mission Peak rises above Fremont.* **OPPOSITE:** *Exotic smooth cordgrass colonizing mudflats at Hayward Regional Shoreline. If unchecked,* Spartina alterniflora *will produce a broad marshland plain without sloughs and lacking in habitat value.*

OPPOSITE: *Sonoma Baylands on San Pablo Bay, an ambitious wetlands restoration project. Before the dikes were breached, dredge spoils from the Port of Oakland were deposited to raise the level of subsided land. Mud naturally deposited by bay waters is expected to finish the job, allowing marsh plants to take root.* ABOVE: *Dawn over vineyards and a restored freshwater marsh at Viansa Winery in Sonoma County.* RIGHT: *Carl's Marsh along the Petaluma River. This former hayfield quickly revegetated when the dikes were broken.*

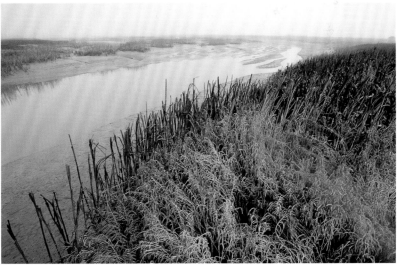

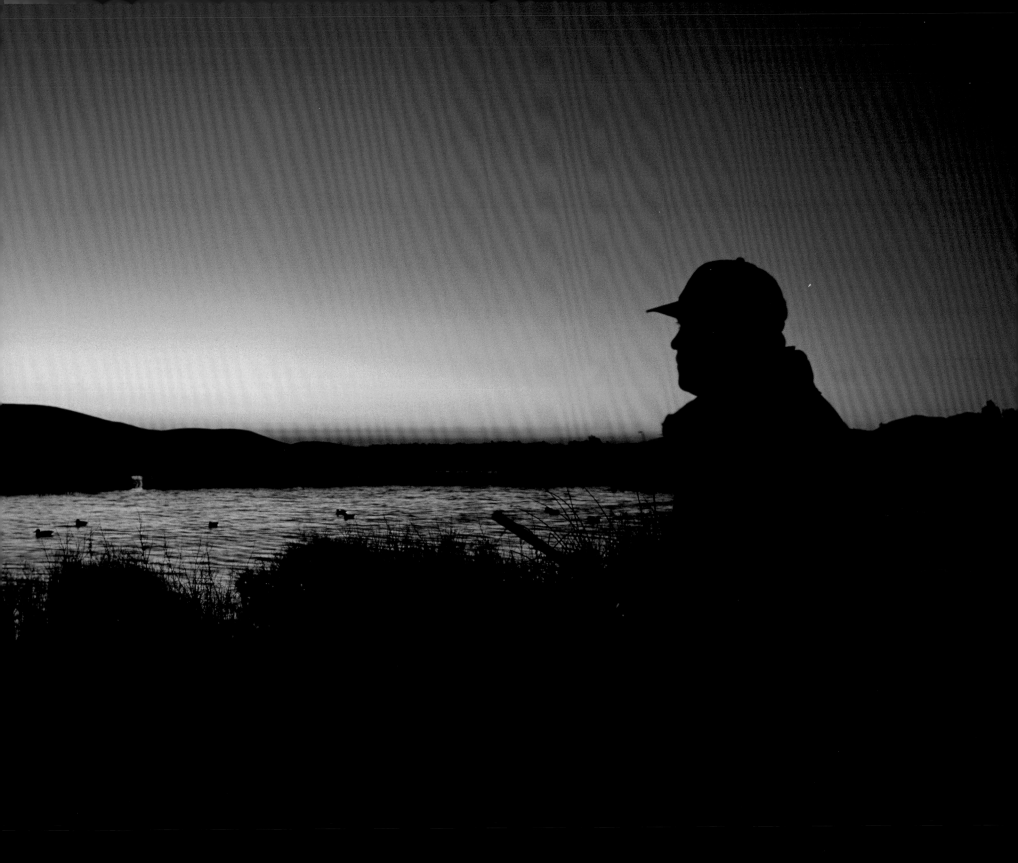

A ll power, Mao Zedong used to say, grows out of the barrel of a gun. I think of this proverb as I sit in a chilly duck blind at the northern edge of Suisun Marsh and watch an expert hunter doing what expert hunters do most of the time: wait quietly for his chance.

One kind of power that has surely grown out of the barrels of guns is the power to conserve natural resources that otherwise would have been lost. Until the 1970s at least, hunters and fishermen were the biggest constituency for the protection of wildlife habitats in and around the San Francisco Estuary. Much later than that, their license fees, duck stamps, and excise taxes were paying most of the bills for conservation work. When nobody else had the clout, hunters and fishermen could moderate the demands of other economic interests, such as farms seeking water. And if the resulting policies were skewed toward those species that could wind up on a duck strap or in a creel, what helps game species often helps nongame species as well. Sauce for the mallard may also be sauce for the sandhill crane.

There was waterfowl hunting in the region before there were guns. The various Indian groups were adept at taking ducks and geese. They made decoys out of eviscerated birds stuffed with tule stalks; they trapped the fowl by suddenly raising nets in front of their flight.

In the American period, market hunters shot birds by the tens of thousands for city tables. When this business was outlawed in 1917, the focus shifted to hunting for sport. From Alviso to Napa, from Fremont to Antioch, marshes and shallow waters were speckled with duck blinds, and in winter the shores reverberated with the shots. You hear these less often now. There are still a few hunting clubs scattered up and down the South Bay, in the wetlands north of San Pablo Bay, and even in the Sacramento–San Joaquin River Delta. But the only place where hunting is as vital as it ever was is Suisun Marsh, the 140-square-mile wetland empire on the north rim of Suisun Bay.

The Suisun region, the middle chamber of the estuary between Carquinez Strait and the delta, has always been a transition zone, a battleground between fresh and salt. In the open waters of Suisun Bay, the balance changes from tide to tide, month to

Duck hunting, Suisun Marsh.

month, year to year, and century to century. The great marsh to the north has also vacillated from brackish to salty and back.

Even in the early days the sloughs and edges of the marsh were hunted. Large basins or lakes, hidden among the tules, had the quality of legendary treasures. Hunters would find them, return with many ducks and stories, and then lose the places again. One such was called Phantom Pond.

In 1879, the Central Pacific Railroad built a shortcut between Fairfield and Benicia. Mainly for the sake of the market hunters, it laid the tracks across the heart of Suisun Marsh, "one of the most railroad-unfriendly environments south of the Arctic tundra," as historian Tony Arnold puts it. Flag stops in the marsh were named Pintail, Teal, and Drawbridge. Later and for the same reasons, the Sacramento Northern built an electrified line crossing the marsh farther east. It once shut down because a hunter's shot had severed the overhead wire.

Beginning in the 1870s, much of Suisun Marsh, like others around the San Francisco Bay, was diked for agriculture. The wave of "reclamation" rolled from east to west. Dairy farms and cattle ranches came in first, then wheat and asparagus and potatoes. The sloughs left open between the diked islands were the transportation corridors. Barges stopped at every farm, taking produce to the cities.

But the borderland nature of the Suisun was soon asserting itself. Salt moved up the sloughs in drought years, and salt turned up in the soil. (One farmer touted as a delicacy his salt-flavored melons.) Agriculture faltered in the westernmost part of the marsh almost as soon as it began, and thereafter retreated toward the east again. As early as the 1880s, the islands were finding another use. One after another they were reflooded within their encircling dikes, not to bring back the native marsh but to establish new, managed, freshwater wetlands suited specifically to the needs of ducks and their recreational hunters.

They didn't call it that, but what occurred here was in a sense the largest wetland restoration ever undertaken—in the world. Suisun Marsh, though changed in character from aboriginal days, is barely changed in size. It is the largest single brackish-water marsh in western North America.

By 1960 the region was purely the domain of the duck club. There are now about 158 of these clubs, many of them wonderfully named. There is the Ibis Club, well over

a century old. There is the Sleeping Pintail. The Grizz/Fizz Club. The Tule Hilton. Inevitably there is a Gang Bang Duck Club. The typical club has no more than ten members, who pay several thousand dollars apiece to join and several hundred in annual dues thereafter. You get in, basically, when an existing member dies.

The spread we are visiting, the Can-Can Club at the foot of the Potrero Hills, is even more private than most, a family-based retreat with invited guests, not members. It is not to be confused with the Can Club, specializing in canvasbacks, on a former salt pond north of San Pablo Bay.

"Duck hunting really is a passion," says our host and companion in the blind, Scott Bohannon. "It's probably a neurosis. It brought my granddad tremendous joy." Grandfather Bohannon bought this land; in a photo in the clubhouse he beams from the mist, outfitted in camouflage even to the gun. At age ninety-six he still made trips to this blind. As a youngster in San Mateo County, grandson Bohannon hunted scaup and canvasback and goldeneye on Brewer Island, where Foster City now stands. "It's really weird," he says, "to go walk on those levees where we had duck blinds."

Now and then Bohannon raises his duck call to his mouth. With this instrument, he produces excellent imitations of the mallard (a descending *quack* or *caw*, sometimes a sort of conversational chuckle); the pintail (a whistle with a bit of a rattle in it); the widgeon (a breathier, up-and-down fluting). A separate dog whistle gives him the level call of the teal. These are the sounds of the most prized species here. All belong to the group known as dabbling ducks, which feed on plants in shallow water and have their legs near the center of their bodies. This layout distinguishes them from diving ducks, like the kinds Bohannon shot in the South Bay, which have their legs set well back for more efficient underwater swimming. There is a sort of merry war between the hunters of the vegetarian dabblers and the hunters of divers, most of which are carnivores and are said to taste like fish—or mud.

Since the duck club culture settled into Suisun Marsh, it has become the guardian of the region's primitive status quo. New owners, historian Arnold reports, may start out regarding the land as mere real estate but soon grow passionate in its defense: "It almost looks as if the marsh has developed the owners rather than the other way around." Duck hunters have provided the money, energy, and expertise to shoot down (so to speak) a long succession of plans for urban or industrial development on their turf. They have fended off a paper mill, a steel mill, a pair of nuclear power plants, a major chemical works, and a toxic waste dump. Since 1977, the marsh has been governed by a triumvirate of agencies: the Suisun Resource Conservation District, which is the creature of the clubs; the San Francisco Bay Conservation and Development Commission; and the Department of Fish and Game, which owns about one-third of the marsh (the Grizzly Island Wildlife Area).

"Stay still," Bohannon suddenly says. We freeze. The report is not as loud as I expected. A male mallard, or "greenhead," falls. The shot was forty yards—"pretty good distance, now that we have to use steel." Lead buckshot carried farther but also proved to be poisonous; it has been banned since 1991. Bohannon and his black Labrador pup splash out among a flotilla of bobbing decoys to retrieve the real, faintly struggling bird. Soon it lies dead on a shelf in the blind, its bright head glistening next to the spent cartridges and film cans. Before the session is done we will add several more mallards; a couple of green-winged teal; and a pintail, or sprig, with a glossy black beak and the protruding tail feather that gives it its name. The species isn't doing so well, and one per gun per day is all the regulations currently allow.

The comfortable world of Suisun Marsh is now under pressure from several quarters: from a natural process; from an artificial force; and from the misguided efforts (as hunters will tell you) of the people who want much of the landscape reopened to the tides.

The natural process is subsidence, the plague of all the baylands. It has not progressed far in this region—the typical terrain is only four to six feet below sea level—but also it has not stopped. The duck marshes are drained for part of every year to seed watergrass, to eradicate avian botulism, and to flush out salt that has leached up out of the soil. Whenever the ground is exposed to the air, busy decomposer bacteria get a chance to oxidize a little more peat. Even working half-time they are quite efficient. They have all the time in the world.

The artificial force is water diversion, symbolized by the pumps in the delta at Tracy, forty miles away. With the general weakening of freshwater inflows to the estuary, the always-fluctuating border zone of brackish and salt has tended to gravitate inland. In 1988, a set of huge tidal gates was installed at the upper entrance to Montezuma Slough, the marsh's major waterway. This expensive device was meant to keep Suisun Marsh relatively fresh by shutting off the slough when the tide is in. Its effectiveness is debated.

But the specter that frightens the hunters most is the new face of restoration. While noting the habitat value of managed wetlands, the modern restoration advocates set the greatest store on natural, self-maintaining tidal marshes. Suisun makes them salivate: because subsidence is still modest, it is one of the few places where you can just breach a dike and get a working marsh with small delay. The *Baylands Ecosystem Habitat Goals* report of 1999, the restorationists' bible, suggests that marshes be restored in a ring next to the hills around the margins of the region, outside the great central loop formed by Montezuma Slough. Grizzly Island, the core region enclosed by the slough and Suisun Bay, would be managed for ducks as before. This doughnut plan, *Habitat Goals* predicts, would conserve what is now here and bring back much that is depleted, including such beleaguered species as the Suisun song sparrow, the Suisun thistle, the clapper rail, and the black rail; it would also benefit the fish in the channels, and the estuary in general, by nourishing the open waters of Suisun Bay. As a model, biologists point to the Rush Ranch, a small intact wetland between Benicia and Fairfield. "Absolute maximum diversity!" one restorationist exclaims. You'd find over one hundred plant species there: here, behind the dikes, maybe ten.

Scott Bohannon, whose land lies right in the projected tidal ring, thinks poorly of this plan. So do the Resource Conservation District and the Department of Fish and Game. The defenders of Suisun-as-it-is have their own list of nongame species that benefit from present management, including shorebirds, muskrat, beaver, river otter, and tule elk. "This ought to be considered *improved* habitat," another hunter fumes.

The duck defenders question whether the present system can be tinkered with without disaster. Breaching the dikes, they think, will make the whole region saltier, ultimately forcing out even the duck clubs initially left intact. They imagine a Suisun bereft of its traditional protectors and abandoned to salinity. Some darkly suspect that this is the goal: with nobody speaking for Suisun, there will be that much less restraint on the water exports out of the region via the pumps at Tracy. There are other reasons than ducks, biologists reply, for keeping the pumping down and the salt at bay; but the hunters so far decline to be reassured.

Those pumps. Talking to hunters, you feel their power even here.

OPPOSITE: *Common mallard, or "greenhead."*
ABOVE: *Montezuma Slough tidal gates, installed in 1988 in an effort to keep salt water out of Suisun Marsh.*

Shanks Island

"These guys kept coming in," says Jim Shanks, manager of Staten Island in the Sacramento–San Joaquin River Delta. "I left two notes." The third time that he found the truck and boat trailer parked on one of his levees, he took action with a backhoe. He dug a six-foot-deep moat completely around the vehicle "and just forgot about it." Later he heard that the trespassers had turned up that night at a local bar, swearing vengeance, having built themselves a way out with the one tool they possessed: a pie tin.

If you are a birdwatcher, you are welcome just about anytime on this agricultural island in the heart of the delta. If you are a waterfowl hunter, and known to Jim and Sally Shanks, you are welcome in the appropriate season, three days a week, before 10:00 A.M. If you are neither a birder nor a hunter who follows the rules, you had better be elsewhere.

Staten Island lies south of Sacramento and just south of the tiny towns of Locke and Walnut Grove, famous for their historic Chinese character. Chinese labor carved the fourteen-square-mile island out of the tules in the 1860s. The first dikes were of island peat and shaky. Reads an early account: "During high water there occurred one of those remarkable cracks in the levee which periodically recur in the peat lands to perplex, annoy and discourage those engaged in reclamation work. The crack started at the bank, ran inward across the levee and continued parallel with it, its whole length being 600 feet. It was 6 feet wide and 26 feet deep."

And it was precisely at Staten Island, in 1874, that an engineer hit on the solution: to build the levees not of peaty soil from the land side but rather of mineral soil washed down from the mountains and reposing in the bottoms of the adjacent sloughs. A hand-built test levee worked very well. The invention of the long-boom clamshell dredge put the program into practice all around the San Francisco Estuary's shores. Fittingly, there was for many years a dredge named *Staten Island*.

So the island's defenses solidified. Well constructed and well maintained, they have stood continuously ever since. Islands east, west, and north of Staten have all been underwater at some point in the years since their creation; Staten Island, never. There have been some close calls, however. Racing along a levee road in his truck one night, Jim Shanks pitched into an incipient breach, where the vehicle served as a vital temporary plug.

Flooded fields on Staten Island in the Sacramento–San Joaquin Delta. In late summer, water admitted from the surrounding channels provides feeding and roosting areas for waterbirds.

The Staten Island levees are the responsibility of a miniature governmental agency, Reclamation District Number 37, which consists of this one island alone and is managed by Jim Shanks. When the water rises dangerously, with winter rainstorms or spring snowmelt, Shanks puts the island into flood mode. Getting on the phone to Dutra Materials—the omnipresent dredger, hauler, and hole plugger in San Francisco Estuary waters—he orders a barge with a crane and more barges loaded with rock to stand by along his shores. He prefers gentler and preventive methods, however. Outside the levees, he has built berms a little offshore to create small brushy islands and calm backwaters. These absorb the eroding waves sent up by speeding recreational boats, a major delta problem. His defenses are also useful to birds.

Jim Shanks was born in the tiny Sacramento Valley farming town of Maxwell. His parents moved to the Fremont area in 1939 and raised vegetables for the soldiers at Fort Ord. In 1952, graduating from St. Mary's College in Moraga, Shanks took the job of running the farm on Staten Island, owned by a San Francisco family. "I just really am not a city boy," he says. "My roots were in the dirt."

Farmer Shanks is also a duck hunter, no surprise: farming and hunting have always gone together. So too, for many, do hunting and conservation. As a hunter, Shanks watched and worried about the decline of many species, and spoke up on occasion for stricter bag limits. As a farmer, he was annoyed by the casual supposition, by some urban environmentalists, that agriculture is an environmental evil. Bringing his interests together, he sought from early days to make Staten Island both a profitable farm and a waterfowl haven. "Every time he makes a choice," says his wife, Sally, "the birds are in the picture."

After harvesting his wheat and corn in the fall, Shanks lets a thin film of river water onto a couple of thousand acres, making an instant freshwater wetland. The birds—some huntable, some not—flock in. There are mallards, northern shovelers, pintails, widgeon, teal: even some canvasback ducks, unexpected here because they feed in deep water. There are quantities of shorebirds. There are drifts of bright white tundra swans.

But the celebrity species, down from the Arctic, are the greater and lesser sandhill cranes. These large, slate-colored, somehow elbowy birds feed quietly by day on winter-fallowed farms throughout the region. At evening, they take to the air in thousands, circling, veering, forming and reforming their flocks, flashing white all at once when they turn into the sun, filling the dusk with their musical, cackling cries. Gradually they sort themselves out and settle to the shallow waters where they roost at night (for safety: no ground predator can silently approach). Not seldom, local roads are lined with people come to see them. Audubon chapters visit from Sacramento, Walnut Creek, Orinda, Marin. At the annual Christmas count, the Stockton chapter logs the second highest number of species in the United States, and Staten Island is one of the reasons why.

The practice of maintaining winter-flooded fields for waterfowl started a little north of here, on rice fields. The idea was championed by Marc Reisner, author of *Cadillac Desert* and other studies of water issues. But it was Jim Shanks who first thought of trying it with wheat and corn.

Sally, co-manager of the island, grew up in Lafayette; she hiked and rode horseback and lobbied with the Sierra Club. It was on a birding trip to the island that she met Jim. "I was a flaming environmentalist," she says, "and I ran into him, and we fought." Something obviously clicked, however, and the couple found not so much a compromise as a truly enormous stretch of common ground. They set out together to prove the compatibility of agriculture and wildlife: to build, as Jim says, "a showpiece that the critics can't deny."

Building that showpiece means more than opening a watergate in the fall. For one big thing, it involves the choice to stay with relatively low-value crops. It would be harder to do this sort of thing with an intensively managed orchard or vineyard. And the Shankses deliberately steer away from what is misleadingly called clean farming, in which fields are disced after harvest to a comely bareness and brush is carefully suppressed. Going in the opposite direction, Jim developed a special reel mower that leaves a generous layer of broken stalks for birds like pheasants and cranes, which peck and scratch for food. This compost layer also keeps the soil moist and crumbly, reducing the need to plow. The Shankses find themselves moving toward what is called no-till agriculture.

Eminently practical though they are proving, such methods are still rare in modern farming. Especially at first, the Shankses' neighbors looked on askance. They feared that managing for wildlife, especially if it drew the interest of the state, would open them up to endless, petty restrictions. What if an endangered species should appear? However, the continued success on Staten Island seems to be changing some minds.

Meanwhile, Staten has an ambiguous place in a much more ambitious restoration scheme.

A few miles away on the Cosumnes River, just above the reach of the tides, the Nature Conservancy in 1984 bought some land and set out to replant the streamside oak forest, tree by tree. As if with an indulgent smile, Nature demonstrated a better way: a levee broke, and a rich riparian woodland sprang up on its own. Winter-flooded woodlands are valuable habitat for birds and—what is not so widely appreciated—for fish like the Sacramento splittail and juvenile salmon, which pause here to feed and gain weight during their migration from mountain to sea. The conservancy property and adjacent lands belonging to several different agencies are now managed jointly as the Cosumnes River Preserve.

The Shankses, at first skeptical of the value of the Cosumnes restoration experiment (and the savvy of the experimenters), were impressed by its success. In 1999, they signed the farm up as a privately owned partner in the Cosumnes preserve. Late in 2001, the process went a step farther: the island's owners sold to the conservancy outright, with the CALFED bay protection program picking up most of the cost.

New plans are being made for Staten Island, but two things are clear: it will remain an island, and all or most of it will remain a farm.

For years, state engineers and biologists have been scratching their heads about the delta. From the biologists' point of view, the delta, even more so than other parts of the estuary, is a biologically impoverished landscape. From the engineers' point of view, it is an endangered one. Within the dikes, the land is, as ever, subsiding. (The southern end of Staten Island lies seventeen feet below mean sea level.) Outside the dikes, the sea level is rising. If global warming changes the timing of runoff as expected, winter flooding seems likely to get worse. Already a few islands have been abandoned, reverting to open water.

From points of view both practical and ecological, what seems necessary is a controlled retreat. "We need," says Curt Schmutte of the state Department of Water Resources, "to get some of the old delta back." But how?

There are various small ways of restoring a seminatural scene. One key is to soften shorelines with marshes and strips of riparian vegetation. These vegetated areas can be created at the expense of the open water, by building offshore barriers behind which silt settles and plants take root, or at the expense of the land, by building new levees well back from the shore and leveling the existing dikes (very expensive). Pocket tidal wetlands can be restored. Channel islands can be re-created, as the Shanks have done. Seasonal freshwater wetlands can be created, as on Staten. All these things are happening and all are good; but to the restoration-minded they are only a down payment.

Many biologists would like to see something more: a corridor of restored, permanent marshes, covering all or parts of several islands, and running from southwest to northeast right across the middle of the delta. The band would begin with Sherman Island at the western apex of the delta; continue northeast with Brannan and Tyler Islands; and link up inland with Staten Island and the rest of the Cosumnes River Preserve.

In no case could dikes simply be broken and control abandoned. So deeply subsided are the islands that the result would be deep-water pools of little use to wildlife, and of zero use to the native species that are of most concern. It may be feasible, however, to establish shallow wetlands within the islands. By keeping the ground wet year round, these marshes would halt the action of aerobic decomposer microbes and bring

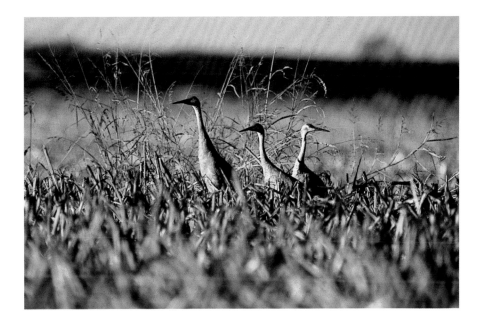

a halt to subsidence. And as marsh plants died and added material to the soil, the ground surface would very gradually rise.

How to reconcile the two visions for Staten Island, as a working, wildlife-friendly farm and as part of a corridor of wetland restoration? The choice is less difficult than it might appear, for there is both space and time. At fourteen square miles, Staten Island has room for more than one future. The southern, deeply subsided section could become a year-round marsh; the northern and higher portion might be farmed indefinitely. And there is no hurry. Certainly, as long as Jim and Sally Shanks are on the job, the status quo will hold.

"In wildness," wrote Henry David Thoreau, "is the preservation of the world." But if we are going to salvage the planet's natural systems, we have to think a little further. Besides saving wilderness, we must also get a whole lot better at cherishing and managing the less-than-wild: the thoroughly civilized working landscapes that surround us and serve us and that now must be knitted back into the ecological fabric of things.

Something awfully important is being modeled on Staten Island.

Sandhill cranes in a flooded corn field.

TOP: *Mokelumne River near Walnut Grove in the northern delta. Staten Island is in the distance beyond the fork in the river.* BOTTOM: *Jim and Sally Shanks with the corn harvest.* RIGHT: *Sandhill cranes at sunset.*

The Estuary and the Harbor

*T*o the biologist, San Francisco Bay is first of all an estuary, an unusually dense and complex crossing of the threads of the life of the world. But this is a new and subtle way of regarding this body of water. To the first Europeans to invade the region, to most of their successors for a century and half, and to many people today, the essence of the place is simpler and grittier and easier to explain. San Francisco Bay is a harbor, a place to shelter and to anchor, to moor, to load and unload ships. It was the harbor that brought the Spanish and then the Americans here. It was the harbor that made this a metropolitan region. Even today, the harbor is a major support of the regional economy.

It was a harbor—but not this harbor—that Captain Gaspar de Portolá was looking for when he came to these shores in 1769. His instructions were to find a land route to the bay at Monterey, which a precursor had overpraised as a superb natural anchorage. Reaching the broad bight of Monterey Bay, he failed to match the place to the glowing description, and kept right on going up the rugged coastline. Climbing a shoulder of Montara Mountain in San Mateo County, some of his men got the first glimpse of an unexpected water barrier, "an immense arm of the sea." Portolá himself took his first look from Sweeney Ridge, west of what is now San Francisco International Airport, where a monument marks the "discovery."

Here indeed was a harbor beyond praise—"such that not only all the navy of our Most Catholic Majesty but those of all Europe could take shelter in it"—and the key to Alta California.

So sprawling an embayment had room for many embarcaderos, or ports, but Yerba Buena Cove on the San Francisco peninsula, just inside the Golden Gate had special advantages. Here mariners found a combination rare in these parts, deep water close to a gentle shore. With the American conquest and the Gold Rush, the spot became an intercontinental gateway. It was the link to the outside world; it was also the portal to interior California, for in those days of few roads and no rails, the bay and its feeder rivers were the highways. San Francisco was the natural center. All else was hinterland.

But when railroads linked California with the eastern United States, the world turned around. From the point of view of overland commerce to the east, San Francisco was simply on the wrong side of the bay. In 1869 the Central Pacific Railroad

Container ship leaving port.

made Oakland its terminus. Oakland seemed poised to take over as the major port of entry.

In fact, that transition took almost a hundred years. San Francisco fought hard to maintain its position, using its clout to get laws and regulations tilted in its favor. It was also a drawback for Oakland that its side of the bay was the shallow one, its offshore waters mostly mudflat. But the most important cause of delay was the fact that the city of Oakland did not control its own waterfront. The shore had been snapped up early (and quite illegally) by a speculator who in turn sold out to the railroad. Until 1910, the Central Pacific (later Southern Pacific) Railroad ran the Port of Oakland, and the owners were only mildly concerned for the development of this corner of their realm.

In the twentieth century, these impediments were gradually removed. The city recovered its shores and received a grant of state-owned tidelands. The Army Corps of Engineers dredged a deep-water channel into the inlet called the Oakland Estuary (and right on through a low peninsula to meet the inlet called San Leandro Bay, making Alameda an island). Laws were changed. Yet as late as 1961, nearly a century after the railroads arrived, San Francisco was still the region's busiest single port.

It was in 1962 that the future docked at Oakland in the form of the SeaLand Corporation ship *Elizabethport*. This odd-looking vessel, a veritable hollow ship with no top deck, came loaded not with cargo in the usual sense but with a stack of uniform metal containers, somewhat resembling wheelless boxcars, called conex boxes.

The idea of handling cargo in these interchangeable units had been pioneered on the East Coast in the 1950s. It was a profounder innovation than at first appeared. The beauty of the conex boxes was that they could be shifted by crane, with minimal labor, between ship, train, and truck. Heretofore arrival in port had marked the end of one journey, the beginning of a second. Cargoes would be broken up, repackaged, and sent on by other means. But with the new "containerization," docking became just one moment in a longer "intermodal" trip, arranged in advance, from the original shipper to the final destination.

Not everyone thought that this new way of doing business would prevail. San Francisco, notably, hesitated. Oakland did not. In the 1960s, general manager Ben E. Nutter staked everything on this version of the future. In the Oakland Outer Harbor, alongside the San Francisco–Oakland Bay Bridge, he set out to build the largest container-handling facility on the Pacific Coast, the Seventh Street Terminal. Reversing the usual cautious order of things, he embarked on this project before signing up a single prospective tenant.

A container port looks very different from a traditional, or "break-bulk," port. The older-style waterfront is a shore fringed with narrow piers, on each of which is a building for handling cargo. It's the scenery of classic movies, the birthplace of the International Longshore and Warehouse Union. The container port, by contrast, looks rather like an airport. Instead of piers it has "aprons," vast open expanses laced with rails. By the water, mounted on dockside tracks, crouch the characteristic box-handling container cranes, as much as 220 feet tall. The commonest sort has four vertical posts, a skeletal body above, and a boom that extends horizontally over the ship it is loading or unloading. When not at work, this boom is cocked in an upright position; the whole contraption looks like a gigantic surreal horse, rearing its abstract head at the waterside.

To have a port of this kind you need two things that Oakland had and San Francisco didn't. One is a great deal of space. The second is convenient railroad access, and here geography was destiny.

By 1970 Oakland had not only surpassed its old rival but also briefly become the second largest container port in the world. Since then it has slipped back in rank, as the technology has become universal, yet it remains without question the region's dominant port. Richmond, where the Chevron Long Wharf takes in millions of gallons of crude oil daily, moves more tonnage but serves far fewer ships. Benicia is an important entry point for automobiles. The ports of Redwood City, Sacramento, and Stockton are relatively minor. So now is the Port of San Francisco, still in business, but mostly entertaining tourists and collecting rents. Cruise liners do favor this western side of the bay, and the port plans a lavish terminal to lure more.

San Francisco Bay the estuary: San Francisco Bay the harbor. At what cost to the first has the second developed and grown?

Certainly an enormous amount of work has been done since the 1850s on the shores and bottoms of the bay. Rocks and shoals have been blasted out of the way and then revisited and blasted some more. Channels have been deepened and deepened again. In the early days, twenty feet of water at low tide was plenty. Today the standard depth is fifty feet. Even Fourfathom Bank, the C-shaped sandbar that forms outside the Golden Gate, must now be periodically dredged.

The filling of the bay really started at the ports. In the nineteenth century, San Francisco simply eliminated the narrow zone of shallows along its waterfront, reclaiming several square miles of mudflat and wetland. The Port of Oakland couldn't fill its way out to deep water, but it steadily expanded its territory westward into the bay, parallel to the Bay Bridge. The last and most controversial bite came in 1966 in the form of Nutter's Seventh Street Terminal. The Bay Area Rapid Transit District was then building its transbay rail tunnel under that very spot, and was happy to offer the

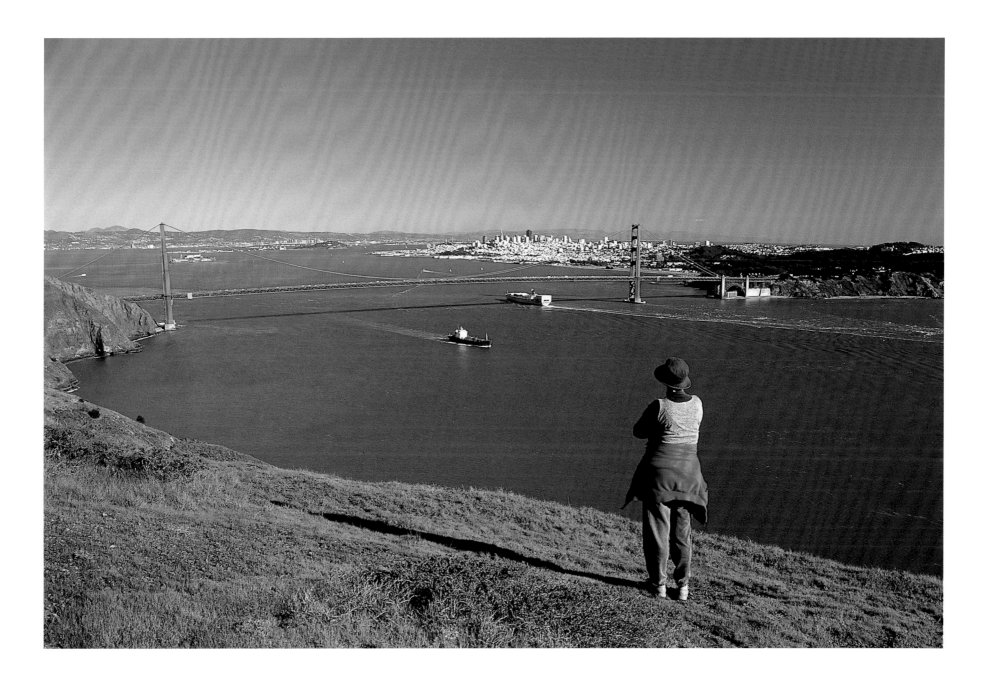

The Golden Gate from the Marin Headlands.
Some 3,500 cargo ships traverse the strait each year.

extracted material for fill. There was one complication: the public had just rebelled against the incessant filling of the bay, and the new Bay Conservation and Development Commission (BCDC) was about to take charge of such matters. The lobbyists got to work. On September 16, 1966, the state approved the Port of Oakland fill. On September 17, as the bay commission met for the first time, ground was broken for the huge new terminal that now bears Nutter's name.

A win for the harbor at the estuary's expense? The citizen leaders of the Save the Bay movement certainly thought so, and fumed. But the newly minted commission may have been just as glad to be spared a difficult decision. Had it taken the matter on, in fact, it's quite likely that BCDC would have approved the port's plans in some form. Under the state law that established the commission, port facilities were a favored use. They still are, though any fill is supposed to be the very minimum required.

This particular conflict seems unlikely to rise again, at least at Oakland. The port continues to expand lustily, but the closing of several military bases next door has given it plenty of elbow room—backland, as they call it in the trade.

Dredging—especially the disposition of dredged muds, or "spoils"—has also been something to fight about. Each year, something between four and six million cubic yards of bay-bottom goop are removed from the estuary's shipping and boating channels. Most of this material was traditionally dumped into the water again at four points in the bay, chosen for the strong currents that (it was hoped) would hurry the sediment out the Golden Gate. At the most heavily used site, near Alcatraz Island, much of the mud in fact stayed put, piling up in a sizable subsurface hill that actually threatened to become a navigation problem. Boaters called it "Mount Alcatraz." It appeared that the dredge spoils dump would itself have to be dredged.

In the 1980s, when the Port of Oakland sought to deepen its channels to forty-two feet, it ran into something new: vociferous objection. Environmentalists worried that contaminants like mercury, hiding in the bay floor sediments since the Gold Rush, would be put back into circulation. Fishermen complained that turbid waters were interfering with sport fishing and that muds were covering the eelgrass beds in which Pacific herring spawn. In 1988, a flotilla of fishing boats converged on the Alcatraz site in a sort of floating sit-in. An alternative plan to dump the spoils outside the Golden Gate, in fishing grounds off the San Mateo County coast, was blocked in court.

This standoff produced some new thinking, revealing a resource where nothing but a nuisance had been seen.

A Sonoma County land trust had just purchased a property on the north shore of San Pablo Bay, near the mouth of the Petaluma River. It hoped to breach old dikes and reestablish marshland there. However, the land had subsided, and now lay well below the level of the sea. For marsh plants to grow, this hole needed filling. Why not use the Port of Oakland spoils?

It took years of negotiation, involving parties all the way up to Vice President Al Gore, to put this simple solution in place. But in the end about one-third of the spoils from the Port of Oakland channel deepening went into the site now called the Sonoma Baylands.

This story will be repeated. A new strategy for dredging and spoils disposal, agreed on by all parties, calls for using almost half the mud dredged up each year on sites like the Sonoma one. Most of the rest will be barged out the Golden Gate and dumped well out at sea, beyond the continental shelf, where fish and fishing won't be affected. No more than one-fifth of the spoils will be dumped, as before, within the bay itself. Though some disposal continues at Alcatraz, it appears to be doing little harm. A party boat captain says, "We fish for bass at Mount Alcatraz now."

Pollution remains an issue. Not all channel dredge spoils are benign. Some come from toxic hot spots, and there is plenty of debate about their proper disposal. A site near Collinsville on Suisun Bay, which takes dirtier muds, has been very controversial. Yet dredging, and port development in general, have dropped off the list of things most fought about around the San Francisco Estuary today.

Ships themselves pose threats to the bay. Oil spills, for one—both the major sort that grabs headlines and the minor, sloppy sort that, occurring year in and year out, contributes no less to pollution. The last really dramatic spill occurred in 1971, when two Standard Oil tankers serving the Richmond refinery collided in the Golden Gate in winter fog. One result of that event was the creation of the Coast Guard Vessel Traffic Service center on Yerba Buena Island (think of air traffic control in slow motion). Another was the establishment of cleanup strike forces, paid for by the industry and kept in constant training. Oil companies long resisted the costly step that most reduces risk: the redesign of ships so that the actual oil tanks are separated by several feet of buffer from the vulnerable external hulls. After a series of disasters, this "double hulling" is gradually becoming universal. Yet cleanliness and preparedness are expensive and tedious; between accidents, attention tends to slacken.

Another side effect of maritime commerce—and a bigger problem than oil pollution, in the long term—is the introduction of exotic species of plants and animals. These interlopers can travel in cargoes or on hulls, but the commonest medium of transport is ballast water.

Ships moving across the open ocean fill special tanks with water to provide weight and stability, adding or discharging it according to the cargo being carried. If the ballast

is taken on in an estuary on one coast and released in a similar environment on another, plants and animals from the source waters can easily take hold at the destination. Two of the bay's most unwanted guests probably reached it this way: the European green crab, which feeds on and competes with the commercially valuable Dungeness crab, and the Asian clam species *Potamocorbula amurensis,* which has become the most numerous invertebrate on the bay floor.

This is not a story of just a few troublemakers: the invading species number at least two hundred, and they have changed the estuary. The mud-living creatures, what scientists call the benthos, are almost all exotics. *Potamocorbula* has altered the ecosystem of Suisun Bay by consuming much of its phytoplankton (the tiny floating plants that form the first link in the food chain). The introductions continue, says Andrew Cohen of the San Francisco Estuary Institute, at the rate of at least two species a year. There is little hope of banishing the species already established, but even slowing the rate of introductions, scientists think, would allow the system to settle down.

Lately the region has taken some steps against this biotic tide. In 1999, the Port of Oakland was one of the first to require captains to exchange ballast water far out at sea, dumping fresh or brackish estuary water and taking on saltier midocean water instead. However, some of the hitchhikers survive this procedure. Better solutions may be coming. For instance, it appears that nitrogen gas, continuously pumped into the ballast tanks during ocean crossings, will drive out oxygen, causing organisms to die in a few days. Because the nitrogen treatment reduces tank corrosion, it may even pay for itself. Whatever net expense there is, however, is surely just a cost of doing business in one of the world's great harbors that is one of the world's great estuaries as well.

That seaports have a special claim on the shores of the estuary is self-evident. And airports? It is not quite so obvious why so many Bay Area airports—including the international ones at San Francisco, Oakland, and San José—are found in the shoreline band, but the reasons make sense. Pilots prefer to begin and end their flights over wide open spaces, risking fewer lives in case of accident, and also reducing the annoyance of noise; the bay is an open space, large and free of charge. In a crowded region, too, real estate for ever-longer runways is hard to find, and the bay has been the traditional source.

When the Bay Conservation and Development Commission put a stop to bay fill, both San Francisco and Oakland airports had recently enclosed fresh tracts of bay floor. The new land sufficed for a while, but by the 1990s, both airports were feeling hemmed in and ready to expand. San Francisco, which often suffered flight delays, partly because of the obsolete configuration of its runways, was the first to start a campaign for the approval of new bay fill. The square mile of fill it proposed would have been the single

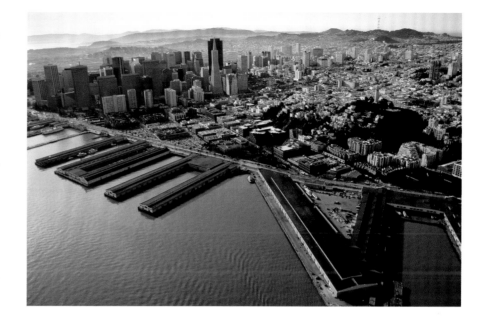

largest in history; the volume of material placed would have exceeded the total dumped in the bay since 1939. To make the plan more palatable, the airport tried to link it to the new movement for marshland restoration: if the fill plans were allowed to proceed, the airport could pay some, perhaps much, of the hefty restoration bill. Scientists began studying the possible effects of expansion on currents and bay biota; citizen groups rallied against the still indefinite plan; and the bay commission braced itself for the toughest decision of its career.

Then came September 11, 2001. Air travel waned for a time, and some of the urgency went out of the debate. But even if this particular plan should be deferred indefinitely, the challenge it represents is likely to be back. In 2001, at a scientific conference concerning the bay, an eminent newsman chaired a panel on the airport issue. An audience member asked this question: If expansion is a true necessity, why should we not pay the price of doing it on land? The moderator laughed it off: "We know how practical that is."

It probably is impractical, yet the question is an important one. Airports exist and expand, after all, in regions without waters to fill. If we are not willing to talk in these terms—if we still consider built-up land, any built-up land, to be in a whole different league of value than the living water—perhaps we are not yet so very serious about our estuary, after all.

Aerial view of docks and downtown San Francisco.

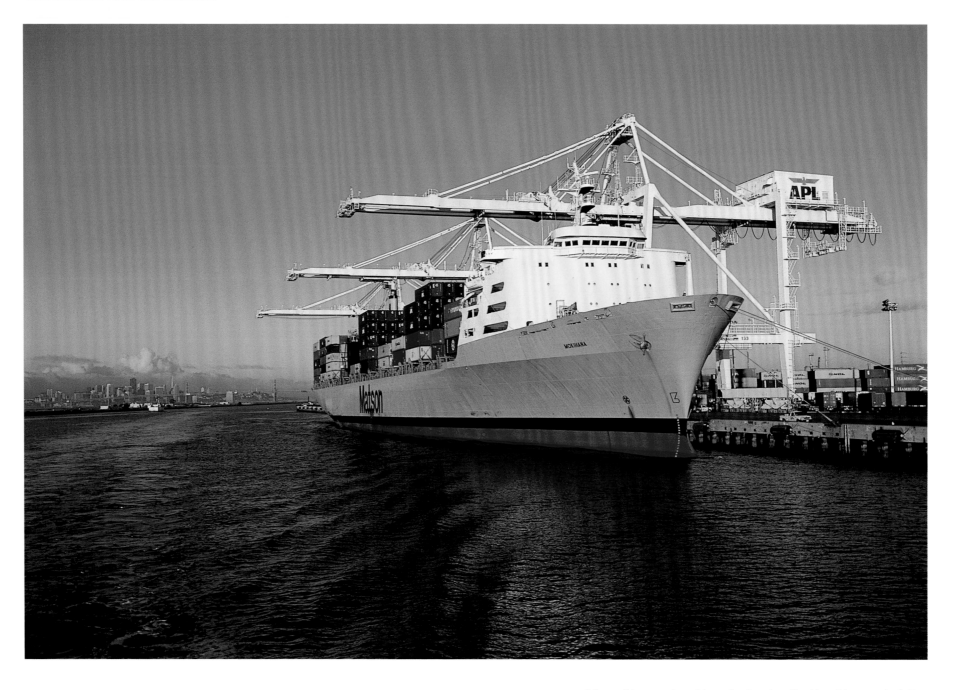

ABOVE: *Matson Line container ship at the American President Lines terminal, Port of Oakland.* OPPOSITE: *Cruise ship (Carnival Lines' Ecstasy) undergoing cleaning and renovation at the San Francisco Dry Dock on the southern waterfront.*

LEFT: *Crane's-eye view of a container ship. One of the world's largest container cranes offloads boxes at the Hanjin terminal, Port of Oakland.* ABOVE: *Big ship and small bird.*

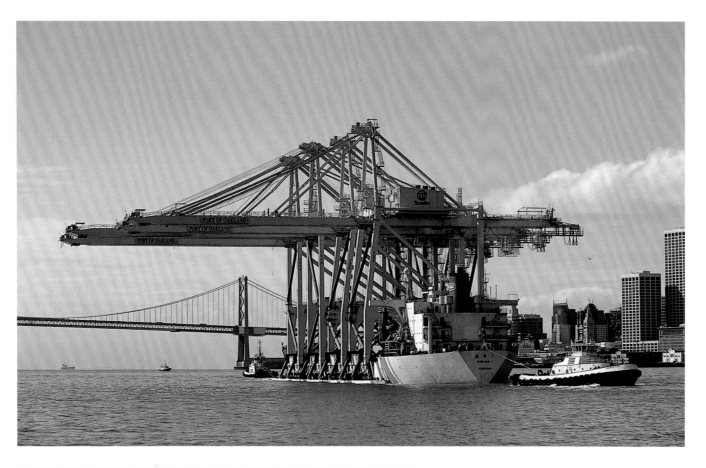

ABOVE: *Cranes bound for the Port of Oakland, arriving from Shanghai on the Zhen Hua 4. Their tips will clear the deck of the San Francisco–Oakland Bay Bridge by twenty-six inches.* LEFT: *Chinese mitten crab, an exotic species discovered in the bay in 1993 and probably brought in through ballast water. Mitten crabs can clog water intakes and weaken delta levees with their burrows.* OPPOSITE: *Dockside container crane, Port of Oakland.*

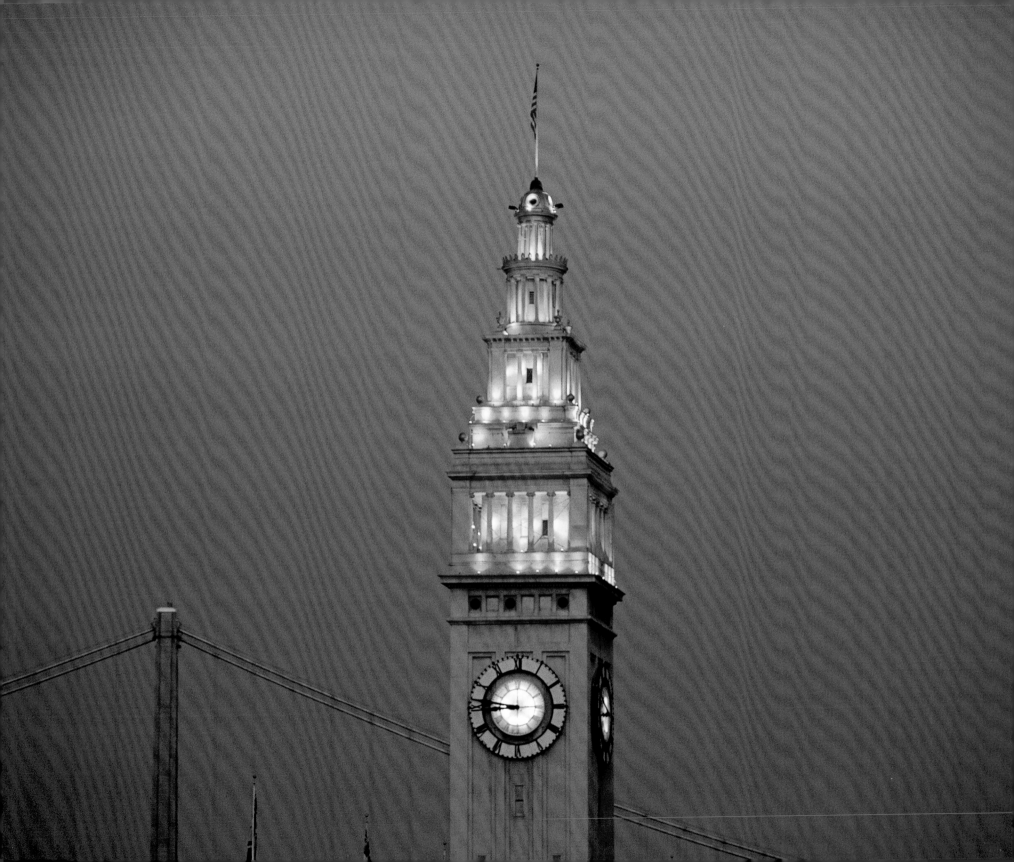

The Ferry Building

In 1892, the voters of California—of the entire state, not just of San Francisco—agreed to pay the bill for a grand new Union Depot and Ferry House at the foot of Market Street. Nothing could better show the dominance of one city in early California, nor the importance to that California of water transportation on San Francisco Bay.

The Ferry Building, replacing a more modest structure, was at the time the largest building in California. Its clock tower, 240 feet tall, was modeled after La Giralda, the famous twelfth-century bell tower in Seville. From the water, it functioned almost as a lighthouse. Under it, ferries docked along the building at five parallel berths. Debarking passengers found themselves in a huge skylit hall with mosaic marble floors and classical arches. From the land side, the building was framed in the vista down Market Street.

From the beginning of the American period, water transport had shaped development around the bay. People settled where boats could reach, and they could reach three hundred miles of shoreline. Townlets started up all around the bay plain at the heads of navigable sloughs. The first public ferry service began running in 1850 between San Francisco and Oakland. Miners took this boat to start their trek to the Mother Lode; conservationist John Muir, who arrived in San Francisco in 1868, immediately jumped on an Oakland-bound ferry to head toward "any place that is wild." (He later lived near the bay, in Martinez, but never showed the slightest interest in it.)

With the rise of the railroads, ferries became the missing links in rail systems, carrying people and goods and often whole strings of cars across the waters. Even the arrival of the automobile at first only increased the need for ferries, as the boats began carrying these vehicles as well.

The ferry system reached its fullest development in the 1920s. At the end of the decade there were forty-three boats on the bay, carrying forty-seven million passengers a year. More than fifty thousand people made the daily water commute from the East Bay to San Francisco. The Ferry Building was the busy center of it all.

But the system was already doomed, for bridges were a-building. The process started at the remoter reaches of the San Francisco Estuary, where the waters to be

Tower of San Francisco's Ferry Building, once the hub of
a great waterborne transit system.

crossed were narrower, and worked its way toward the center. A private ferry company converted itself into a bridge company and built the Antioch and Carquinez spans, opened to traffic in 1926 and 1927. The Dumbarton Bridge, near the southern tip of the bay, also opened in 1927; the Hayward–San Mateo Bridge, in 1929. The Central Bay waters were more challenging to cross; the engineering marvels called the San Francisco–Oakland Bay Bridge and the Golden Gate Bridge opened in 1936 and 1937. Two latecomers—the Richmond–San Rafael Bridge and the Benicia-Martinez Bridge—followed in 1956 and 1962. With each bridge, a ferry service died.

When the transition was over, the relationship of people to bay had undergone an unmistakable, subtle change. A ferry ride, however routine, had been a chance to see and smell and feel the bay. I can myself just remember the Richmond–San Rafael auto ferry. You could choose to sit in your car, of course, but most people didn't; they went upstairs and watched the waters stream by, wondered about the island called Red Rock, watched the approach of the opposite shore. But the bridges did not invite this connection to the estuary. Drivers in heavy traffic can't be sightseers, and, except on the Golden Gate Bridge, even passengers find their gaze interrupted by girders or blocked by tall, opaque railings.

In the space of ten years, the Ferry Building went from grand transit hub to elegant anachronism. After World War II, it was remodeled into characterless office space for the Port of San Francisco and other tenants. Its handsome facade and tower still stood, but in 1959 its irrelevance was underlined when a double-decker aerial expressway, the Embarcadero Freeway, was planted before it in what seemed almost a conscious act of defacement.

By the 1960s, as auto traffic swelled, the region realized that it could not move on asphalt alone. The Bay Area Rapid Transit system (BART) opened its transbay tube from Oakland to San Francisco in 1974, passing right under the Ferry Building. But if bridges limit the traveler's experience of the bay, a tunnel like this simply annuls it. As part of the BART work, a new pier was built outside the Ferry Building, wrapping halfway around it and occluding three of the historic ferry bays. From the water side as from the land side, the great old building was cut off, degraded, hemmed in.

A timid rebirth of ferries, however, had already begun. In 1970, a group of commuters in the wealthy Marin County community of Tiburon, isolated at the end of

From the top of the South Tower of the Golden Gate Bridge.

San Francisco–Oakland Bay Bridge. Increasing traffic on Bay Area roads adds pressure for transportation alternatives like ferries.

their peninsula, got together to charter a boat for a service to San Francisco. Then the special district that runs the Golden Gate Bridge, looking for ways of easing congestion on the span, began ferry service to San Francisco from Sausalito and from a glossy new terminal at Larkspur. The private Red and White Fleet became a player, taking over the Tiburon run and launching a second service to Sausalito. In 1986, when the theme park Marine World moved from Redwood City to Vallejo, a ferry linked that city, too, to San Francisco. At the San Francisco end, these various lines converged at an improvised slip not precisely at, but near, the old Ferry Building.

So the ferries were back? Not really. The service was very pleasant but not very fast and not very convenient, and the boats carried the merest fraction of the historic passenger count. The system, if it could be called that, was something of a gimmick, something of a token, something of a toy.

Then plate tectonics took a hand. The Loma Prieta earthquake of 1989 shook a piece of decking out of the San Francisco–Oakland Bay Bridge. When the temblor struck, the Red and White Fleet had charter boats standing by at Candlestick Park in San Francisco, where a World Series game was being played. Instantly the company organized a ferry service to the East Bay, taking twenty thousand people home that night. In the ensuing bridgeless weeks, additional craft were hurried to the region. At Richmond, Berkeley, and Alameda, old channels were dredged and makeshift terminals erected. For a moment the waters of the bay seemed as busy as in the old days. When the bridge reopened, ending the boomlet, the new services to Oakland and Alameda nonetheless survived; and people started looking far more seriously at the neglected water highway.

Might San Francisco Bay again have an admirable ferry system? In 1999, the California legislature created a new Water Transit Authority to explore the possibility. Two years later the authority offered a plan that would lace the bay with ferry routes from Redwood City to Antioch. There is certainly room to grow. People now take about four million trips a year on the region's ferries—quite a number, and a real help in cutting traffic on the bridges, but less than a tenth of the 1930 ridership, and less than a fifth of the ridership on the Puget Sound ferries today.

A "real" ferry system will cost a lot of money. It will have to offer frequent service and smooth connections. It will require boats that move faster and ride more shallowly in the water. It will also have to meet some environmental objections. Traditional diesel engines are pretty dirty; much cleaner propulsion systems, becoming available, will be standard. (There is even a pilot model that burns soybean oil.) Some of the dreamed-of ports of call may not work out because of the channel dredging they would require or because of the disturbance to wildlife that ferry traffic would entail. The wakes of ferry boats can erode marshes and threaten shoreline houses. As in everything connected with the bay, progress seems to consist of a series of difficult balancing acts.

Yet it is hard not to root for the ferries. Taking the ferry feels somehow like a vote for the bay. It seems a part of the current process of rediscovering, reconnecting to, the regional home waters. For new ferry passengers, as for tourists, each trip is an adventure. Habitual riders aren't glued to the windows, but with repeated ferry trips, you absorb the rhythms of the waterscape: what the wind and the tides and fog are doing, what colors the water top is showing, what cargo ships are in, what sailboats are racing, what the windsurfers are up to (they love to jump the ferries' wakes). Tame though it is, the experience brings its whiff of the sea.

Part of the reconnecting process, and a symbol of it, is what has happened since the 1989 quake to the Ferry Building itself. The same shock that reinvigorated the ferries so damaged the Embarcadero Freeway that it had to be taken down. Once more the Market Street vista led the eye to the old clock tower. In 1998, the building's centennial year, the Port of San Francisco launched a second remodel. The old partitions were ripped out, the vast lower hall restored. Elegant new ferry piers were opened just north and just south of the building, and two more are planned to feed directly into it.

The "old" Ferry Building, with its row of uniform slips and its central ticket windows, spoke of an integrated system. Those pieces cannot be put back together, quite. The refurbished historic building is a cross between a transit hub and a tourist destination, full of restaurants and gracious public spaces that commuters will ignore. Yet if it is a compromise, the new Ferry Building complex looks like a viable one.

In the long run, the years when ferries were gone from San Francisco Bay may seem a curious gap in the long story of water transit in a region superbly suited for it. (What were they thinking?)

The region didn't, after all, miss the boat.

Sightseeing boat, seen from the Golden Gate Bridge's South Tower. Tourism is a major contributor to the bay economy, bringing in more than $6.5 billion in 2001 to San Francisco alone.

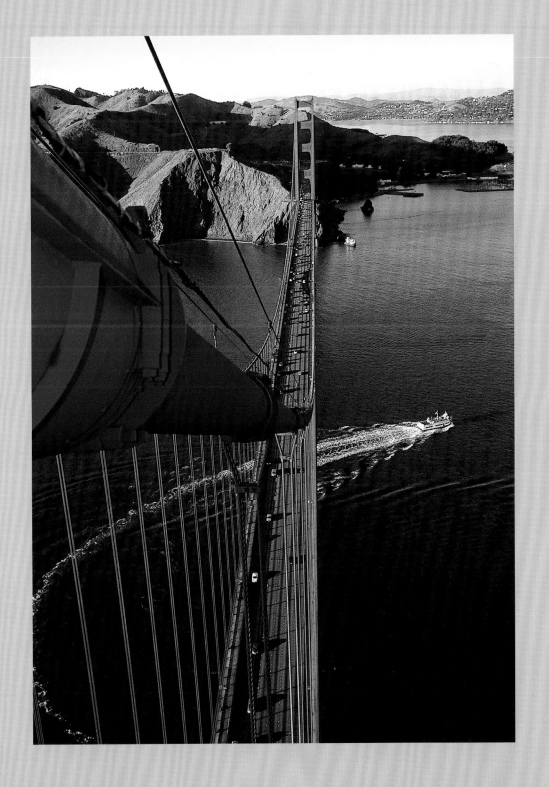

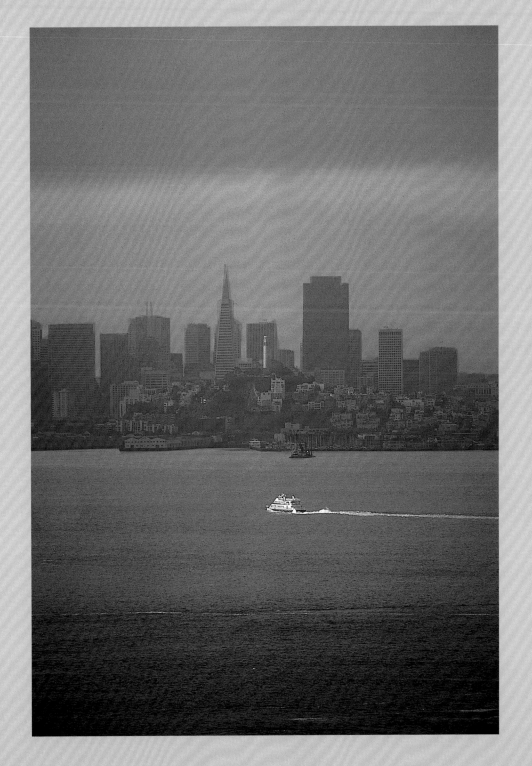

OPPOSITE: *Passengers on the ferry to
Angel Island.* RIGHT: *Commuter ferry
from Tiburon approaching San Francisco.*

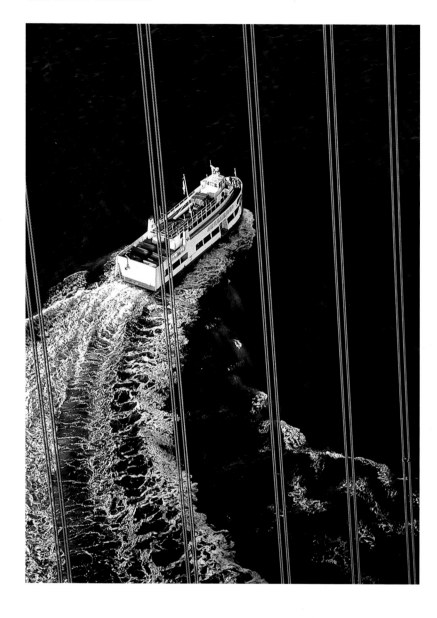

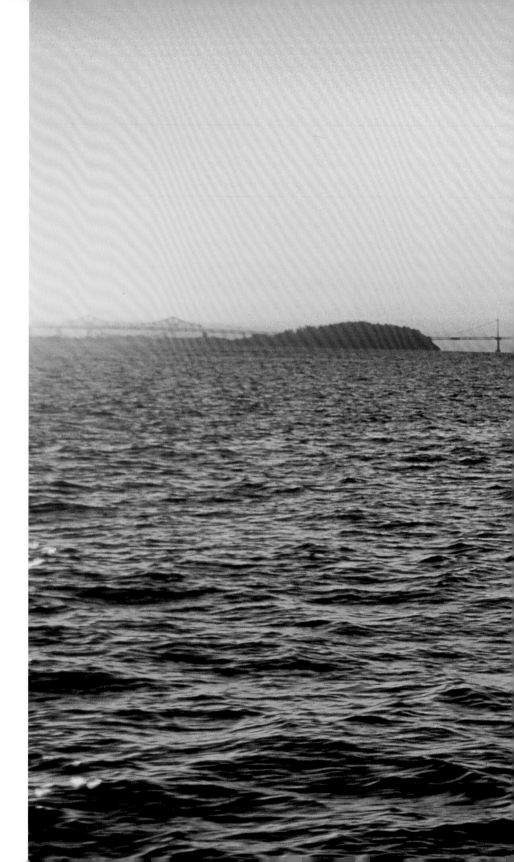

ABOVE: *Tour boat seen through the suspension cables of the Golden Gate Bridge.* RIGHT: *Bay Bridge and San Francisco skyline at dawn from Richardson Bay in Marin County.*

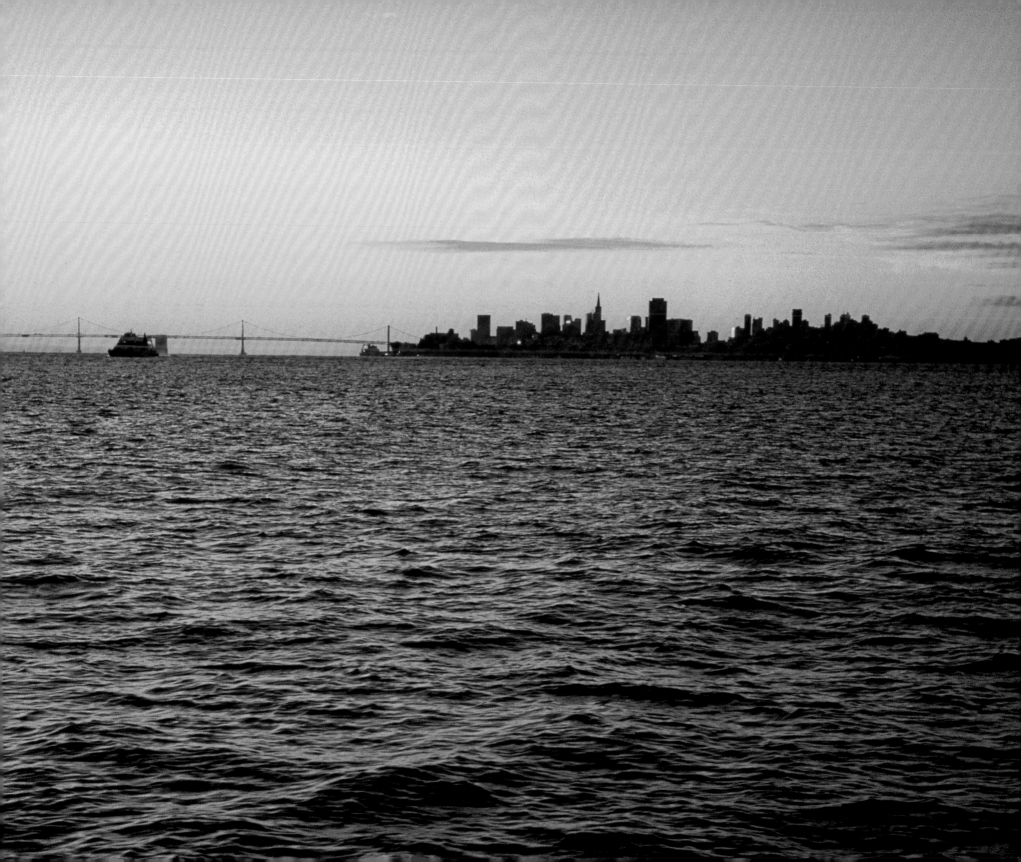

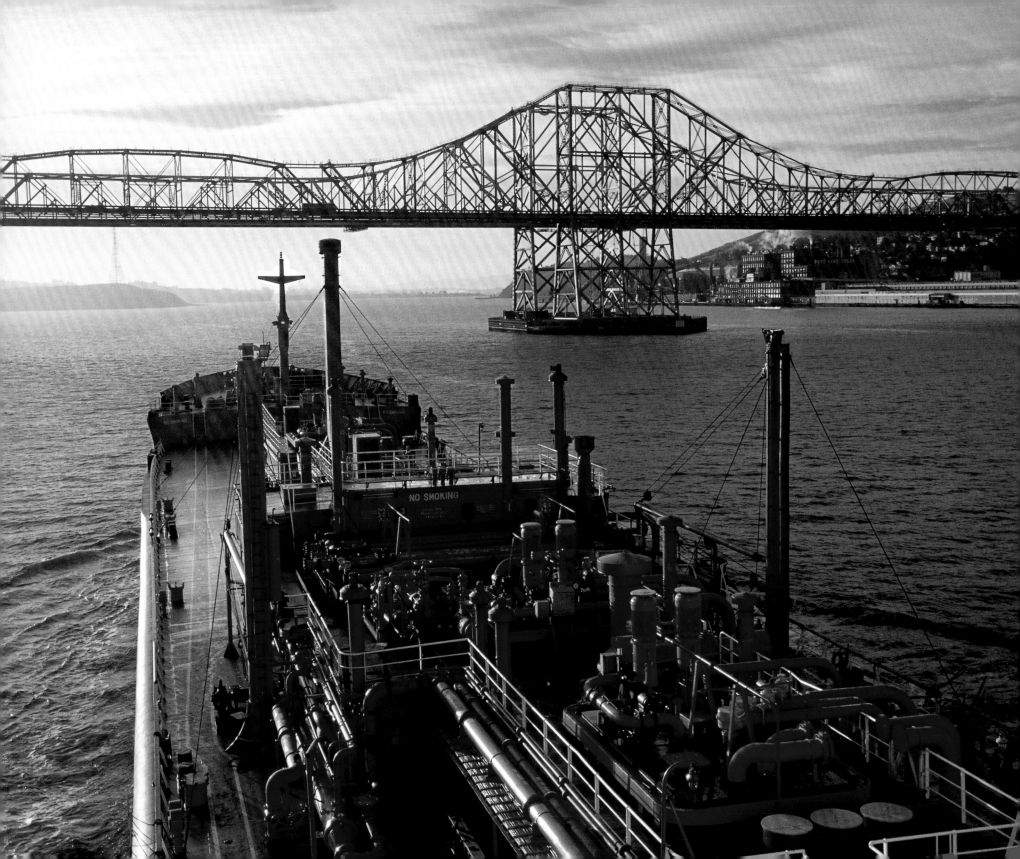

The Ammonia Tanker

*I*t is dawn in the Pinole Shoals. We are upbound to Stockton, in nonescort condition, aboard the *Gaz Master,* a tanker that last docked at Kalamantan, Indonesia. "Upbound" is inland, through a succession of bays and rivers to one of California's farthest inland ports. "Nonescort condition" means that we are not accompanied by a tug. We are carrying ten thousand tons of supercooled ammonia, which is what they call a sensitive cargo. It can suffocate you. It can blow you up. Sixty miles of channel lie ahead, and the shoal we are now traversing in San Pablo Bay is the first of many sections that require the captain's full attention.

The man giving orders in the wheelhouse today is not the ship's master, a genial fellow named Leonid who comes from Odessa in Ukraine. Leonid is here, of course, and standing at the wheel; but yesterday, outside the Golden Gate, he handed off command to a local seaman of the type known as a bar pilot. Bar pilots train for years to navigate the intricate channels of the San Francisco Estuary. Every ship over six hundred tons that comes into the harbor must hire one of these experts. The pilots' association has existed in some form since 1835; it is in fact the oldest private organization in California. The law requiring pilots on every large ship dates from a 1971 oil tanker collision and spill.

Many bar pilots have served time on the high seas and found it dull. "The most fun thing about driving a ship is bringing it to shore," one of them told us. "The adrenalin part. No boring watches." Besides, you're never long away from home.

One doesn't too easily become a bar pilot. The typical career path begins with study at the California Maritime Academy, a special campus of the state university, located in Vallejo on the Carquinez Strait. (We will be passing it soon.) With years of service, you work up to a boat command, perhaps as a tugboat pilot. After three years as a skipper, you can start working toward your pilot's license or "pilotage." Among the things you must do to earn it: draw a map of all the harbor channels, freehand, from memory, showing every change of depth, every change of heading, every buoy. You make your drawing on a transparent sheet. When you finish, that sheet will be placed on top of a nautical chart, and the lines had better match. After the tests comes a long apprenticeship. Before you get your pilotage, you will bring in hundreds of ships with a licensed pilot looking over your shoulder.

Our captain today, E. D. Melvin, has done all that. He is proud of the difficulties passed and the ones he faces working one of the least forgiving harbors in the world.

Tanker MV Gaz Master *approaches the Carquinez Bridge at dawn with a cargo of supercooled ammonia from Borneo.*

"We have two hundred miles of waterway," says Captain Melvin, exaggerating slightly. "We have strong currents. We have fog. I've gone under the Golden Gate Bridge for months and never seen it. We have high winds. We have shoals." He gestures at the uncommunicative, ripple-fretted surface. "Looking out here, I don't see the water. I see the bottom. The bay bottom is like a weird Dalí painting."

Look at one of the 3-D images on the walls of the bar pilots' headquarters, Pier 9 on the San Francisco waterfront, and you see how much topography there really is down there: strange humps and hollows, the wide roots of islands, wandering tendrils of valleys, dune fields of mud working outward toward the sea. Generally, the estuary is deep wherever it is narrow: near the Golden Gate; west of Yerba Buena Island; between Point San Pedro and Point San Pablo; in the Carquinez Strait. Everywhere else it is shallow. Only one of its ports—the original one at San Francisco—has unimpeded access to deep water. All the rest are served by dredged channels, kept just as deep and just as wide as they have to be, no more. In San Pablo Bay, we look out on an almost oceanic expanse, but the strip we can use is only six hundred feet wide. In Pinole Shoals, on the present tide, we have two feet "underkeel," between hull plates and mud. To stray from this narrow road is to go aground.

As we approach the strait the water deepens, and here is the Carquinez Bridge, its girders silvered with first day. To the right steam the stacks of the oil refinery at Rodeo, as impressive this morning as Yellowstone, and the lesser ones of the C&H sugar plant at Crockett. The color of our ship emerges now, an "international orange," about the hue of the Golden Gate Bridge. From the wheelhouse, located aft, we look along a long expanse of deck, sprouting pipes and bulges. Everything is worn and battered but trimly painted and well maintained. I remember where the word *shipshape* comes from.

The *Gaz Master* illustrates another word, *globalization*. The vessel was built by Norwegians. It is owned by Greeks. It is crewed mostly by Filipinos. Except when the bar pilot comes aboard, Ukrainians command it. Its flag of convenience is Maltese. The responsible mate knows everything conceivable about its cargo—its chemistry, its hazards, its proper care and handling—except how it was made and what it will be used for. (The stuff comes mostly from natural gas; it will be applied to farm soils by an injection process.)

At New York Point in Pittsburg, a small lighter, or "pilot boat," comes out to us, taking away Captain Melvin and depositing Captain Charles Rhodes. Charlie Rhodes is a river specialist, holder of a distinct river pilotage and an heir to the steamboat pilots in Samuel Clemens's *Life on the Mississippi*. "It's Mark Twain up here," he says, with zest. The rest of the trip will be on the San Joaquin River, or technically on the Stockton Deep Water Ship Channel, a route that sometimes follows the natural river and sometimes cuts across its meanders.

No longer is there the illusion of wide waters: from here on in, the narrowness of our passage is unmistakable. The channel marker buoys seem very close on either side, and, Rhodes tells us, the usable space is actually narrower still. For much of the way this channel is a one-way street, strictly one ship at a time. Rhodes has little leisure to chat. Commands to helm and engines are a constant stream.

"Hard starboard."

"Starboard 20."

"Starboard 10."

"Midships."

"Midships" means straight ahead, but on this vessel, it doesn't quite. The *Gaz Master* pulls just slightly to the right and needs constant correction. Bar pilots learn to grasp such idiosyncrasies in a hurry and adjust to them.

Speed is an important control element, too. If you go too slow in a river or tidal channel, you can lose headway against the current. If you go too fast, your ship will ride low and risk scraping the bottom. Tule fog can be a major problem, and radar and

ABOVE: *The* Gaz Master *on its way up the San Joaquin River to Stockton.*
OPPOSITE: *Carquinez Strait from the hills above Port Costa.*

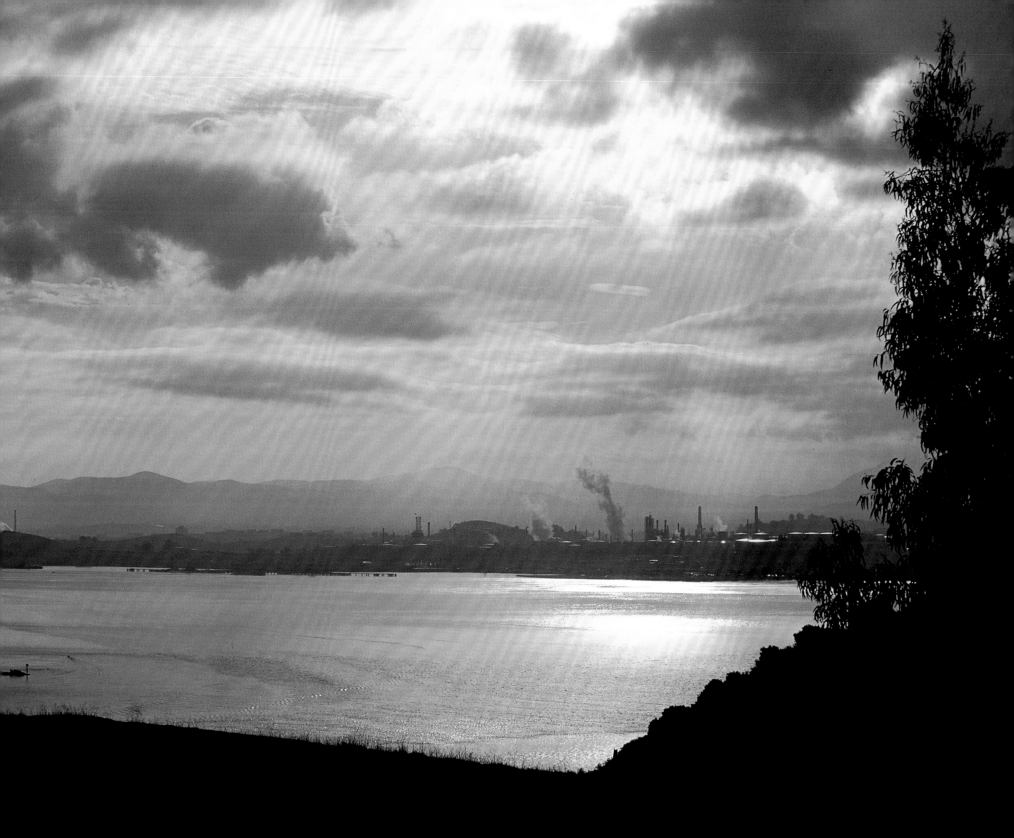

global positioning systems don't provide the whole answer. "Some GPSes aren't dead on," says Rhodes.

The farther inland we get, the stranger our situation seems to be. We're standing one hundred feet above the river, looking down to it, and onto the tops of the dikes, and across the dikes to sunken fields where treetops or corn tassels do not reach so high as our waterline. It's like sitting on the back of a tall horse on a narrow causeway. We seem too big for this river, too maritime for this landscape. Out of our element; fish out of water, but not quite. We are still in the tidal zone, still in the harbor. A cluster of buildings down there, adorned with an old coastal lighthouse, is the inland outpost of San Francisco's St. Francis Yacht Club.

Ten hours after boarding ship, we approach the Port of Stockton, and the trickiest sequence of all, the docking. Two tugboats, the *Angie* and the *Heidi,* pull up alongside. The thing tugboats do least often is tug; they make their living by pushing. And they rarely move boats forward or back; they nudge them from the side. What they provide, in close quarters, is turning power. The slip we are going into is a notch in the shore almost perpendicular to the river. Unaided, the *Gaz Master* could make a right turn in about half a mile. The tugboats will make it happen in a few hundred yards.

OPPOSITE: *Bar pilot E. D. Melvin in command.* ABOVE: *A replacement pilot boards at Pittsburg to take the* Gaz Master *on up the river.*

What follows is an hour-long, intricate dance. Rhodes now commands not one boat but three. The two tugboats attach themselves near the bow. The Ukrainian master hovers anxiously.

"Dead slow ahead."

"Full ahead."

"Stop engines."

"*Angie,* easy astern."

"Okay, *Heidi,* you can stop and switch over to starboard."

Heidi goes around the stern and plants itself on the same side as *Angie.* Rhodes and the officers move out onto the outlying deck on the port side, nearest the wharf. We are moving at less than a saunter, but still with a feeling of huge and dangerous mass.

"Dead slow ahead."

"Starboard 20."

"Starboard 10."

"Hard aport."

"Midships."

"Hard aport."

"Hard starboard."

"Midships."

"Dead slow ahead."

There is silence for a bit. The crew is active forward. Lines are going ashore. A truck labeled West Coast Ship Supply pulls alongside on the quay. Now Leonid says, "Stop engines." The impact as we touch the wharf is barely perceptible. I breathe.

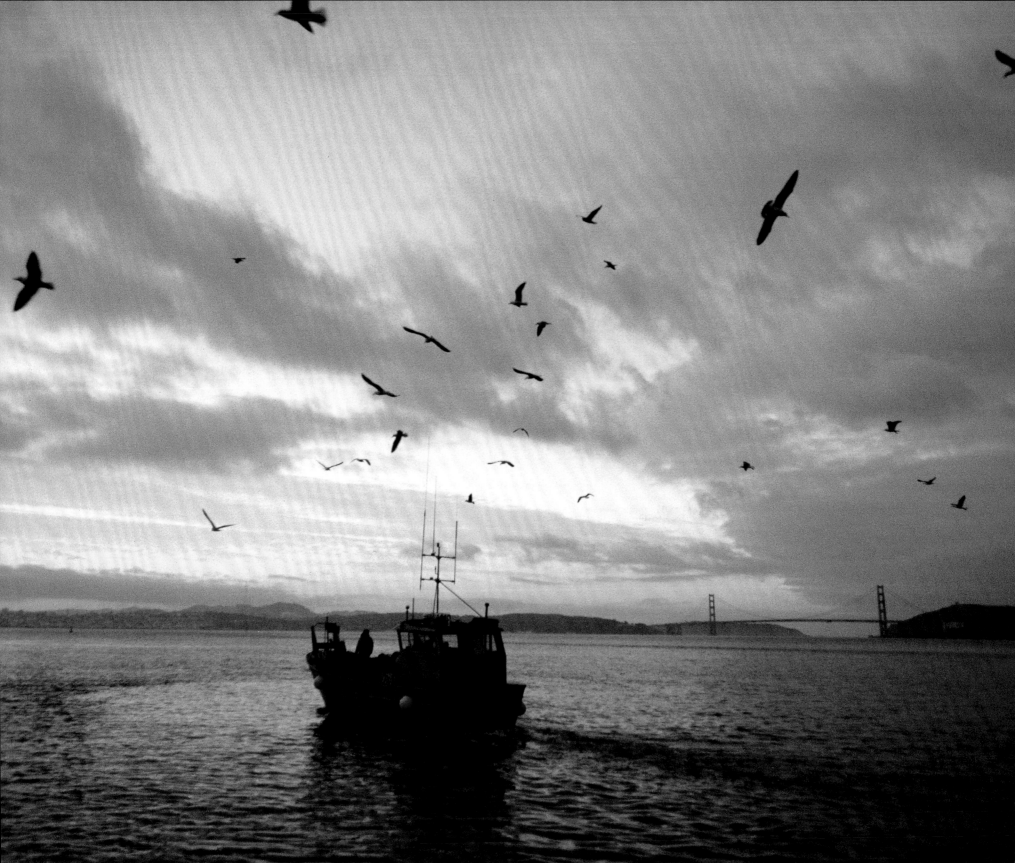

The Herring Boat

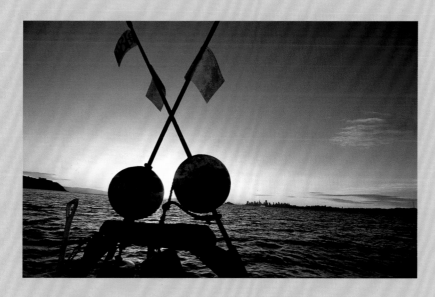

*I*t's a cool January night on San Francisco Bay, and we are hunting the Pacific herring. Hunting, because you have to find the fish before you can start catching them, and at this particular moment in the spawning season, there isn't a school in sight. Our search has led along miles of shores to what seems an unlikely place: the cove formed by a couple of crumbling piers at the former Hunters Point Naval Ship-yard. The land is dark but for the aircraft warning lights nearby on the summit of an enormous, disused crane.

I boarded the *Ursula B,* a commercial herring boat owned and captained by Ernie Koepf, twelve hours ago at Fisherman's Wharf in San Francisco. Here, behind the restaurants and the T-shirt sellers, another Fisherman's Wharf extends: a workaday place from which the boats go out for Dungeness crab and chinook salmon, for halibut and herring. Most of those craft head west for the ocean, but the herring boats stay inside the Golden Gate. The herring roe industry, or "fishery," is one of the newest in the nation, and one of the very few that takes place along densely urban shores.

The Pacific herring lives in waters around the northern coasts of the Pacific Ocean from Korea to California. To breed, it needs shallow water about half as salty as the sea—estuary water, in the winter, when dilution by the rivers is high. The fish lay eggs on any hard surface: eelgrass, seaweed, pilings, rocks. In San Francisco Bay, they spawn around the shores of the Golden Gate, especially favoring the Marin County inlet called Richardson Bay; they range as far north as the Richmond–San Rafael Bridge and as far south as the San Francisco and Oakland airports. After hatching, the floating larvae disperse inland with the tides; marshland sloughs, like those in the Petaluma Marsh, are nurseries for them. The following summer, having matured into swimming fish, they move out to sea.

Herring, though heavily fished here in early days, didn't appeal to later American taste, and by 1954 the catch in the bay had almost ceased. But across the Pacific in Japan, the appetite for herring remained so strong that nearby waters were fished out and had to be closed to harvest. In the early 1970s, a search began for a replacement source of herring roe, or *kazunoko,* a traditional delicacy. The best one turned out to be near the extreme opposite tip of the arc of the herring range, in San Francisco Bay.

OPPOSITE: *A herring boat in Richardson Bay in Marin County, with attendant gulls.* ABOVE: *The morning after a night of fishing. Floats are used to mark the locations of deployed herring nets.*

The revived California fishery began with a bang. Mindful of the danger of over-exploitation, the California Department of Fish and Game stepped in early and set harvest levels that—so it is presently thought—will be sustainable. The quota varies but is typically about six thousand metric tons, of which about one thousand tons is the valuable part, the unlaid eggs or roe. Each female fish contains two big arcs of linked eggs, large and honey colored. A perfect horseshoe of golden herring roe is a princely gift in Japan.

When the herring are running, all their many predators come after them and their spawn. Salmon whip through, nipping at the school. Gulls swoop and swear. Bottom-feeding sturgeon browse the egg deposits. Sea lions bark and gobble. And over one hundred herring boats, working almost gunwale to gunwale, lay out and pull in their nets as fast as they can.

This isn't one of those times. We're between spawning surges and are "fishing on the come"—on a hunch as to where the fish may show up later. So far no other boat shares our particular hunch. The *Ursula B*'s chromoscope—a downward-looking sonar—sees only the round blobs of jacksmelt, an abundant fish that is also here to spawn. It is a key food item for the endangered California least tern.

Ernie Koepf and his son Eric, crew for tonight, are guiding a net as it unfurls. It winds off the reel near the cabin, passes over a now quiescent device called the shaker, and crosses a second reel on the bow before slanting into the water. The stanchions that support this second guide reel give a herring boat its unmistakable two-pronged bow. This net will catch fish by snagging the covers that protect their gills. Two hundred feet long and eighteen feet wide, it has openings of more than two inches, wide enough so that only fish with a couple of spawning seasons behind them will be trapped. Now its trailing end flaps over the bow, and it floats free. To mark its location—and indicate its ownership—the men drop a distinctively labeled buoy beside it. They repeat the whole process with a second net and marker. On a prime night, the first net might be full of fish and needing retrieval by the time the second is placed. This isn't a prime night. "Let 'em soak," Ernie says, and we get some sleep.

The San Francisco Bay herring fishery receives a lot of press because it is exceptional. Here is a species of interest that is not in decline; here is a resource that is not being mismanaged. The bad news is implicit in the good.

All accounts agree about the opulence with which the story begins. The first European comers marveled at the huge chinook salmon beating their way up the old river channel past Angel Island toward their inland spawning grounds; of steelhead trout and coho salmon in every lesser stream; of pods of blue whales thronging around ships inside the Golden Gate. Nineteenth-century diners praised the delicate flavor of the native Olympia oyster, a staple of the Ohlone and Miwok peoples and then of Gold Rush San Francisco. And in restaurants of the day, while studying the menu, you'd be offered a plate of bay-caught shrimp to nibble on.

The Anglos weren't very avid fishermen, but the Italians and the Chinese were, and they set about exploiting these resources with a will. For decades the harvests climbed, reaching a climax about the turn of the twentieth century. From 1870 to 1915, San Francisco was the preeminent fishing port on the West Coast, and much of that harvest took place inside the Golden Gate. "Naturally the San Francisco market is at all times well supplied with fish," says a report of the time. "No ice is used, and very rarely are the fish cleaned before being sent to the market. This results from the great plenitude of fish, and from the fact that fishermen are able to market their catch within such short distance of the place of capture." Quotas were occasionally imposed to keep prices up. Dungeness crabs were so dense in the bay as to be thought a nuisance. "They are taken in immense numbers in seines . . . yet the supply seems to be undiminished."

Even before 1900, though, the decrescendo had set in. The native California oysters had already been depleted by 1870. Crabs were scarce inside the Golden Gate by 1890. Sturgeon became too few for mass harvest by 1901. The planting of eastern oysters was stopped by 1920, because urban pollution made the crop unsafe to eat. Even striped bass, an Atlantic species that flourished after its introduction to these waters around 1880, went off the commercial list by 1935.

The inland fishery for chinook salmon lasted longest. As late as the 1950s, gill nets were strung across the Carquinez Strait, and there were canneries from Martinez to Collinsville. Even under what was undoubtedly overfishing, even with all the changes occurring in the bay and on the feeder streams, the runs continued to be impressive. But by 1956, the stocks were crashing, and the commercial taking of salmon inside the Golden Gate was banned. Only shrimp and anchovies continued to be netted within the bay, and these only for bait.

Here is one melancholy distinction that the San Francisco Estuary has gained: it is the only large bay in the world on whose shores you cannot order in a restaurant, or buy at a fish market, some creature that grew and was caught in the home waters.

Despite the decline, the surprising thing about fish life in the estuary at midcentury was not how reduced it was but how rich it was—still. If the 1850s belonged to a golden age, the 1950s were anyhow a silver one. With the competition of commercial fishing removed, people fishing for sport had the bay catch to themselves, and it seemed bountiful.

The downward trend, unfortunately, continued. Like the earlier deterioration, it can't be blamed on any one thing. Pollution played a part. So did the competition of

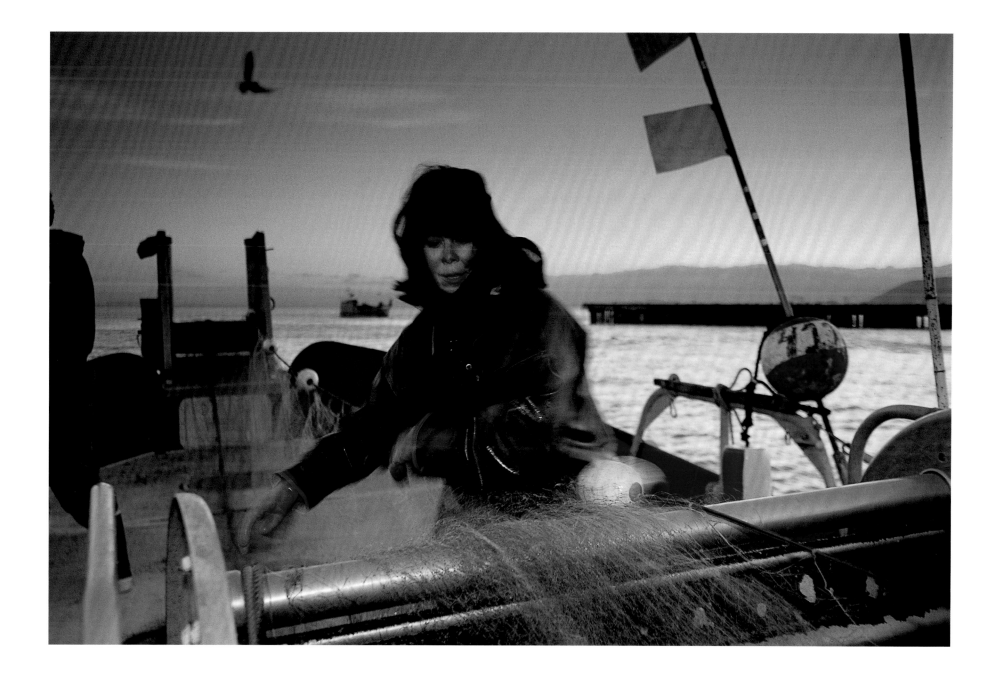

Herring fisher Anna Lee unwinds a net from its storage reel.

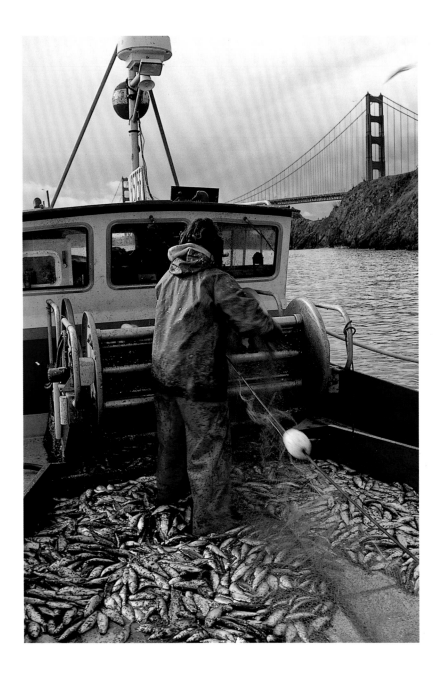

Fresh load of herring on an early winter morning inside the Golden Gate.

new, exotic species. Fishing pressure, in some cases, was probably still too high. Natural fluctuations in ocean temperature depressed some species (while aiding others). But if the problem was "multifactorial," as scientists love to say, there was one factor that now stood out: the damming and diversion of the estuary's feeder streams.

Between 1944 (when Shasta Dam impounded the Sacramento, Pit, and McCloud Rivers) and 1967 (when Lake Oroville captured the Feather River), state, federal, and irrigation district dams cut off half the spawning grounds of anadromous fish coming in the Golden Gate. Water diversions to farms and cities began noticeably changing the size and timing of bay outflows. In the 1970s, the state and federal pumps at Tracy hit their stride. The winter run of chinook salmon—the chinook stock that heads inland in winter, summers in mountain pools, and spawns in fall—was almost wiped out at this time by drought combined with overpumping; it is now on the endangered species list.

Just about the time the first Save the Bay campaign was stopping the obvious insult of bay fill, the biotic impoverishment of the larger system was gaining speed. Tracking the populations of many kinds of fish, biologists see a range of fortunes, a sawtooth pattern of ups and downs; yet for numerous species, especially the native ones, the highs are getting weaker, the lows more profound. Many noncommercial fishes, important to the food chain if not directly to us, are in sharp decline, and the biologists' concern has shifted lately to these.

There is still much to catch in the inland sea. Several species that depend on the bay, including salmon and Dungeness crab, are taken outside it in large though reduced numbers. Sport fishing, of course, continues and is no small industry; its annual value in the regional economy is put at $150 million. In a good year—which usually means a wet one—one feels a whiff of the old abundance. Even after a successful season, however, biologists and elderly fishermen alike will add: "Of course, it's nothing like it was fifty years ago." This is not mere nostalgia. It isn't like it was fifty years ago—let alone one hundred and fifty.

Except, maybe, for the herring.

Two A.M., and we roll out of the bunks. The men reattach the first net and start hauling it in. They have guessed right. It is silvery and shivery with herring. These are small, businesslike fish, streamlined except for the protruding flaps that have entangled them. As the net travels inward, the shaker—it should rather be called a beater—begins to roar and spin. As the net crosses over it, it whacks and dislodges the fish. Most fly as intended onto the broad collection deck, but some are thrown out of the containment area, even over the rail to the gulls, and some break into pieces under the impact. Some of the fish don't shake loose and are wound into the accumulating layers of netting on

the reel. I stand out of the way, aware of the essential violence of all predation, glad for my waterproofs as the air fills with an organic mist of scales and slime. When the second net has been emptied, Ernie and Eric open hatches leading into storage holds and shovel the harvest in. The yield is about a ton, not bad, not good. After washing down the decks, we head back to the bunks.

Herring are smelly. At peak times on Richardson Bay, the odor is detectable on shore. Bill Kier, a lifelong student of fisheries with an office in Sausalito, loves those times. "It smells," he says, "like a healthy bay." He sees this resurgent fishery as a harbinger for others. What else might rebound?

The herring are in a way an easy case. They are mainly ocean dwellers, less affected by changes in the estuary and its watershed than are fish that spend more time within the Golden Gate. They are also fast growers and fast reproducers, low on the food chain. The edible fish that are doing less well, like salmon and sturgeon, are higher on the chain and depend on the estuary for a longer time. We can't expect to see an in-bay harvest of such species anytime soon.

Shellfish might be another matter. One candidate for recovery is the native Olympia oyster, a huge and profitable crop in the early days of the American period. "There are extensive deposits of this species in the shallow water all along the western part of the bay," wrote an expert in 1893, "and their dead shells washed ashore by the high seas . . . have formed a white glistening beach that extends from San Mateo for a dozen or more miles southward." Buried by hydraulic mine waste and afflicted by pollution, the oyster was thought to be nearly extinct—though it remained important to the economy: the millennial shell deposits are still dredged and barged to Petaluma, Collinsville on Suisun Bay, and other places for use in making concrete. Recently some stubborn remnant populations of the living oyster have been found. Habitat is coming back, and it seems possible to think of deliberately growing the creatures—though the bay is not yet clean enough for the meats to be eaten without passing some time in a "depuration tank."

As an employee of the Department of Fish and Game in 1960, Bill Kier sat in on a meeting about bay pollution control. Asked what the department wanted to see, he answered: "We want the bay clean enough to get the oysters back." The reaction, he recalls, was incredulity.

The incredible, though, can happen. Take the ongoing restoration of the middle stretch of the San Joaquin River.

In 1941, the gates closed at Friant Dam, impounding the San Joaquin in the Sierra Nevada foothills near Fresno. Unlike most dams, this one was allowed to actually dry up its river. After irrigation exports out of Friant hit their stride, twenty miles of riverbed

below Fresno carried water only in wet years. One of the largest salmon runs in the bay-delta watershed disappeared. In 1988, a coalition led by the Natural Resources Defense Council and the Bay Institute sued the Friant authorities to force more water to be released downstream. Ten years later, the local water districts agreed to work with the plaintiffs to restore the river—and to bring back its anadromous fish. In 1999, for the first time in fifty years, some water was deliberately released from Friant Dam to meet the needs of the river below.

Chinook salmon in Fresno? Native oysters in San Francisco Bay? Each is now a conceivable, if perhaps a still distant, goal.

Pacific herring caught in San Francisco Bay. The valuable part is the roe (kazunoko), *a delicacy exported to Japan.*

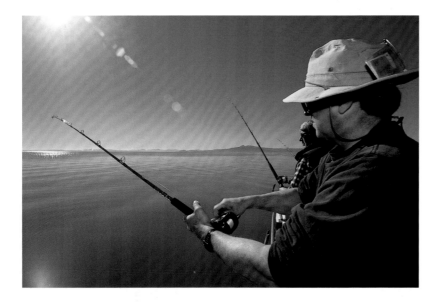

ABOVE: *Sturgeon fishing on San Pablo Bay on the party boat* Morning Star.
RIGHT: *Fisherman's Wharf in San Francisco, still home to active salmon, herring, and crab fleets.*

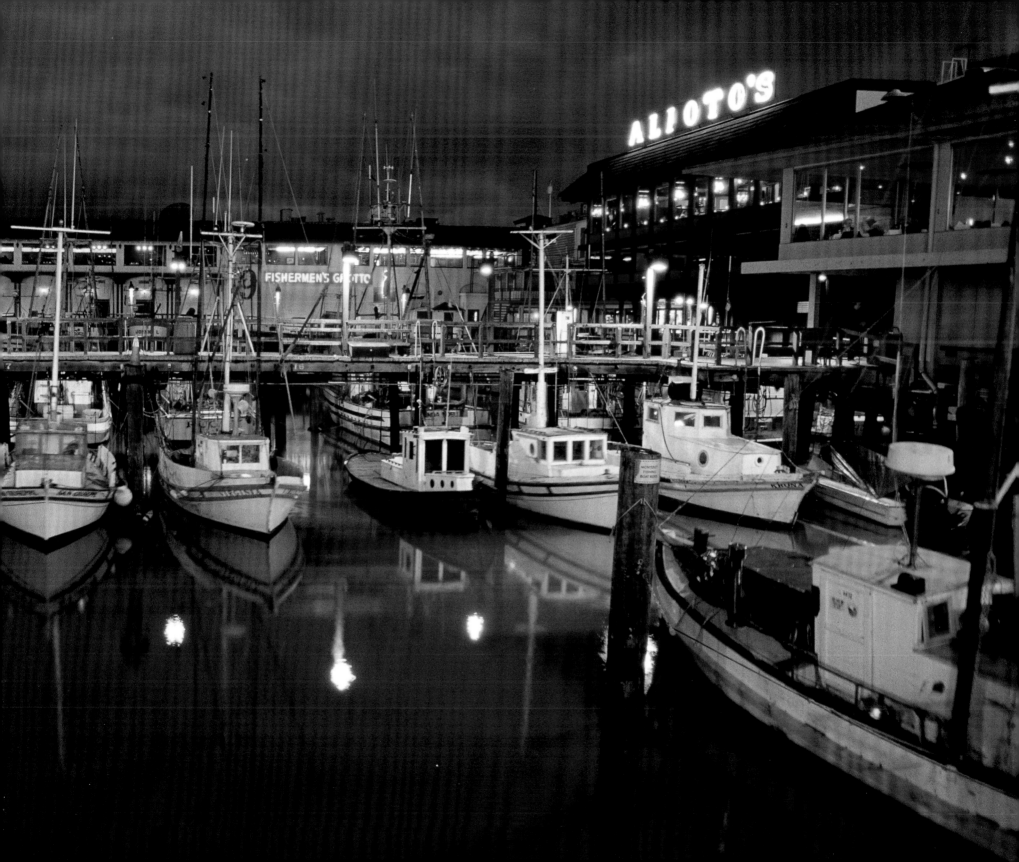

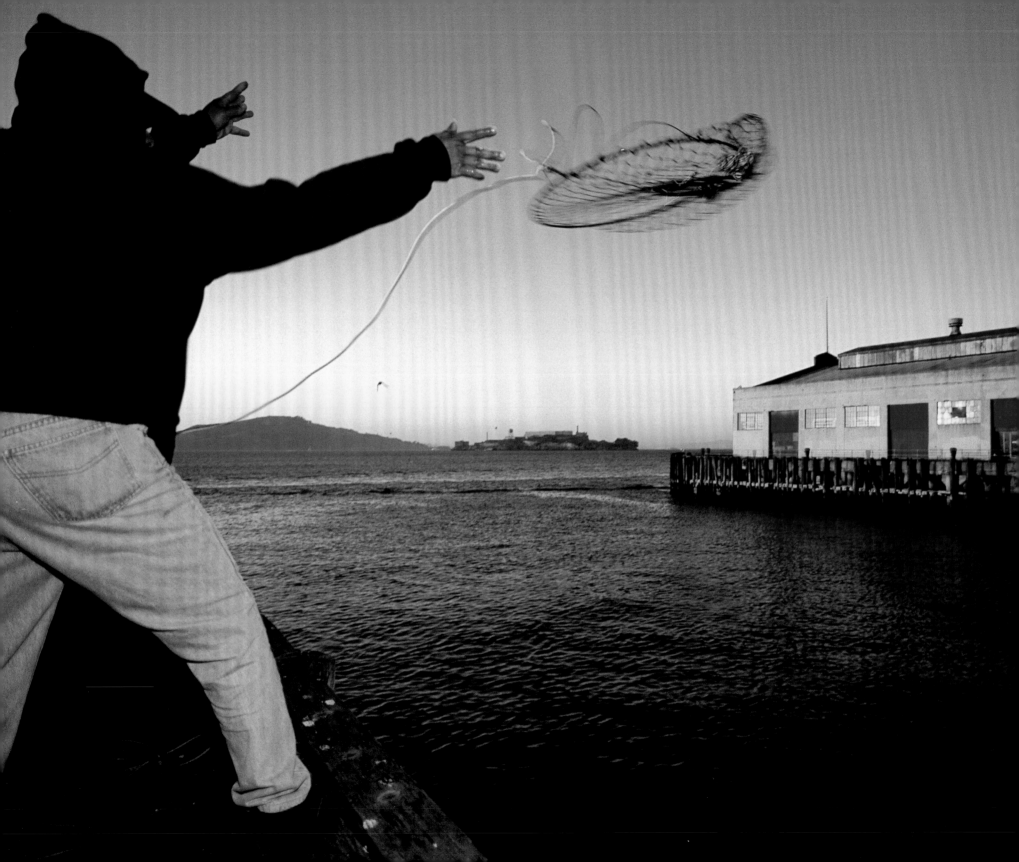

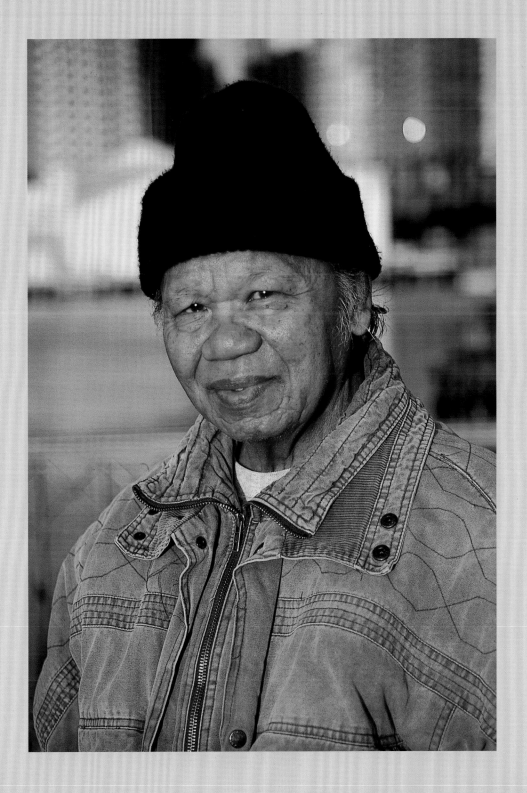

OPPOSITE: *Crab fisherman casting his trap at Fort Mason in San Francisco.* RIGHT: *Fisherman at Pier 7 in San Francisco. Many Asian Americans and Asian immigrants fish the bay for food as well as recreation.*

A Grain of Salt

The color changes," our helicopter pilot observes, "with the position of the clouds." We are looking down from a little over a hundred feet at the most striking landscape along the rim of San Francisco Bay. It is not some natural marsh or mudflat, not even some rare rugged shore. It is the honeycomb of straight-sided, dike-delineated ponds that wraps around the southern half of the South Bay from Union City on the east shore to Redwood City on the west. These ponds are in effect a factory making salt from bay water. They are the latest face of an old industry that has transformed, and to some extent preserved, one of the richest reaches of the San Francisco Estuary's shores.

With little freshwater input and a narrow northern opening, the South Bay was always the saltiest part of the estuary. Even in aboriginal times, hypersaline pans formed all along the inland border of the marshes. Filled only on very high tides and emptied only by evaporation, these "hot ponds," or "salars," could accumulate as much as eight inches of crystalline salt. Most pans were small, but one, just north of the eastern approaches of the present Hayward–San Mateo Bridge, covered a square mile. For the local Tuibun and Yrgin Indians, the salt was a valuable stock-in-trade; they visited the salars annually to scrape it up and also harvested it by picking the stems of a plant called, naturally, salt grass.

In the Spanish mission period, the Indians continued to gather salt but now turned it over to the centralized economy of the missions. In 1827, American explorer Jedediah Smith reported: "From the S.E. extremity of the Bay extends a considerable Salt Marsh from which great quantities of salt are annually collected and the quantity might perhaps be much increased."

Under the Americans, of course, it was. John Johnson, a roving seaman washed up on the docks of San Francisco, started the first commercial salt collecting operation at the great Hayward pond in 1854. Business exploded when the Comstock silver lode was opened in Nevada in 1859. Salt, essential to the silver refining process, went over the mountains by horse-drawn wagon and briefly even by camel. Competitors entered the field. By 1868, seventeen small operations had spread along the eastern shores of the South Bay, producing seventeen thousand tons per year.

The typical family salt farm was just a couple of hundred acres. The basic unit was a three-pond system. An outer, or intake, pond started the process of concentration. A

Salt evaporation ponds in South San Francisco Bay, colored pink by halophilic bacteria.

middle, or "pickle," pond continued it until the water turned pink with salt-tolerant bacteria. Human taste buds would determine when the brine was ready to go to the third pool, the crystallizer proper, where it would be evaporated until only solid sodium chloride and a liquid called bittern—an oily solution of multiple residual chemicals—remained. Chinese labor, here as elsewhere, built the first levees. Windmills powered the pumps that moved water between ponds.

These crude early methods produced a salt contaminated with traces of the bittern and not considered of table quality. Those who could afford it used English salt from Liverpool, brought over as ballast on ships that would return to Britain with loads of California wheat.

Toward the end of the nineteenth century, though, local operations became more sophisticated. They also consolidated. In 1901, the Leslie Salt Refining Company started its operation near San Mateo. By 1936, Leslie had absorbed all the other companies. By 1961, it was the largest solar salt operation in the country, with forty-seven square miles of ponds and an annual production of one million tons. In 1979, Leslie was purchased by Cargill, an agricultural conglomerate headquartered in Minneapolis, but the Leslie name remains as a brand.

In the modern layout, salt making is a five-year process. The water enters the first pond at a salinity of about 25 parts per thousand. In several intermediate ponds, it reaches about 250 parts per thousand and becomes red, saturated "pickle." Finally it arrives at crystallization beds, where the bittern is pumped off and a floor of sodium chloride precipitates. Six gallons of original bay water yields one pound of salt.

A crystallizer pond in October is an unearthly scene. Little harvesters scrape the dead-flat, bright-white surface and deposit bladefuls of salt into trucks. The product at this stage looks something like brown sugar. Crystals, some of them large enough to take home for gems, crunch under your rubber-booted feet. A thin pink sauce, the remnants of the bittern, forms pools here and there. Your eyes sting and your fingers, rubbed together, feel slick and soapy. "It's a fairly corrosive environment out here," says a guide. I believe her. In the distance, stored salt rises in white dunes. Ski scenes in movies have been filmed on these.

The conversion of marshes to salt ponds remade the margins of the South Bay. Ponds replaced 80 percent of the former broad marshy borderland; some thin strips of new marsh that formed on the outside margins of levees only slightly softened the loss. Species that depended on the marshes were correspondingly reduced, and the waters of this estuary arm lost one input of nutrients, detritus from marsh plants.

There were some compensations, however. Except for the saltiest, the artificial ponds did and do have habitat value in themselves. Ponds of low salinity attract about a quarter of the estuary's total waterfowl. Ponds of moderate salinity, resembling salt lakes in the desert, produce peculiar foodstuffs: brine shrimp, water boatmen, and various brine or alkali flies. These attract some forty species of birds, many of them otherwise rare in the region, including the eared grebe, the American avocet, the black-necked stilt, the Wilson's phalarope, and the white pelican. The western snowy plover nests in colonies on inaccessible dikes. Perhaps most importantly, in the days before anyone thought of outlawing bay fill, salt making was a way of earning money from the baylands; it thus reduced the temptation to sell the real estate off for urban development.

However altered, these bay margins at least remained wetlands of a sort; and when attention began to be paid to the values of such soggy places, they were still there to be argued over.

In 1965, Florence LaRiviere, a wetlands activist in Palo Alto, saw a small news item in the *San Jose Mercury News*. "It said, if you're worried about what's happening to the bay's wetlands, come to a meeting next Monday at 10 o'clock." The host was Arthur Ogilvie, a planner on the Santa Clara County staff. "And he had picked up a little paper about how you too can have a wildlife refuge established if you have duck stamp money. And he said, Hey, we'll get duck stamp money, and we'll have a refuge here. Of course it wasn't as simple as that."

Indeed it wasn't. As Ogilvie and the citizens he rallied began pushing the idea of a national wildlife refuge, they found little interest from the authorities. In fact, the authority that seemed the obvious sponsor—the U.S. Fish and Wildlife Service—shied away from the idea. The service at that time had small appetite for managing land near cities, and it feared the probable expense. Such sources as duck stamps—special fees levied on hunters and earmarked for conservation—really didn't begin to cover land acquisition on the required scale.

Nevertheless the advocates persevered. They got the ear of local congressman Don Edwards, who in 1968 introduced a bill to establish a San Francisco Bay National Wildlife Refuge. It did not pass, and kept on not passing; but Edwards kept on introducing it, and each time it progressed a little further. Meanwhile the advocates were preaching to every available audience the odd new gospel about the importance of wetlands.

Nineteen seventy-two was a good year for San Francisco Bay. The Clean Water Act, the key to cleaning up the rampant pollution problem, was enacted. In the Central Bay, a new national park was created, based on old military lands and called the Golden Gate National Recreation Area. And Don Edwards's bill establishing the first urban national wildlife refuge in the country's history was signed into law by President Richard Nixon.

The initial boundaries of the San Francisco Bay National Wildlife Refuge included thirty-six square miles, of which over half were Cargill's salt ponds. Under a deal struck in 1977, the federal government purchased the salt pond acreage outright, but salt making could continue as long as the company desired, and in exactly the fashion the company desired. This stipulation has caused some tensions ever since.

The national wildlife refuge was nonetheless a great achievement. It brought into being a block of protected wetlands along the western bayshore between the Hayward–San Mateo and Dumbarton Bridges, and a longer and deeper strip along the eastern shore from the Alameda Creek channel to Alviso. The refuge protected the two big intact marshes in the region—Greco Island on the western shore and Dumbarton Marsh on the eastern. In the Coyote Hills at Newark, overlooking the Dumbarton Marsh and also the major Cargill plant, a handsome headquarters building went up on a site once slated for luxury homes.

The presence of the refuge drew a lot of new attention to the values of the South Bay wetlands, natural and artificial, and the creatures that lived there. It was at this time that biologists began to understand the usefulness of some of the salt pond habitats. They also further defined the plight of the species that lived in the few remaining natural marshes. The California clapper rail—a plump, secretive bird that had once appeared on San Francisco menus—barely clung to existence in this corner of the estuary. Its most famous companion in danger was the southern subspecies of the salt marsh harvest mouse.

Knowledge did not bring reassurance. Refuge or no refuge, too many species were still in decline. Birders and duck hunters alike saw the objects of their interest diminishing. Meanwhile development was still chipping away at unprotected wetlands, including peripheral parcels sold off by Cargill. It was more and more apparent that the refuge was a promise half fulfilled.

After their initial victory, the refuge backers had dispersed into local organizations, each seeking to protect some particular section of the shore—and often losing. In the middle 1980s, the coalition reformed as the Citizens' Committee to Complete the Refuge. The committee floated a plan to bring all the remaining undeveloped, unprotected baylands around the South Bay into the boundaries of the reserve. Again Don Edwards carried the bill. Again the Fish and Wildlife Service had doubts, but this time the debate was not, in fact, a long one. In 1988, the boundaries of the wildlife refuge were expanded to enwrap both shores of the South Bay south of the Hayward–San Mateo Bridge, enclosing a total of sixty-seven square miles. Among other ownerships, it now included virtually every acre of Cargill salt operations in the region. Though the act of drawing that boundary did not in itself change the ownership of the lands or limit their possible use, it established a sort of hovering claim.

Rail track section used in winter salt harvest.
Trucks have since replaced the traditional rail cars.

A part of that claim was made good in 1997, when the Citizens' Committee and local Audubon chapters persuaded a Japanese corporation to drop development plans for Bair Island at Redwood City (former salt ponds sold off years before). The three parts of Bair Island—Inner, Middle, and Outer—now belong to the U.S. Fish and Wildlife Service or to the state.

Then, in 1999, the San Francisco Bay Area Wetlands Ecosystems Goals Project issued its great charter, the *Baylands Ecosystem Habitat Goals* report. This roadmap for renewal called for some thirty square miles of marshes to be restored in the South Bay. Cargill, which either owned or had permanent operating rights on most of the potential South Bay restoration sites, was the only private landowner mentioned in the report by name. The company wavered between seeing this as a threat or as an opportunity. In the end, it decided on the latter.

In 2000, Cargill announced a plan to shrink its South Bay salt pond empire. By making its processes more efficient and intensive, the company calculated, it could produce just as much salt, of higher quality, on about a third of the acreage it then owned. The balance of its holdings Cargill offered to sell—if possible, to government agencies for wetland restoration. In 2002, the deal was struck. Cargill received $100 million, mostly from state and foundation sources, in return for some twenty-six square miles of ponds. The company retained operating rights on a compact twelve-mile strip north and south of its Newark headquarters, outboard of the Coyote Hills. It also held on to some eminently developable outlying properties. With this grand acquisition, the refuge—it is now officially the Don Edwards San Francisco Bay National Wildlife Refuge—might be said to be four-fifths complete.

While local conservationists continue to fight for the last fifth, attention turns to the complexities of restoration. The challenge can be judged by a similar case on San Pablo Bay. In 1994, Cargill sold fifteen square miles of former salt ponds in the Napa-Sonoma Marshes to the land-rich and cash-poor California Department of Fish and Game; how to manage them proved a puzzle. To restore a very salty pond, you can't simply break a dike; the resulting flush of salt into the bay would kill fish and break multiple laws. You also can't stop pumping and let the ponds dry up; this would create a problem of blowing toxic dust and break a different set of laws. Stumped, the state kept sending water from San Pablo Bay through the system, essentially making salt without a customer and adding to the ultimate disposal problem. Now a solution is in sight. Under a plan advocated by North Bay sanitary agencies, highly treated water from local sewage treatment plants will be pumped backwards through the system, gradually picking up the salt and bittern and carrying them into the bay at a manageable rate: a sort of salt making in reverse.

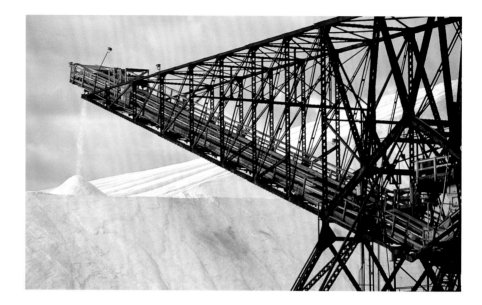

Restoration in the South Bay poses problems, too, notably in the area around Alviso, where the land has deeply subsided owing to groundwater pumping in the Santa Clara Valley. But in general the job should go somewhat more smoothly at this end of the bay. For one thing, Cargill will keep its existing operations going, maintaining the status quo while the refuge managers work out definitive plans.

And sometimes restoration is truly just a matter of breaking levees and getting out of the way. Take the handsome marsh you drive past as you near the wildlife refuge headquarters at the Coyote Hills. It started out as Tract 102, a dry, glistening flat that had been a crystallizer bed, the most inhospitable environment imaginable. The first refuge staff dug a channel reconnecting the area to Newark Slough, which lies on the other side of the refuge access road; but they were tentative about it, using skinny culverts and gates that muted tidal flow. No marsh plants reappeared. In 1986, a new manager, Rick Coleman, decided to open things up. He removed the gates and culverts, widened the gap under the road, and let the tides move freely. In the space of a couple of years, cordgrass and then pickleweed appeared and blanketed the field. In 1997, the former industrial site was renamed the LaRiviere Marsh, in honor of the Palo Alto conservationists Florence and Philip LaRiviere. It is one of the best clapper rail habitats around.

ABOVE: *Salt mountain at Cargill's Newark plant. Salt is piled awaiting cleaning, processing, packaging, and shipment.* OPPOSITE: *Salt ready for harvest. It has been five years passing from pond to pond, and months in the final crystallizer beds.*

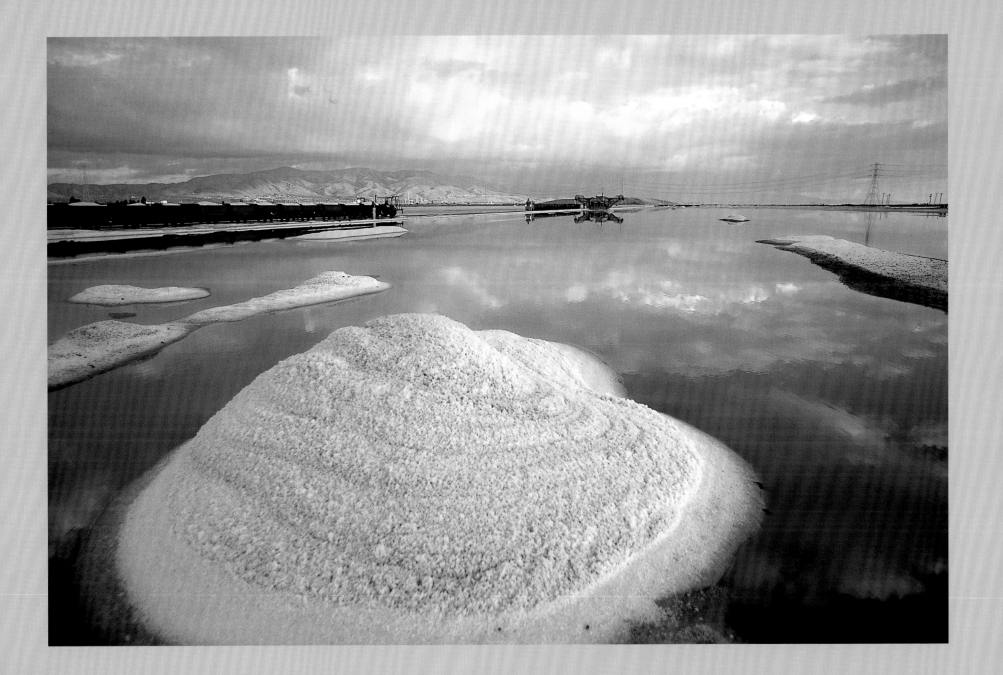

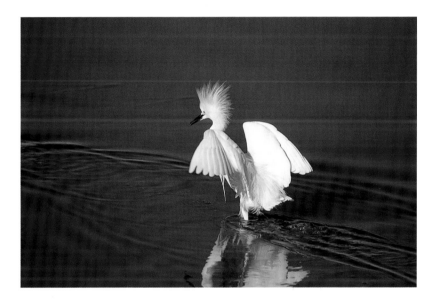

LEFT: *Salt pond in the Don Edwards National Wildlife Refuge before dawn. These quiet-water habitats are important to many birds.* ABOVE: *Snowy egret.*

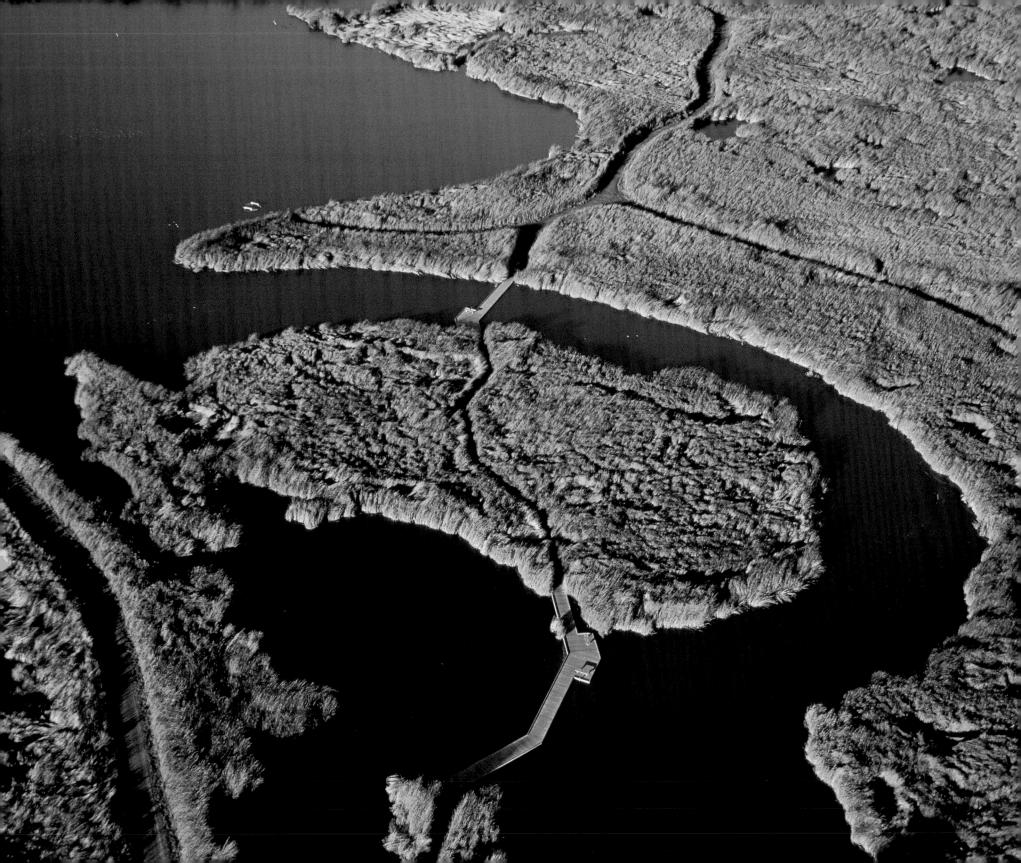

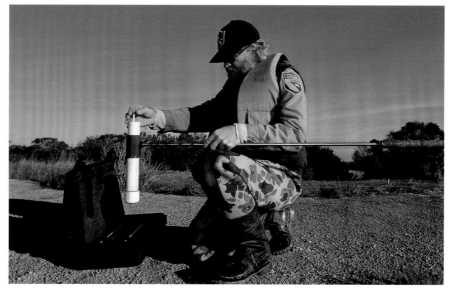

OPPOSITE: *Natural wetlands, like this freshwater marsh in Coyote Hills Regional Park, are rare in the South Bay.* TOP: *Pond 7A in the Napa-Sonoma Marshes on San Pablo Bay. Once used in salt production, it is now a lifeless salt trap—and a habitat restoration challenge for the California Department of Fish and Game.* BOTTOM: *The department's Tom Huffman takes a water sample to check salinity.*

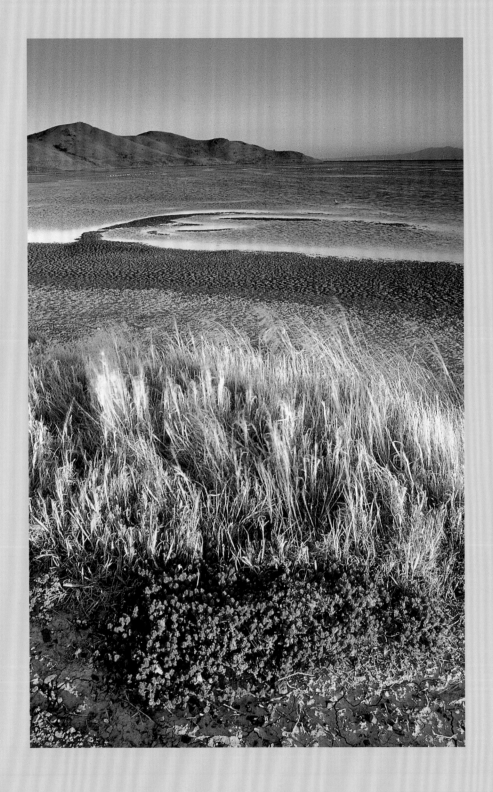

LEFT: *Grasses and pickleweed on a South Bay salt pond levee.*
OPPOSITE: *Pickleweed in the San Pablo Bay National Wildlife Refuge. This marsh plant stores excess salt in the tips of its stems, which turn red in the autumn before falling off.*

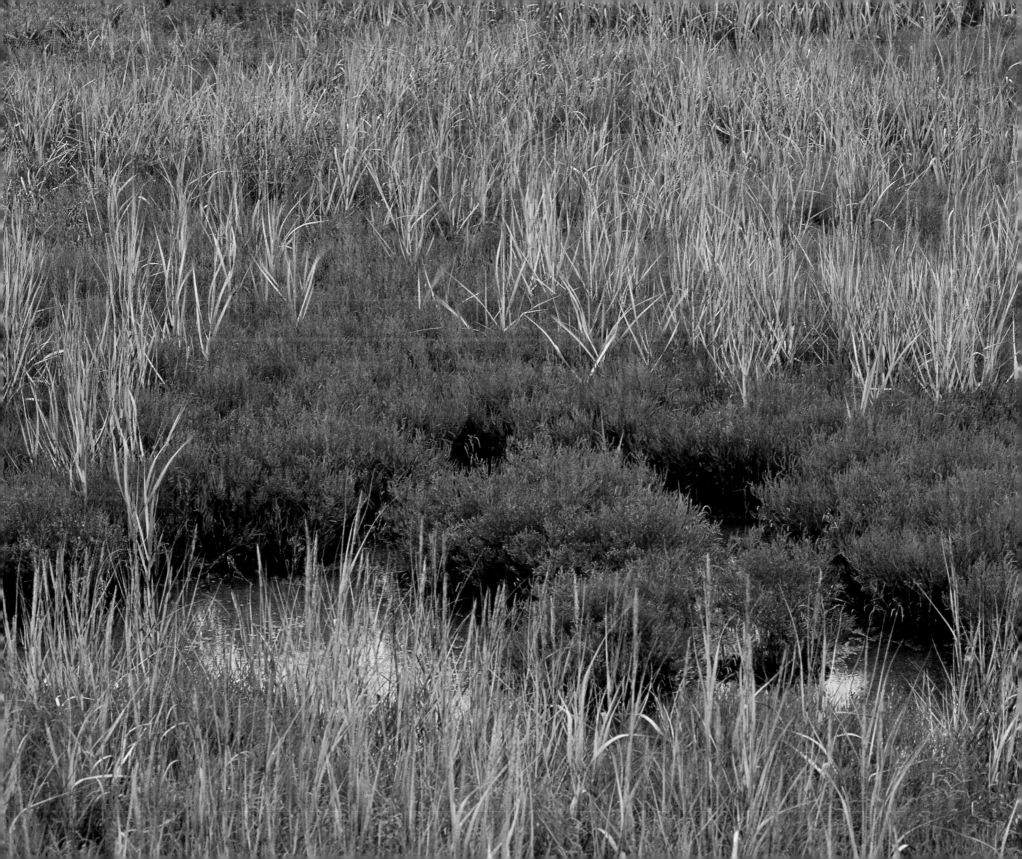

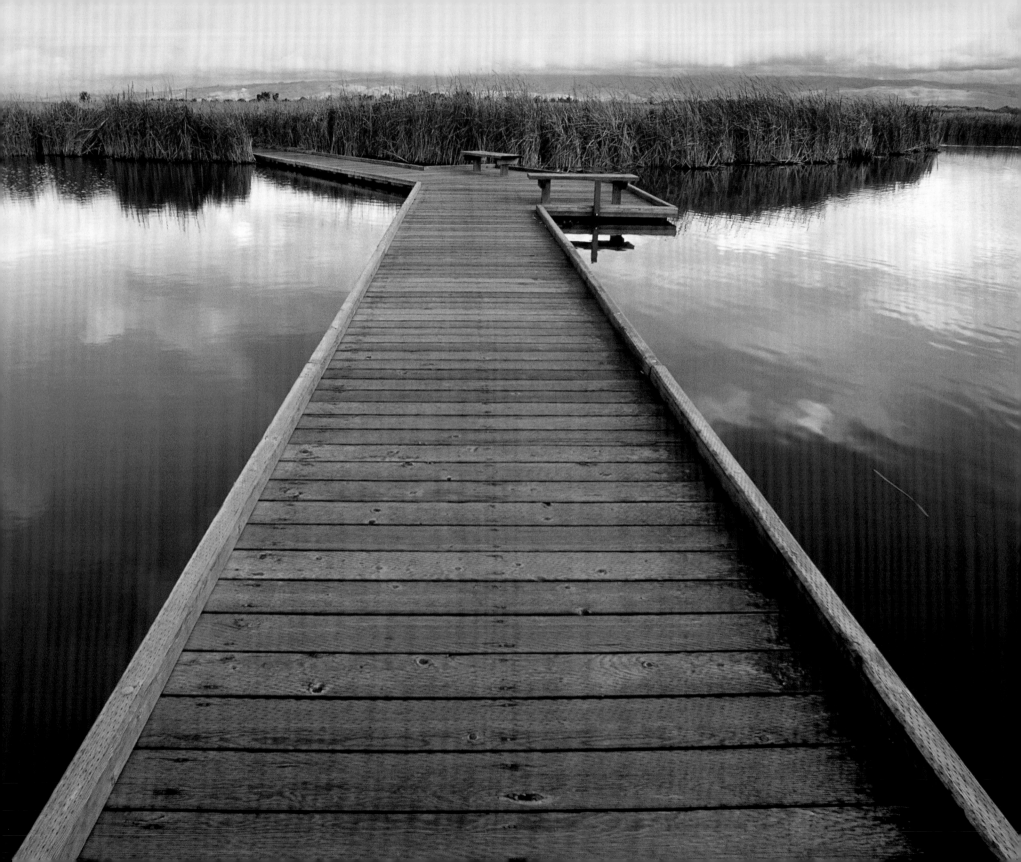

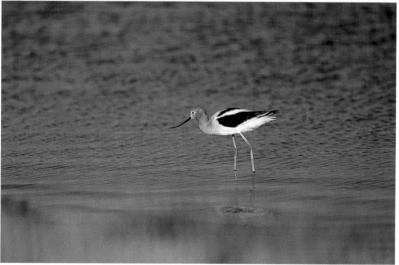

OPPOSITE: *Interpretive boardwalk through the marsh at Coyote Hills Regional Park.* ABOVE: *Florence and Philip LaRiviere, wetland activists, in the Palo Alto Baylands.* RIGHT: *American avocet searching for food in salt pond shallows.*

The Industrial Shore

Two legal white crystalline substances are processed on the shores of San Francisco Bay. One, as we have seen, is salt, derived from the waters of the bay itself. The other is sugar, brought here in raw form by sea and refined at a plant in the village of Crockett, at the western entrance to the Carquinez Strait. The California and Hawaiian Company refinery is one of oldest factories standing on the shores of the San Francisco Estuary. It may be (so the claim) the largest sugar processing operation in the world.

The nine-story brick pile seems to belong to another place—New England perhaps—and to another era. Its foundations were laid in 1881 by one Abraham Starr. Starr wasn't thinking about sugar but about yet another white substance, flour. California's second great crop, after gold, was wheat, and the 1880s were its glory years. Wheat was planted up and down the state, in the Central Valley, around Mount Diablo, on the Montezuma Hills east of Suisun Bay. By boxcar and barge and horse-drawn freight wagon it flowed toward the Carquinez Strait, the nearest convenient deep water. Both shores of the Carquinez, from Vallejo to Benicia and from Crockett to Port Costa, were lined with wooden piers. Great wind-powered cargo ships called barkantines took the grain out the Golden Gate and around Cape Horn to Europe, mostly to the English port of Liverpool, a journey of fourteen thousand miles. California's rich and durable wheat, hardened by summer drought, could both survive the trip and pay for it. In some of the wheat boom years the strait shipped more tons of cargo than San Francisco, the mother port.

What went by ship was at first the raw grain, but local entrepreneurs saw more profit in the export of locally milled flour. In 1880, the world's biggest flour mill opened across the water in Vallejo; it is the Betty Crocker products factory now. Starr's mill at Crockett was to be even bigger.

Construction went slowly, however, and the mill was barely open when the financial panic of 1893 shut it down again and signaled the fading of the wheat economy. The building's next owner was George McNear, a busy North Bay investor who retooled it to make sugar from beets. He tried to get a local beet agriculture going, but it didn't take; the local hills were ill suited to the new crop. At about this time, Hawaiian

Carquinez Strait from the hills above Port Costa.
Steam rises from an oil refinery in Martinez.

Island sugar growers were looking for a mainland beachhead to process and distribute their cane. In 1906, they became the owners of Starr's old mill.

Mill workers lived in the villages of Crockett and Valona, founded in the same year as the mill. Under C&H, the dual community continued as a virtual company town. The company collected the garbage, ran the library, maintained the landscaping. It built a swimming pool and a men's club and a landmark hotel. In Crockett proper, which it literally owned, the company sold lots to homebuilders, often also financing the sales. This benign grip has loosened over the years, but even today the company is much more than a business that just happens to be in town.

The processing of cane uses a lot of water, about three million gallons a day in the inefficient early years. The water in the Carquinez was fresher at the turn of the last century, and at times the plant could draw directly from the strait. At other times, however, and increasingly as the years went on, the company had to go far afield. It bought water from wells in nearby Port Costa; from wells on farmland near Napa, north of the strait; even from the Marin Municipal Water District, which built a "water pier" for the company's tanker barges. (This pier is now the dock of the Marin Rod and Gun Club at the western root of the Richmond–San Rafael Bridge.) But mostly the water came from upriver. C&H barges went up through Suisun Bay to the Sacramento and San Joaquin Rivers, sampling until they reached water fresh enough to use. The distances they traveled were recorded, and they provide the first good data on the changing balances of fresh and salt in the upper San Francisco Estuary. The record ends in 1937, when the refinery got municipal water.

If not always fresh enough for use in manufacturing, Carquinez Strait water was fresh enough to discourage pest species that attack and foul wooden ships in salty harbors. It was for that reason that the first naval shipyard on the West Coast had been sited on Mare Island, across the water from Crockett. But things changed in 1913, when the teredo, or shipworm, arrived at Mare. This creature—actually a clam that uses its two shells as tools to burrow into wood—could tolerate much fresher water than could its native Pacific cousins. As many exotic species do, it exploded in numbers soon after its arrival and announced its presence with a loud crumbling noise. In 1920, the wharves, ferry slips, and pile-supported warehouses all along the strait began collapsing into the water. The C&H docks, having just been put on concrete pilings, were spared; but the

teredo made its way into the factory itself, in salt water used for cooling, and started tunneling into redwood storage tanks. "Destroying teredo climbing upstairs," the local paper headlined. Then the shipworm faded somewhat, but became a permanent part of an altered ecosystem.

In the 1930s, the Carquinez Strait was a center of labor unrest. Unions of long-shoremen, warehousemen, and sugar workers battled the bosses and one another. After a successful coastwide strike in 1934, Harry Bridges, the famous San Francisco labor leader, led the International Longshore and Warehouse Union on a "March Inland" to organize workers along the Carquinez docks. C&H was the first stop and, after several years of struggle, the first union victory. The cozy identity of company and town seems to have waned after that.

The C&H refinery is just the quaintest landmark in a band of heavy waterside indus-try—running from Richmond north and east to Antioch at the entrance to the Sacra-mento–San Joaquin River Delta—that some have compared to Germany's Ruhr river valley. What drew firms here initially was the deep and tidally active water, good for transportation, waste disposal, and cooling. What kept industries coming was natural linkages—a chemical plant can get some of its raw materials from an oil refinery next door—and also precedent. It is easier to site something odorous or hazardous (and the pioneer operations were unabashedly both) next door to something else odorous or hazardous. A kind of informal regional zoning has resulted, with this stretch the desig-nated Factory Row, producing the things that everybody uses—but that most people want to see made "somewhere else." "Somewhere else" is here.

There are now five oil refineries in the strip, whose names and corporate affilia-tions change frequently. By far the biggest, there since 1901, is the sprawling Chevron refinery in Richmond. The oldest, founded in 1896, is the smallish plant in Rodeo near Crockett. Martinez, at the east end of Carquinez Strait, has a pair of refineries. The last of the five is on the north shore in Benicia.

East of Martinez toward the delta lies the veritable capital of heavy industry, Pittsburg. The place once thought of calling itself New York on the Pacific but adopted instead, sans *H,* the name of the Pennsylvania steel town. Sure enough, here is the former United States Steel (now Posco), the largest foundry in the region, whose output built the San Francisco–Oakland Bay Bridge. Next door is Dow Chemical, producer of a host of basic products familiar and not, the largest plant of its kind in the west.

Industry, of course, makes waste of various kinds, requiring disposal in air, land, or water. Most factories around the bay now pour their liquid effluent into community sewer collection systems, treatment plants, and outfalls. The refineries and Dow Chemical

are different; they treat and discharge their own specialized wastes. (In Crockett, as usual, there is a twist. Here C&H Sugar functions as a sanitary district, treating the liquid waste of the whole community as well as its own.) Such well-defined "point sources" are fairly easy targets for pollution control. Under the scrutiny of the San Francisco Bay Regional Water Quality Control Board and citizen watchdog groups, the industrial water pollution load has been very substantially cut since 1972.

The Contra Costa shore is also a zone of power plants. Between them, Pittsburg and Antioch have the most imposing cluster of such stations in the entire state. These plants burn natural gas, and the older ones make lavish use of another resource: the water of Suisun Bay, which they suck in to absorb waste heat; it returns to the estuary warmed by several degrees. The two biggest plants each take a billion gallons per day. Living things in the cooling water die. The larger ecological effects are unclear, but in any case this "once-through" cooling method is considered primitive, and its phasing out is long overdue.

The challenge is constantly, expensively renewed along the industrial shore: to use the resource, but not to use it up; to take advantage of the so convenient waters, but to pollute them or impair them less and less as the decades pass, not more and more.

ABOVE: *California and Hawaiian Company sugar factory in Crockett.*
OPPOSITE: *Power transmission lines in the Palo Alto Baylands.* OVERLEAF: *Wind turbines on the Montezuma Hills east of Suisun Bay. Especially when the inland regions are hot, strong winds flow eastward through the lowland filled by the San Francisco Estuary.*

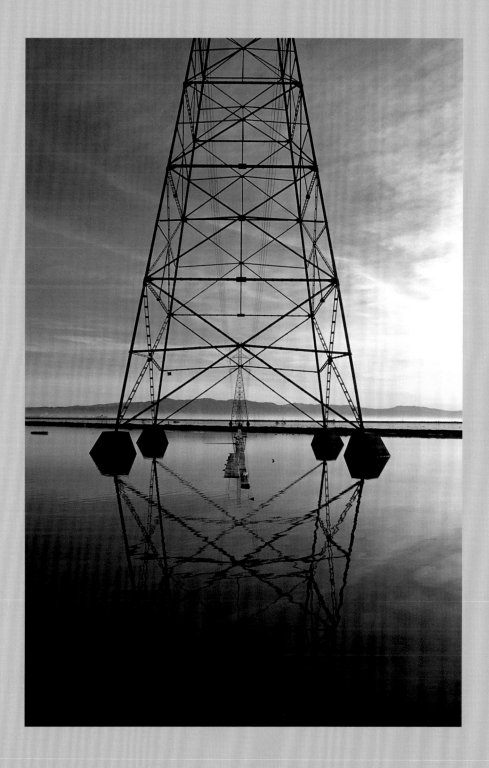

Hunters Point

As late as 2002 the former navy shipyard at Hunters Point in San Francisco was a kind of ghost town, half romantic, half forbidding. The glass was gone from the windows of the Golden Anchor Coffee Shop. The great crane at the south pier—war booty from Hitler's Germany—stood quiet. The world-class dry dock was a vertiginous pit. Approaching the old base on a shoreline walk from points north, you would come to a ferocious fence, topped with razor wire and extending far out into the water to discourage waders. On it were warnings in five languages: "Caution No Trespassing. Multiple environmental and health hazards are present. Do not eat fish or shellfish taken from this area." Just beyond it, out of reach, lay one of the loveliest pocket beaches to be found on the shores of the San Francisco Estuary.

Bright potential, thorny problems, detritus of past uses and mistakes: these come together at many places around San Francisco Bay, but nowhere more than at Hunters Point.

The natural Hunters Point, a wooded peninsula cut off from the north by a deep salient of marshland, was a rather isolated place. When the Spanish came to the region from the south, their highway, El Camino Real, avoided this part of the bay's shore, running west around San Bruno Mountain almost to the sea before cutting back east to Mission Dolores and the Presidio at San Francisco. In the late 1800s, Hunters Point was the site of one of the numerous bayside camps where Chinese fishermen caught grass shrimp for drying and shipment back to Asia. After the 1906 earthquake and fire, there was even a proposal to exile San Francisco's urban Chinese to this still seemingly distant corner of the city.

But if it was metaphorically a backwater, Hunters Point could never be one in fact, because it had splendid access to deep bay channels. In 1867, the first permanent dry dock on the entire West Coast was built here. Because the peninsula was made of a good, solid granite, the dock could be graven—that is, dug out of living rock. By contrast, the one at Mare Island (the second oldest surviving dry dock on the Pacific Coast) had to be excavated from bay mud and lined with imported stone. Hunters Point Dry Dock 4 is still among the largest graven dry docks in the world.

In 1910, Bethlehem Steel bought the dock and the port complex that had grown up around it. In 1937, the navy in turn acquired this property. In 1941, eleven days before Pearl

Dry Dock #4 at the former Hunters Point Naval Shipyard, the oldest permanent dry dock on the Pacific Coast and one of the largest of its kind in the world. The German-built crane in the background can lift 880 tons.

Harbor, the government expropriated the surrounding neighborhood, giving the inhabitants two weeks to leave. During World War II, Hunters Point was a major naval shipyard and repair facility; in 1945, eighteen thousand people, mostly civilian, worked on the base.

Among those thousands was a very large percentage of black Americans, for a sad and simple reason: in Jim Crow America, young black men were not drafted into the military; thus they were the largest male labor force available. Like other northern industries, Hunters Point actively recruited these workers from the South.

This history set the modern character not only of Hunters Point but of a wide slice of southern San Francisco and northern San Mateo County. From Hunters Point nearly to the ocean shore, all through the lowlands north of the long bulk of San Bruno Mountain, lies a solid band of majority nonwhite neighborhoods, which are also relatively poor.

The case of Hunters Point was not unique. The same effect is seen near the huge Kaiser shipyards in Richmond, and on a smaller scale near the former Marinship yards in Sausalito, north of the Golden Gate.

Grubby but needed facilities and industries, history shows us, tend to be put in two kinds of places: those where people are few, and those where people are poor. The southeast corner of San Francisco had begun attracting polluters on the first count and continued to attract them on the second. The city's sewer system has its major outfall here. There are two big power plants within the city limits; both are here. When additional plants are proposed, it is inevitably here. The city's dirtiest small industries are crammed into this corner.

Partly in spite of and partly because of these things, there was a gritty vitality about this part of the bayshore—as long as Hunters Point itself was a going operation. Employment fell off after World War II, reached a trough in the early 1960s, and rebounded during the Vietnam War. Then a second and definitive decline began. Navy operations stopped in 1974. The unemployment rate in the community instantly rose above 20 percent and stayed there.

In the 1980s, President Ronald Reagan proposed to home-port the historic World War II battleship *Missouri* and its attendant ships at Hunters Point. Local opinion was very much divided. Some people welcomed the plan; the many private businesses that had meanwhile been renting space on the base rallied against being displaced. It was "outsiders," organized as the Coalition for a Safe Bay, that tipped the balance against the *Missouri*. But they got little thanks, even from neighborhood people who agreed with them. A man named Saul Bloom, who worked on this campaign, vividly recalls the reaction: "You environmentalists," he heard, "put through your agenda and *leave*."

To Bloom the accusation rang all too true. He made a conscious and rather difficult decision not to leave: to work as hard for the proper redevelopment and revitalization of Hunters Point as he had worked to ease the military out of it. As the founder of an organization called Arc Ecology, he began watchdogging the transition process that he had helped to begin.

In the organization's modest Market Street office, Bloom waves at about fifty feet of heavy-duty shelving, lined with environmental impact statements, scientific reports, and all the hefty paraphernalia of a long legal and regulatory campaign. "That's Hunters Point," he says.

Indeed the road from stopping the *Missouri* to renovating Hunters Point has proved a long and bumpy one. The base was formally closed in 1993 and slated for transfer to the city of San Francisco once cleanup was completed. That was the first rub. If all former military bases are polluted, Hunters Point may just be the most polluted of them all.

The legacy is partly radioactive. Nuclear-powered ships and submarines were serviced in Dry Dock 4, and vessels deliberately exposed to bomb test radiation in the Pacific were brought here to test decontamination methods. Though the worst of the resulting waste was taken out the Golden Gate and sunk near the Farallon Islands (another story), some traces remain on the base. The "hottest" sort of debris appears to be instrument dials taken off ships, coated with luminous radium paint.

The bulk of the contamination was less sensational—but not a bit easier to clean up after. It was a potpourri of contaminants, insults, and major and minor poisons, accumulated over the decades. Nobody's obvious fault. The result of people following rules and people cutting corners. People doing what everybody did.

There was a bay fill and garbage dump where everything conceivable was dumped, undocumented. In 2000 it caught fire from the methane it generated, and it smoldered for weeks.

There were dozens of storage tanks, buried and aboveground, once full of the most varied chemicals, uniformly prone to leak.

There was an unlined pit where old oil was poured for a primitive kind of recycling: contaminant particles settled out to the bottom, and the cleaner fluid at the top was skimmed off for reuse.

There was groundwater contaminated with solvents. There were soils and bay muds laden with toxics: copper and nickel; cadmium and chromium and thallium; manganese and lead; solvents and oils; polychlorinated biphenyls; and the potent biocide tributyltin, an antifouling agent used in marine paints.

There were also houses with asbestos in the walls and with lead paint on them (as in any suburb of the era), and gardens drenched with questionable herbicides and pesticides (as in any suburb today).

There was what there is in any polluted urban landscape, but much more so; what there is in any polluted military base, but more even than that.

Foreseeing that cleanup and redevelopment would take time, Bloom and his allies backed a plan to bridge the economic gap. They proposed firing up the point's existing industrial assets: the great graven dry dock, and the army of skilled men and women in the community, trained in all manner of shipyard work but now mostly unemployed. The idea: use the dry dock to dismantle some of the ships in the Suisun Bay mothball fleet. Bring them, one by one, down to Hunters Point for breaking, as the process is called. It seemed like a triple win. Middle-aged local workers would get serious, well-paid jobs and build nest eggs for retirement. Wasted and sometimes irreplaceable skills would be made use of. And the demolition would help clean up a growing environmental problem, the leakage of toxic materials from the deteriorating ghost fleet. If all the ships were "broken," Bloom estimated, the process would take about fifteen years, by which time the promised new industries would be developing.

The navy agreed, but the dream turned into something of a nightmare. Ship breaking is potentially very toxic work, and the successive firms the navy selected to take over the dry dock seemed incapable of doing a clean job. Spills and complaints multiplied, and Arc Ecology found itself joining the community in suing the very operation it had advocated. The interim solution was itself delayed. By the time these problems were brought under control, the idea of ship breaking at Hunters Point had become sensitive in the community, and precious time had been lost.

"Some people plan," futurist Alvin Toffler once remarked to a U.S. Senate committee. "Others are planned upon." The Hunters Point/Bayview community has a long history of being "planned upon." Homegrown leaders complain that their own ideas for reuse of the naval base have either been cold-shouldered by the navy and the city, or picked up and then dropped, unrealized. Even Arc Ecology, a valued ally, is an outside ally. Now a key local organization, Bayview–Hunters Point Community Advocates, is gearing up to offer its own fully developed vision for the former base. "We need to represent ourselves," says executive director Olin Webb.

Among other things, the advocates want local firms and labor to be hired for the continuing cleanup work. They urge that new industries and jobs be developed at the outset, not, as now appears likely, as a late step in the process. And they want to make

sure that housing on this scenic and temperate site—truly one favored by nature—remains at least partly affordable. In short, they seek to make sure that the redevelopment of Hunters Point will benefit the same people who have lived with it, in its toxic and ramshackle state, for generations.

Does the old dry dock, the historic heart of Hunters Point, have a place in this future? Something like Bloom's ship breaking plan may yet happen. In the long term, the dock could be the regional service point for really big vessels, the ones that lesser facilities cannot accommodate. The Bay Conservation and Development Commission calls for keeping the area in maritime use indefinitely. The dock might instead become a marina or an aquarium, but that seems rather a comedown for so splendid and so useful a hole.

PG&E's Hunters Point Power Plant, one of many pollution sources on this part of the San Francisco shoreline.

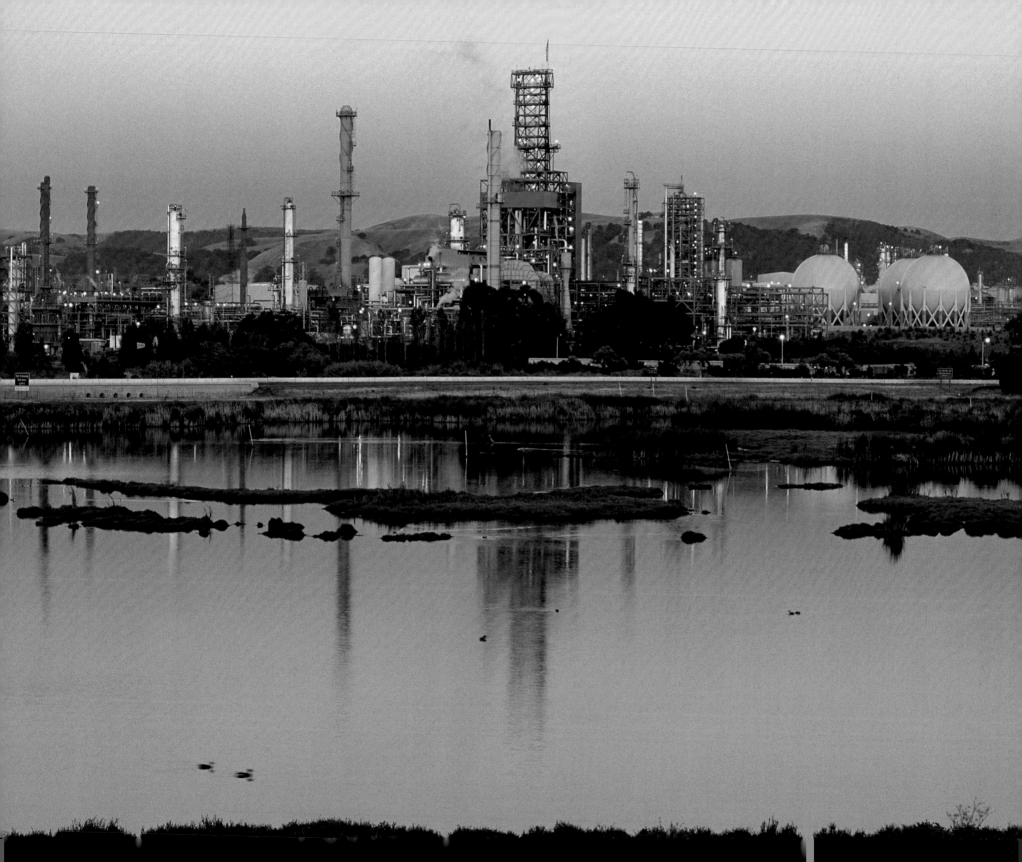

A glass containing half a cup of water, as everybody knows, can be thought of as partly full or as partly empty. So it is with pollution in the San Francisco Estuary. The same body of water is seen by some as troublingly dirty, and by others as encouragingly clean.

The verdict depends partly on what corner of the sprawling system you are dipping your sampler into. Some stretches are much cleaner than others. It also depends a bit on historical perspective. Look back at the progress made in pollution control since the 1970s, and you have to feel good. Look ahead at growing population and the ever-growing variety of polluting sources and substances, many of them covered by no law, and you find yourself taking a dimmer view. In the long run, the race between pollution and pollution control is just that, a race, and simply too close to call.

Bill Jennings, the man known as the DeltaKeeper, doesn't much like the odds, but he knows which side he's on.

Jennings is a citizen pollution watchdog for the Sacramento–San Joaquin Delta. His organization, also called DeltaKeeper, is part of a loose network of WaterKeepers groups that began on the Hudson River in the 1970s and has since spread nationwide. Seeking to buttress the efforts of government pollution controllers, the Keepers have two major tools: they sample, gathering more data from more places than the regular authorities can; and they sue. And sue. And sue. They take a positive pride in being adversarial, in pinning polluters down, in driving a lazy system to do its job.

We are spending a windy spring morning with Jennings on a DeltaKeeper sampling boat. We've paused in an unlikely location: a tidal lagoon, linked to the San Joaquin River, in the middle of the city of Stockton. Surrounded by lawns and public buildings, the lagoon is one of the city's charms. But when Jennings drops a sensor under the surface and reads off a screen, he shakes his bearded head. "We've got a major D-O depression here," he says. "D-O" means dissolved oxygen; fish and other organisms need it; the decay of organic matter depletes it. Low oxygen levels mean that too much

Uneasy neighbors in Martinez: McNabney Marsh (Waterbird Park) and the adjacent oil refinery. In 1988, an oil pipeline break badly polluted this marsh. The resulting fine money was used to acquire this and other habitats around the San Francisco Estuary. Full restoration at McNabney has proved difficult owing to physical barriers and old toxic waste.

organic stuff is getting into the water, producing what is called eutrophication. Eutrophication is not a widespread problem in the coastal parts of the San Francisco Estuary, but it does occur in these narrow inland reaches.

The delta, in general, has more than its share of the estuary's pollution headaches. Water from 40 percent of California converges on it, with all the contaminants picked up on the way: the yield of fields and orchards and animal feedlots, cities and industries, toxic dumps and poisonous mountain mines. "From Redding to Fresno," Jennings says, "the trash ends up here."

And having arrived here, it tends to stay for a while. In this tidal realm, waters move back and forth many times before they work their way west to the sea. Anything nasty you dump off your dock in the morning will probably float right back to you in the afternoon. And, unlike the wide bay reaches toward the Golden Gate, the delta in the dry season doesn't have the water volume to dilute the pollutants much.

We motor westward past industrial shores to the Port of Stockton. One of DeltaKeeper's major, and successful, campaigns has been to clean up these port operations. In the old days, Jennings tells us, all sorts of materials spilled into the channel here: wheat and sugar, whose decay in the water led to oxygen depletion; ammonia; sulfur; petrocoke, a solid petroleum product resembling coal; and more. Now the transfers are much cleaner. "They've made huge strides," he says. Still, the muds beneath the channel here are full of toxics, and people are warned not to eat even small portions of fish caught near the port. San Joaquin County has a large population of Southeast Asians—people accustomed to fishing for subsistence—and the warning is aimed especially at them.

Bill Jennings grew up on a farm in Tennessee, worked in the civil rights and peace movements in the 1960s, and then settled down to run a fly fishing shop in Stockton. The world's problems followed him there, however. A series of fish kills on the Mokelumne River, the result of acid drainage from an old mine, drew him back into action. With his gold-rimmed glasses, long white beard, and aromatic pipe, he radiates a sort of diehard benignity.

Jennings is reluctant to single out one kind of pollution as most worrisome—"It's a death of a thousand cuts"—but in this part of the world the spotlight has to shine on agriculture. The San Joaquin River in late summer consists almost entirely of used irrigation water. Common farm chemicals, flushed out of the fields in spring, regularly

produce "killing zones" in rivers and delta channels. Farm operations have long had an exemption from pollution control rules; as the result of WaterKeepers pressure, this gap in the system may soon be closed.

Specific toxic chemicals can be phased out of use, and many, going back to the pesticide DDT, have been. More fundamental is the problem of agricultural drainage. When arid regions are irrigated, one result is a buildup of salts in the soil; this salt must be removed somehow if intensive agriculture is to continue. In the original water development plans for the Central Valley, the two great aqueducts taking fresh water south from the delta were supposed to be balanced by a third channel taking salty irrigation waste back north. Along its course, the water would be spread to form wetlands, valuable, it was thought, for birds. This channel was called the San Luis Drain; one of the associated marshes was Kesterson National Wildlife Refuge. The system was partly built when the story broke in 1983 that birds at Kesterson—ducks, coots, stilts, grebes, and avocets—were dying and producing deformed young. At fault was the metal selenium, found naturally and harmlessly in Central Valley soils but toxic when dissolved by irrigation water. The drain project stopped dead, but the region is still struggling with the problems of salt buildup and selenium pollution.

To complicate matters, San Francisco Bay has become more vulnerable to selenium, because the newly arrived exotic Asian clam *Potamocorbula amurensis* concentrates the metal in its tissues and passes it up the food chain to the white sturgeon and other fish that eat the clam, and on to anything or anyone that eats the fish.

Continuing westward, we join the San Joaquin River proper and follow it briefly southeast, toward its headwaters. Shortly we reach the outfall of Stockton's sewage treatment plant. Jennings's group has forced the city to install the most advanced form of sewage treatment. The tide is in—seven hours later than its schedule at the Golden Gate—and the discharge isn't visible. Significantly, it isn't smellable, either.

We next explore a channel called Fourteenmile Slough. One bank of the channel now is sterile riprap of the kind we've been seeing for hours; but the other is complex and green. The levee here sits farther back, and a rich zone of willows and cottonwoods and tangled underbrush lies along the water. A little more of this, Jennings thinks, would do wonders for the delta. Not far from here, though not on our route today, is seminatural Disappointment Slough, a model of how it might be, and some of the best bird habitat around.

We pause at a cove choked with the succulent leaves and stems of *Egeria densa,* a pretty Brazilian plant often seen in aquariums. Escaped to the wild, it has become a first-class nuisance. *Egeria* roots in the mud and creates an undulating thicket up to twelve feet deep. Boaters hate it because it fouls their props. Water managers hate it because it plugs their intakes. Biologists dislike it because it monopolizes sunlight and creates environments useless for native fish, though not so bad for some exotic ones; if you breach a levee in hopes of restoring habitat, you are likely to get instead an *Egeria* pond. Bill Jennings, though, is wary of the herbicides used to control the plant, fearing cures that may be worse than the disease. The WaterKeepers have insisted that herbicide spraying be considered a form of pollution, subject to permit under the water quality laws.

"It's a complex equation," Bill Jennings acknowledges. "And we've got to solve it all."

As we putter back toward the DeltaKeeper headquarters on the Calaveras River, I find I still don't know whether the glass is half empty or half full, half dirty or half clean. Our human capacity to create problems—for ourselves and for just about everything else that lives—is awesome. So is our capacity to solve those problems, once our attention is engaged. Like some many-armed and many-minded Hindu deity, we destroy and create and repair all at once, in frantic competition with ourselves.

There is plenty of reason for pessimism, but I guess I sign up, with my fingers duly crossed, on the optimistic side.

ABOVE: *Water hyacinth in the Sacramento–San Joaquin Delta, one of several exotic nuisance plants that clog waterways and degrade habitat for native fishes.* OPPOSITE: *Bill Jennings, DeltaKeeper, measuring water quality in a channel in Stockton.*

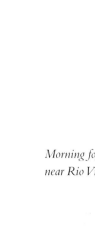

Morning fog along the Sacramento River near Rio Vista.

Along the Water Trails

O n the shoreline of Albany, opposite the Golden Gate, is a curious, expensive, emblematic mile of trail.

It is a paved path, almost invisible if you don't know where to look, squeezed between the thunderous lanes of the Interstate 580 freeway and the open water of a nook of San Francisco Bay known as the Albany Mudflats. The cove is flanked by peninsulas: north, Point Isabel; south, the Albany Bulb. Point Isabel was once a wooded island, long since leveled, joined to the mainland, and squared off with fill; the Bulb is entirely artificial. Both shores now belong to the Eastshore State Park, an eight-mile-long waterside strip preserved for public use by a long and stubborn citizens' campaign. The trail along the Albany Mudflats is an essential link in this shoreline band.

Essential, but not easily won; and its story says much about the future of recreation on San Francisco Bay.

In the 1960s, as we have seen, industry, defense, and commerce had first claim on the shores of the bay. The general public, by and large, had no claim at all. Even the bridges, with the blessed exception of the one at the Golden Gate, had no pedestrian or bicycle ways. And the water itself was, too often and in too many places, made unpleasant by urban effluents.

Even in those days, certainly, the San Francisco Estuary added immeasurable plea-sure to the region's life. You could see it from the hills; you could admire it from the deck of a waterside restaurant; you could boat on it, if you had a boat and a place to launch it, or an invitation from someone who did. What you couldn't do in many places at all was take a simple walk by the shore. Unstructured, unpaid-for access was a rare thing.

The changes wrought by the Save the Bay movement, the Bay Conservation and Development Commission, and large expenditures of public money have been aston-ishing. The amount of accessible shoreline has grown from four miles to over one hundred miles. The Don Edwards National Wildlife Refuge in the South Bay, the Golden Gate National Recreation Area in the Central Bay, and numerous state and regional parks have sprouted, enlivening the maps with green. The fences of former military bases are disappearing. Under Bay Commission rules, shoreline paths are a feature of virtually every new development that has bay frontage.

The Bay Trail at Marina Park in Emeryville.

These bits and pieces of access, however, rarely connect for long stretches, and some are barely used. Except in a few spots, they function as access points, not access corridors. Wouldn't it be nice, people began asking themselves in the 1980s, to be able to walk or cycle for long distances along the bay, around the bay, across the bay?

In 1987, the California legislature passed state senator Bill Lockyer's bill establishing, in concept, a San Francisco Bay Trail and instructing the Association of Bay Area Governments to get to work on planning it. (The association is a powerless but occasionally useful congress of the region's nine counties and one hundred incorporated cities.) The route that has now been mapped includes some four hundred miles of "spine" trail and several hundred miles more of feeders, spurs, and branches. Of the core four hundred miles, about one-third is usable at this writing; undoubtedly, at the reading, the open mileage will have grown.

The original Bay Trail advocates had a pretty simple vision. They imagined a bayside circuit: from the Golden Gate south to Alviso and north again to Crockett; across to Vallejo on a new and path-equipped Carquinez Bridge; and west and south along the northern shores of the estuary to the Golden Gate again. The Dumbarton Bridge, which also has been rebuilt with a path, would provide a cross link near the southern end.

This literal vision of a single, waterside Bay Trail is being realized in many places, mostly in urban zones where the shoreline is artificial, armored, and not far from buildings. The most splendid single segment is probably in the Golden Gate National Recreation Area in San Francisco, where a three-mile stroll takes you west from the historic ships and buildings at the Hyde Street Pier, past the mellow recreational cove called Aquatic Park, then along a section of unaltered sandstone shoreline at Fort Mason and a recently restored tidal lagoon at Crissy Field, and finally to Fort Point, at the foot of the Golden Gate Bridge.

Elsewhere the reality the planners face proves more complex. There are, of course, large areas of private land to be skirted or crossed by agreement. There are zones where ports, airports, and industries monopolize the immediate shoreline. There are bridges lacking pathways or bicycle lanes. Most significant is the problem of routing the trail in the regions of diked former marshlands: the salt ponds of the South Bay, and the varied wetlands north and west of San Pablo Bay. Here there is no simple shore, but a patchwork of islands and channels. Existing levee-top trails tend to be loops that come back to their starting points. Biologists and conservationists are skittish about allowing open access to bayland areas that are valuable for birds and other wildlife; in particular, they don't much want to see new bridges across sloughs, which would be necessary for any continuous nearshore trail in such regions.

The Bay Trail planners early concluded that the trail could not be what it sounds like: a continuous asphalt loop at the bay's edge. What is emerging is rather a webwork of routes, sometimes miles back from the current water's edge, sometimes following existing roads, and often splitting into alternates for people on bicycles and on foot. Sometimes the link is pretty notional, represented, for instance, by a bus that ferries bicycles across an otherwise inhospitable bridge.

At the Albany Mudflats, however, these complexities disappear. Here the Bay Trail is not a network, not a concept, but a trail.

The opportunity to open up this part of the bayshore—so close at hand and yet so out of reach—arose when the California Department of Transportation was expanding Interstates 80 and 580 along the waterfront. The Bay Conservation and Development Commission permitted this necessarily disruptive work, but in compensation received funds for two purposes: to improve bird habitat in the mudflats, and to improve access along the shore. For habitat, the commission created two artificial shell-surfaced islets on which birds—including the endangered least tern—might roost and, it was hoped, nest. For access, it planned the trail.

Access and habitat: two noble values. But were they compatible?

Biologically the Albany Mudflats are a significant spot, the best shallow-water habitat left in the Central Bay. At low tide, they draw more shorebirds than any other nearby site, up to fourteen species and eleven thousand individuals at one time. The little western sandpiper, which arrives in summer from the Alaskan tundra, is most abundant. Herons, egrets, red-tailed hawks, ospreys, merlins, and peregrine falcons work the muddy cove. At high tide, the fish come in, followed by diving fish-eaters like grebes and terns. Ducks arrive to eat submerged vegetation and mud-dwelling creatures, and to shelter from wind on the open bay. The Bay Commission's plan raised the stakes by attempting to lure the least tern, which is notoriously sensitive to disturbance.

One might wonder, how could a few people on foot scare birds when heavy freeway traffic did not? In fact, it appears that the birds, notably the terns, are surprisingly tolerant of vehicles, which do not strike them as possible predators. Terns started making their nests on the tarmac at the Alameda Naval Air Station when airplanes were still rolling by. People moving more slowly and quietly, on bicycles and especially on foot, are quite another matter.

Further study defined the problem more narrowly and showed the way to a solution. What frightens birds particularly, it develops, is the scissor action of walking legs. Well, then, how about an opaque fence high enough to hide this motion? The design was modified to include one.

Kayaker, Aquatic Park, San Francisco.

The debate did not end quite there, however, because the barrier troubled another group: people in wheelchairs, who would now have their view cut off. The solution was to add a spur path ending on a mound with see-through fencing and a fairly distant view of the action on one of the habitat islands.

The trail past the Albany Mudflats was completed in 2000.

The path is perhaps best suited for the cyclist, or the very tall pedestrian who can freely look over the fence. Certainly many other miles of the Bay Trail, notably the stretch past Hoffman Marsh just north of here, are more scenic and less confined. Yet there's much that is pleasant about this improbable segment of trail. At the south end of the route, Brooks Island appears in the narrow opening of the Albany Mudflats embayment; as you reach the middle of the arc, Angel Island is displayed; as you get toward the north, the view is of the Golden Gate Bridge. Just over the much-debated fence is a narrow strip of healthy pickleweed marsh, and beyond it either rippling water or glossy mud, depending on the tide; in either case and at any season there are birds to admire and identify. Two of the East Bay's many buried creeks, Cerrito Creek and Marin Creek, pour out of culverts under the path into short tidal sloughs. Local groups are working now to exhume these streams and others like them wherever they can.

Even before the trail was officially completed, people were walking and cycling the new link, and the terns had showed up, too, apparently nesting on one of the new islets. Birder Larry Turnstall watched the terns—joined by avocets, stilts, killdeer, and "peeps" (small shorebirds)—drive off a red-tailed hawk. The hawk concerned them; the human audience apparently did not.

It would be dangerous to conclude from this case that wildlife and recreation are everywhere compatible. At some times and places they plainly aren't. Certainly it is the depleted plant and animal life of the estuary, not human pleasure or convenience, that should get the benefit of any doubt.

But it also matters that people be able to see and savor and study, if they like, the waters they live by. At the Albany Mudflats, a closer look discovered a way, clumsy perhaps, of combining access and preservation. May the tribe of such cases increase.

"There is nothing, absolutely nothing half so much worth doing," says the Water Rat in Kenneth Grahame's children's classic *The Wind in the Willows,* "as simply messing around in boats, or with boats. In 'em, or out of 'em, it doesn't matter." San Francisco Bay and the Sacramento–San Joaquin River Delta are full of water rats—in and out of boats, or perched on slender, floating boards—moving by wind power and arm power and motor power, probing sloughs and braving currents and tides, splashing their way across an inexhaustible playground. For people on the water, the Bay Trail might be said to be everywhere.

In Oakland's Arrowhead Marsh, a metal canoe powered by laughing children noses into a tidal channel. A guide from Save the Bay explains the wonders of mud.

In the middle of San Pablo Bay, twenty people line the rails of the *Morning Star,* a party boat out of Crockett, watching their rods for the tremor that announces a bite. A big shake might mean a big fish, the fish everyone is hoping for but not many catch these days: a white sturgeon.

At the Golden Gate, a kayak from Sea Trek bucks and rolls as it leaves the shelter of Horseshoe Bay on the Marin side and rounds the corner of Lime Point under the bridge. The winds and currents here have challenged mariners since 1775, when the first Spanish ship to enter the bay almost wrecked on this shore.

At Aquatic Park in San Francisco, onlookers cheer as a traditional whaleboat approaches the finish line of a race from Alcatraz, its eight oars lifting and falling in fine unison. Nearby, a swimmer from the Dolphin Club, sleek and dark in her wetsuit, strokes through the chilly water. A harbor seal pokes its conical head out of the water beside her.

At Crissy Field, a mile to the west, a kiteboarder struggles with his gear, coaxing a bright, flapping crescent of fabric into the air, then with a sprint and a hop mounting on a stubby board to run behind the wind.

On Sherman Island at the western edge of the delta, windsurfers perched on longer boards equipped with sails tack back and forth across the windy Sacramento River, bodies leaning at an angle opposite the masts.

Under the red-brown canvas of the schooner *Hawaiian Chieftain,* the crew scrambles and shouts and brings the boat about as it comes around the backside of Angel Island on a favorably windy day. The paying customers clustered on the decks top up their champagne.

People have been playing on San Francisco Bay, no doubt, since there was a San Francisco Bay. When ships approached Yerba Buena during the Gold Rush, men in wooden whaleboats would row out to meet them and get first crack at their business— a purely commercial competition memorialized by today's whaleboat races. For decades there were races on the Fourth of July between oceangoing schooners and the sail-powered scows that plied the waters of the bay.

The San Francisco Yacht Club, the oldest on the Pacific shores of North America, was founded in 1869; it is headquartered north of the Golden Gate in Belvedere now. The Corinthian Yacht Club in Tiburon followed in 1886; the Encinal Yacht Club in

Oakland in 1890; the Vallejo Yacht Club (to which writer Jack London belonged) in 1900. The St. Francis Yacht Club on San Francisco's marina broke off from the parent San Francisco club in 1913.

Rowing and swimming clubs started early, too. Two of the oldest, the South End Rowing Club and the Dolphin Club, date to the 1870s. Members swam to Alcatraz, across the Golden Gate, along the waterfront; they rowed, on occasion, all the way to Sacramento. They still do. The two funky clubhouses stand side by side on the beach at Aquatic Park.

By the twentieth century, however, engine power had replaced wind power for commerce, and engine power was taking over recreation, too. It was in San Francisco, in fact, that a man named Frank Hicks invented a simple but transformative gizmo, the rope-pull starter for the gasoline engine. Think of your lawnmower. With that came the motorboat as we know it. Older forms of water play didn't go away, but they became more and more the domain of the rich or the eccentric. Ninety percent of the craft at the estuary's three hundred marinas, by one estimate, were gasoline powered. At the Vallejo Yacht Club in 1944—to take one documented case—there were 46 powerboats and 11 sailboats.

After midcentury, however, this tide began to turn. By 1975, the Vallejo fleet was evenly divided between wind and engine power. By 2000, the harbor held 25 power-boats—and 111 sailboats.

Windsailors specialize. They associate by the type of boat they have and by the kind of place they go. In the delta, for instance, there are "gunkholers," who work their way through the channels, anchoring in the mud rather than tying up at docks.

You don't think of canoes on the open bay—the water is too often rough—but they have always been a fine means of exploring protected tidal sloughs and getting close to birds. In 1997, Save the Bay launched its regular series of Canoes in Sloughs trips, aimed particularly at schoolkids. The sleeker and more seaworthy kayak became common on the estuary in the 1980s. With a spray skirt to keep the paddler dry, a kayak can go anywhere inside the Golden Gate.

An entirely new group of water rats, the windsurfers, appeared on the water in the 1980s. Their craft can be thought of as absurdly cut-down sailboats or absurdly built-up surfboards with sails; in practice, they ride rather like snowboards, driven by wind instead of gravity. Like their compatriots in the snow, windsurfers lean and carve turns and occasionally go airborne. The clear monofilament sails, trimmed with bright color, resemble nothing so much as the wings of dragonflies. Windsurfers go where the wind is; favorite spots are Crissy Field, the East Bay shores opposite the Golden Gate, Coyote Point in San Mateo, and the lower Sacramento River in the delta. The wakes of freighters and ferries provide a favorite terrain.

Just as landside travelers are working to complete the Bay Trail, the water recreationists, led by the kayakers, are seeking to establish a San Francisco Bay Water Trail. Since the bay itself provides the linkage, the water trail would be really just a network of access points. The advocates want to make sure there are enough of these, close enough together, and laid out conveniently enough, to facilitate all sorts of jaunts with all sorts of craft. In other regions with water trails, campsites for multiday journeys are provided. Though more difficult to realize here, the idea is intriguing. As always, there are environmental concerns to be weighed. Waste disposal must be provided for. Certain waters, like those near the tern mounds at the Albany Mudflats, will be off-limits part of the time; others, like the neighborhood of the harbor seal haulout at the Castro Rocks under the Richmond–San Rafael Bridge, will surely be off-limits all of the time.

Bay Trail, water trail, shoreside recreation, sensitive wildlife: all of these elements come together in the new Eastshore State Park. The groups that united to wrest this shoreline strip from the grip of the Santa Fe Railroad have engaged in a long debate, not entirely friendly, about what should be accommodated there. Boat landings? Ball fields? Look-but-don't-touch habitats? How much parking, and for whom? There is perhaps no one right combination.

Such are the puzzles to be solved when shorelines are accessible and owned by the public. They are the problems of success. Considering the alternative, they are good problems to have.

ABOVE: *Marina at Emeryville, one of three hundred boat harbors on the shores of the bay and delta.* RIGHT: *Crissy Field in the Golden Gate National Recreation Area, San Francisco. The Bay Trail (left) borders a historic airfield (foreground) and a restored tidal lagoon.*

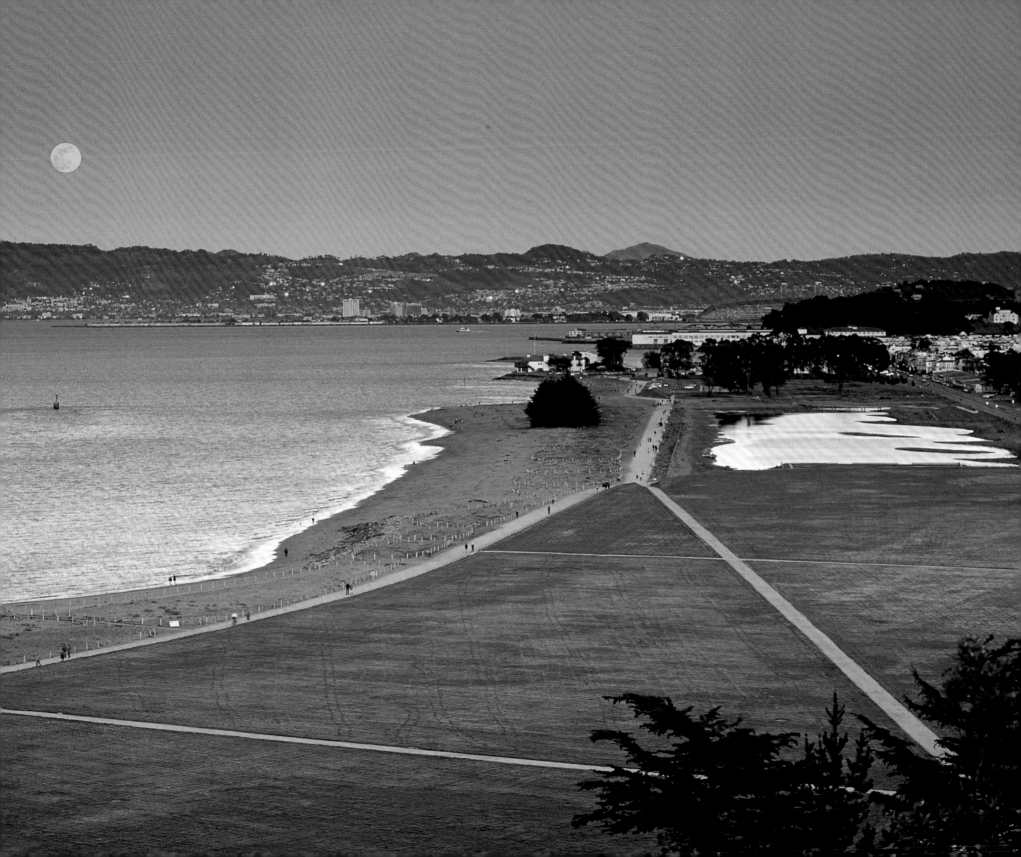

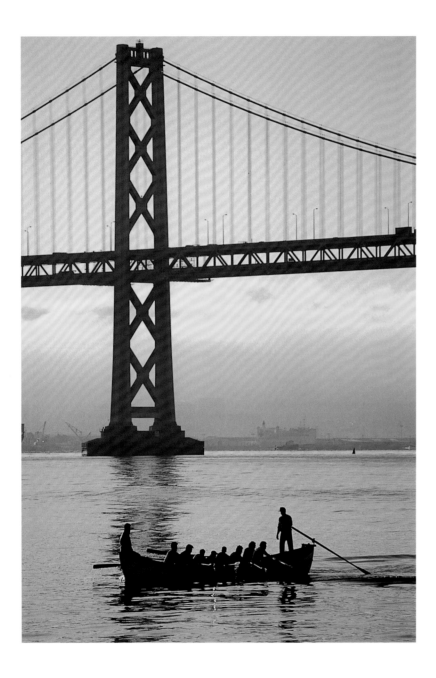

ABOVE: *Traditional wooden whaleboat beneath the San Francisco–Oakland Bay Bridge.* RIGHT: *Sailboat returning to the Berkeley Marina.*

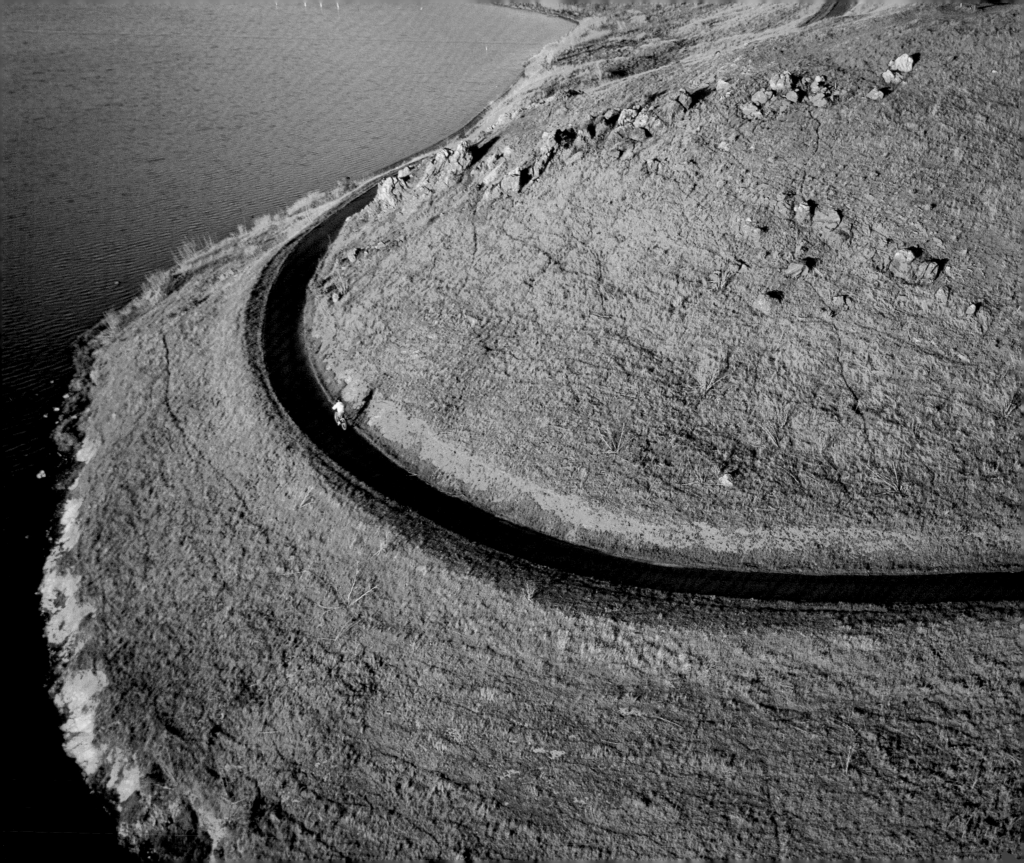

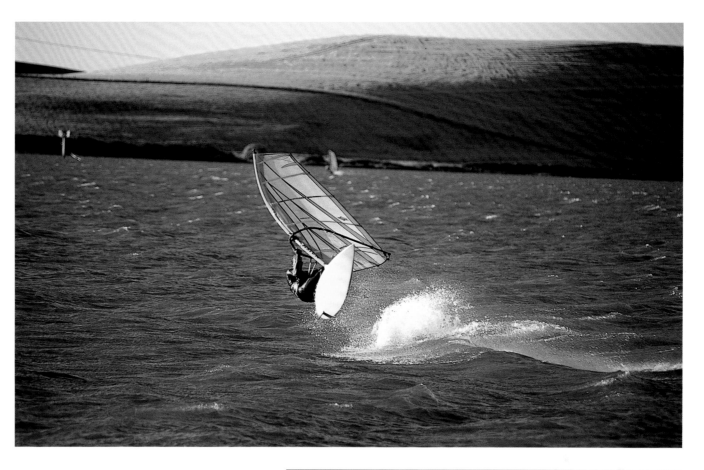

OPPOSITE: *Bicyclist in Coyote Hills Regional Park, Fremont.*
ABOVE: *Windsurfer on the Sacramento River at Sherman Island.*
Windsurfers need shoreline access and winds of at least twenty miles
an hour, both plentiful in the western delta. RIGHT: *Boater on*
Little Potato Slough near Helen and Herman's Marina in the delta.

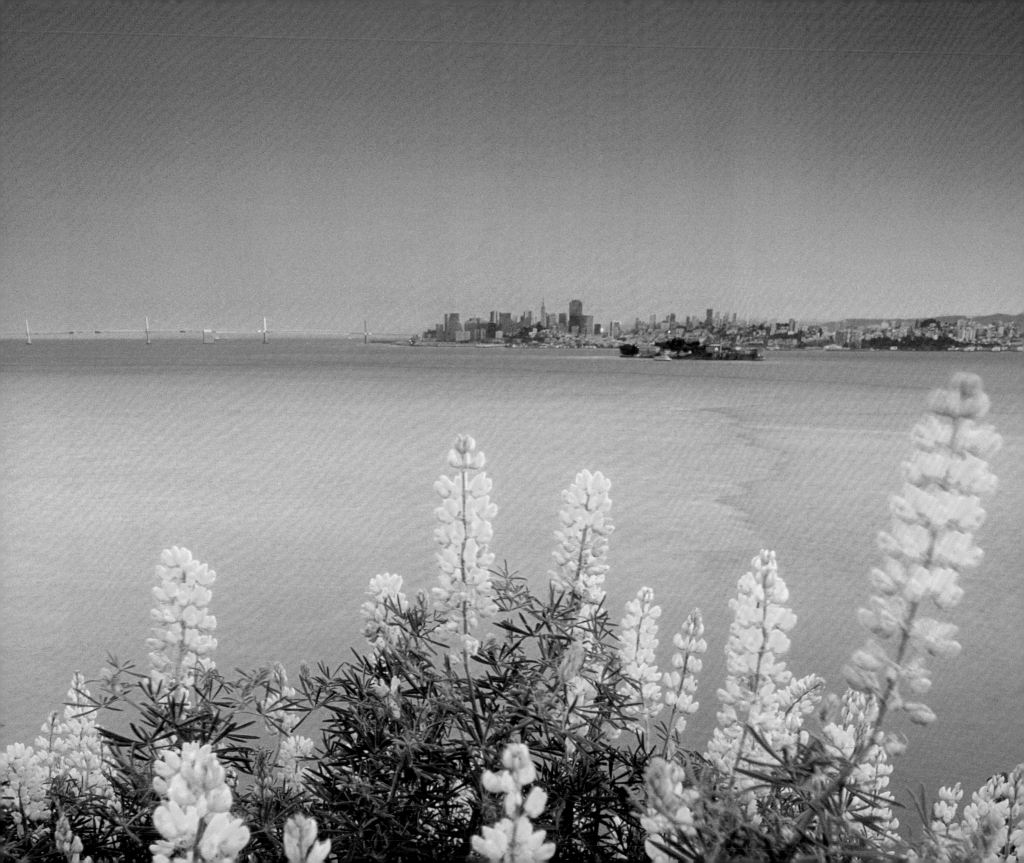

The View from Mount Livermore

The life of San Francisco Bay swirls around the square-mile hump of Angel Island, the floating hilltop just inside the Golden Gate, but leaves it seemingly untouched. Climb a windswept ridge to the high point, and you stand a few feet higher than the orange towers of the Golden Gate Bridge, three miles away. Around you are some of the bay's deepest waters and a ring of densely populated shores. The ancient channel of the Sacramento River, now called Raccoon Strait, separates you from the mainland of Marin County; freighters slide past on the San Francisco side; airliners slant over your head toward bayshore airports. On the island itself, in the middle of this web and hustle of traffic, is quietness. Nothing going on.

For much of its history, Angel Island was not a still center but a hub of activity. For the Huimen Indians, the local tribe of the Coast Miwoks, it was a valuable hunting and fishing site. When the Spanish came in 1775, the island became a major point of contact between cultures. In August, Lieutenant Juan Manuel de Ayala anchored his brig *San Carlos* at a cove, now named for him, on the Marin side of the island, and stayed there for five weeks. Indians from all the shores of the Central Bay crossed the water in tule boats to pay their respects to the new arrivals. Meanwhile Ayala's pilot, José Canizares, took the ship's longboat out for a detailed survey of bay shorelines and had many additional friendly encounters.

Ayala named the island Isla de Los Angeles, but early English and American visitors thought of it rather as Wood Island, after the big oaks that crowded to the waterline. Richard Henry Dana, in his famous diary *Two Years Before the Mast,* speaks of wood gathering here in 1835. Returning a quarter century later, he found the island denuded. The army arrived in 1862, building a post at the western tip of the island, Camp Reynolds, and installing cannon along the shores. On the opposite side of the island, at Winslow Cove, the inevitable Chinese shrimping camp appeared. Reportedly the camp also kept the Reynolds garrison supplied with whiskey.

At the end of the nineteenth century, the island grew more crowded. A new post, East Garrison, was built for the Spanish-American War; it was a major jumping-off point for Pacific-bound troops and materiel for decades thereafter. Ayala Cove, meanwhile, had become a fumigation station for ships and a hospital for sick crewmen. At China Cove—formerly Winslow Cove, where the shrimp camp had been—there rose a

San Francisco Bay and city skyline from Angel Island; butter lupine.

cavernous immigration station, designed to detain, discourage, and perhaps grudgingly admit would-be immigrants from Asia; at least 135,000 came through the facility before World War II.

After that war, federal authorities ran out of uses for Angel Island. By 1962 it had passed to the state of California for use as a park. In 1969 President Richard Nixon came close to demanding it back, proposing to build a missile defense site on the island's commanding summit. In 1970 the state offered its own scheme of development, with a luxury restaurant where the missiles would have gone. This brought the predictable sharp protest, and such ideas were dropped. The long sleep of Angel Island began.

Happy for the quiet, happy for the walk, happy for a place that can still be reached only by ferry, I linger on the top of the summit once called Mount Ida (after the peak in Crete) and now named for Caroline Livermore, a Marin County conservationist and an early fighter for the bay. With all respect to a great lady, I prefer the older name. From this vantage, the bay is an almost Aegean splendor. I wonder just how many blues there can be. Fog is bunching up outside the Golden Gate, getting ready to cool us all. The white points of sails are leaning off Crissy Field on the San Francisco side. The melding of cityscape and waterscape seems just right. Everything problematic about the San Francisco Estuary and the life around it is missing, edited out. I relax into sheer gratitude.

I have been to this spot before, but I know more than I used to about the territory I can see from here, and about the unseen reaches that lie beyond the bridges visible to the south and to the north.

When people see David Sanger's photographs of little-known aspects of the bay and its shores, a common reaction is this: "I had no idea this was here." I'm a local boy, but the same goes for me. I too had no idea that this—so much of this—was here.

I hadn't seen the salt scrapers working on the crystallizer flats at Newark.

I had certainly never been on a herring boat, let alone on an ammonia tanker.

I hadn't probed the dwindling, branching sloughs within the Petaluma Marsh, or joined the large community of people who keep tide tables close at hand.

I hadn't watched over Staten Island the evening flight of the cranes.

I didn't realize just how much had been lost of the living richness of the estuary—still less how great are the ambitions for recovery.

The bay divides its region as much as it unites it. People who live on one of its shores may rarely cross the water to visit another, or do so only in the grips of a daily commute that dulls perception. The disconnect between the coastal and the inland regions is worse. Only lately have people started using the words *bay* and *delta* in the same sentence. We have seen the system in pieces. We have been saving it in pieces, too. We have come late to the notion of seeing and saving it whole.

Fifty years from now, barring catastrophe, the view from this spot will be much the same. The cities will still be the cities, however changed their skylines. The generous parks will still be parks. The bridges will be in the same places, though the Bay Bridge at least will have a handsome new eastern span. Ships only somewhat larger than today's will be making their way to Oakland, to Richmond, and inland through the Pinole Shoals. The water will still be shining and opaque and cool. The fog will still pump in and out. Not even earthquakes and global warming seem likely to alter what you see—from here.

But the realities the postcard images can't capture—the worlds under the water, in the air, and along the distant margins of the estuary—are most unlikely to have stayed put. San Francisco Bay and the Sacramento–San Joaquin River Delta will have changed by the middle of our century. Maybe for the worse—but maybe, just maybe, much for the better.

It's as easy as ever to work up a bleak scenario: to paint, by extrapolating certain recent trends, a most alarming world. Let's go there, briefly. In fifty years, wetland restoration has foundered on lack of money and lack of mud. Development has crowded still tighter around bay shores and covered many former wetlands. In the face of a rising sea level, attention has turned to strengthening dikes, not breaking them. The remaining marshes and mudflats, caught between eroding waters and riprapped seawalls, are narrowing, not widening. Migratory birds, both shorebirds and waterfowl, are correspondingly fewer. Conservation battles are shrill with desperation.

There are fewer fish, especially native ones. A serious drought (there is bound to have been one) has pushed some species into extinction. In the attempt to protect what remains, sport fishing has been curtailed. Commercial fishing outside the Golden Gate, if going on at all, is feeble. Waterfowl hunting, too, is on the wane.

In the delta, farmers are fighting to save their islands from inundation. Salt is on the move, but the pumps at Tracy are working harder than ever. The water they send southward is now brought down from the Sacramento River directly—around, not through, the beleaguered delta—via a peripheral canal. Less fresh water than ever before is allowed to pass out west toward the Golden Gate.

Water pollution has regained the upper hand. With growing population in the watershed, the dispersed "nonpoint" sources, so hard to get a handle on, have overpowered the efforts of the regulators.

There is still beauty in this imaginary place. There is still the grandeur of cities meeting water. There is still the commerce, still much of the recreation. You can still send the postcard. The bay is still the bay; but the estuary is dying.

We already know that this worst case is not going to happen. Too many people are working too hard to make sure that it does not.

How far will we get, I wonder, toward an alternative vision?

In this future for the bay and delta, the web of life is richer and denser, with some of its present tatters repaired. There are more wetlands nourishing the system; more fresh water is reaching it in the spring, making its food chains hum. After a slow beginning, great arcs of marshes are reappearing around the South Bay and along San Pablo Bay. More of Suisun Marsh is also nourished by the tide. Wherever possible, nearshore open spaces have been left open, allowing wetlands to migrate landward as sea level rises. Many creeks that enter the bay have been liberated from culverts and ditches, their banks replanted with native vegetation. In quite a few formerly sterile streams, spawning steelhead trout have returned.

Pollution is less. The controllers have kept the pressure on; archaic technologies like once-through power plant cooling have disappeared; the myriad small actions needed to curb diffuse nonpoint water pollution have gradually become habitual. The new marshes help clean the environment, too.

As habitat has reappeared, many native birds and mammals and fish and plants have increased in number, shortening the old Endangered Species list. With proper treatment of ships' ballast water, the introduction of exotic animals and plants has also slowed down. Sport fishing is improving. Fisherman's Wharf is vital. Olympia oysters are once again being harvested from bay waters.

More people are enjoying the bay in more ways. The Bay Trail is real, its route twisting this way and that to avoid disturbing wildlife, but continuous. All the bridges now have bicycle and pedestrian paths. It's easy to get to the water with your kayak, sailboard, shell, canoe, dragon boat, or, I suppose, rubber duck; multiday camping trips are possible along some shores.

The delta is still in intensive care. Parts have been deliberately or accidentally flooded; parts are in carefully managed marshes; most of the land remains agricultural. The budget for dike maintenance is huge. But the banks of many channels have been renaturalized, providing habitat in the form of streamside thickets and calm backwaters and shallows. More and more island farms are being managed with the needs of water-fowl in mind. Land subsidence has slowed, and has been reversed in many places.

Statewide, the population has grown. But, unwilling to pay the environmental and financial price of extracting more water from rivers, Californians have resolved to live within the limits of their existing developed water supply. The precious liquid is being used more efficiently, in homes and factories and above all on farms. It is understood as fundamental that the San Francisco Estuary gets the river input it needs.

In 1776, if the conquerors climbed to the top of Angel Island, they looked out on a world of astonishing natural abundance, waiting for the taking—or the kill. We cannot go back to a scene that looks, from our safe distance, like a paradise. But we face our own amazing prospect and a challenge that is stirring.

We have had our go at simple exploitation, and have gained great wealth thereby. Now comes the harder act: finding a way to inhabit this place—or any place—in a manner that does not progressively destroy, but respects and accommodates and restores, the parts of it that aren't the same old Us: the other creatures, the other values, the other processes in operation there.

We are here in our multitudes, doing the things we do, making the things we make, moving the things we move. We have a right to do so, but no longer the right to ignore the costs we impose. In fact we seem to be learning more kinds of concern. Maybe we are growing up. Maybe we are settling down.

The human relationship with Nature has too often been compared to war. On the shores of the San Francisco Estuary, as in quite a few places here and there around the world, we are trying to substitute what might be thought of as a negotiated peace.

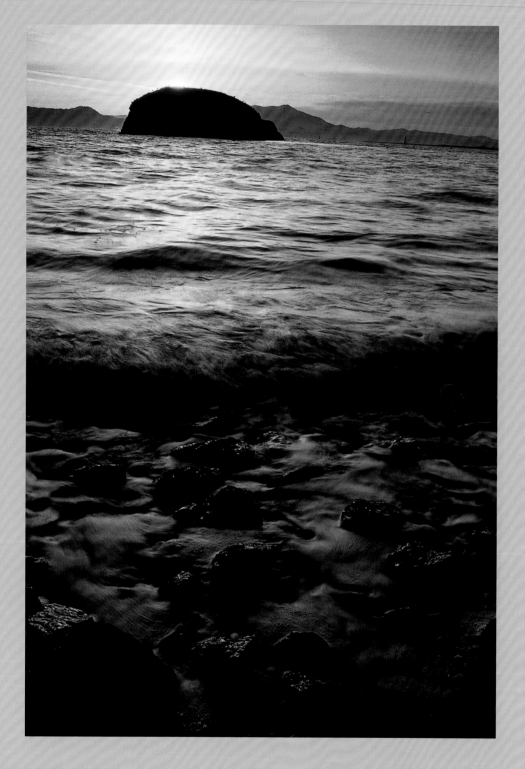

LEFT: *Sunset behind Bird Rock, off the Richmond shore. This hard-to-spot islet is a satellite of larger Brooks Island, from which it is seen here.*
OPPOSITE: *Angel Island and the Tiburon Peninsula from Grizzly Peak in the Berkeley Hills.*
OVERLEAF: *San Francisco Bay at sunrise from Mount Tamalpais.*

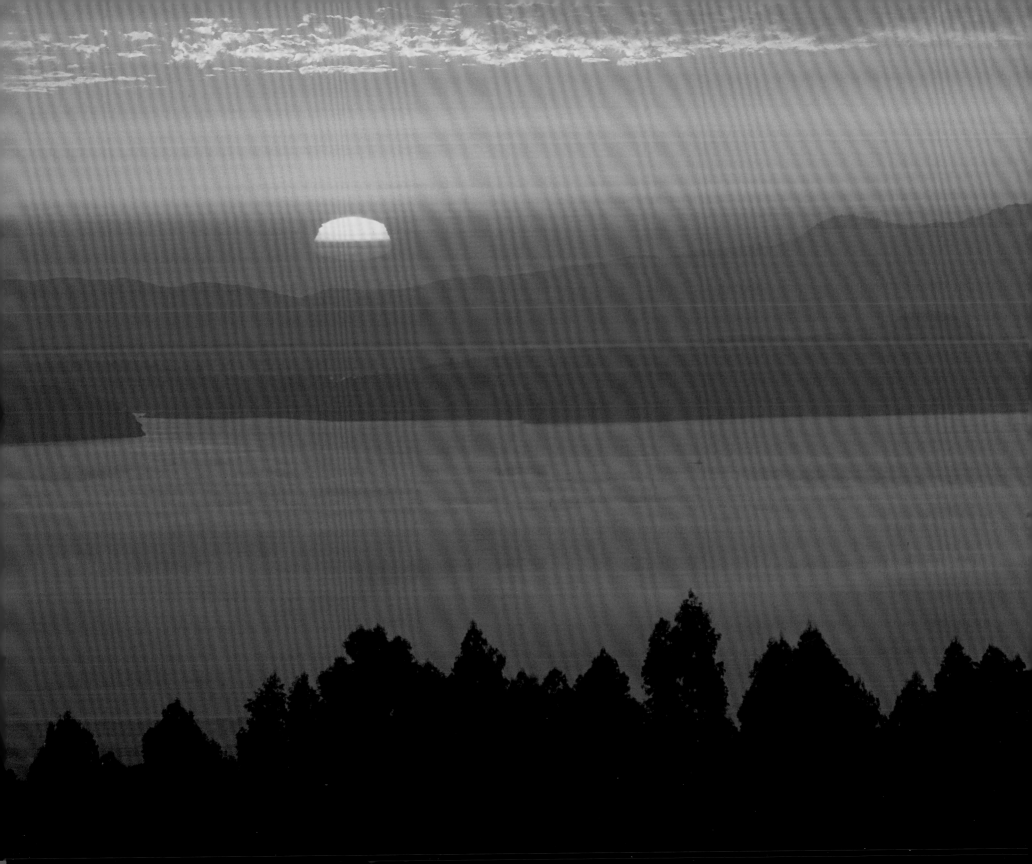

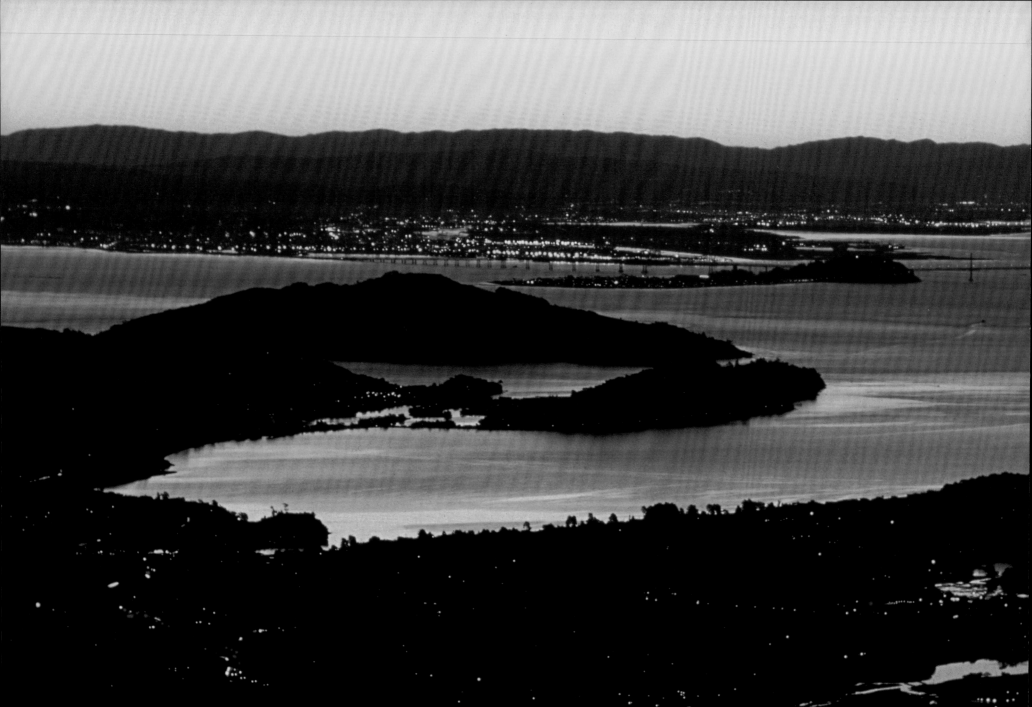

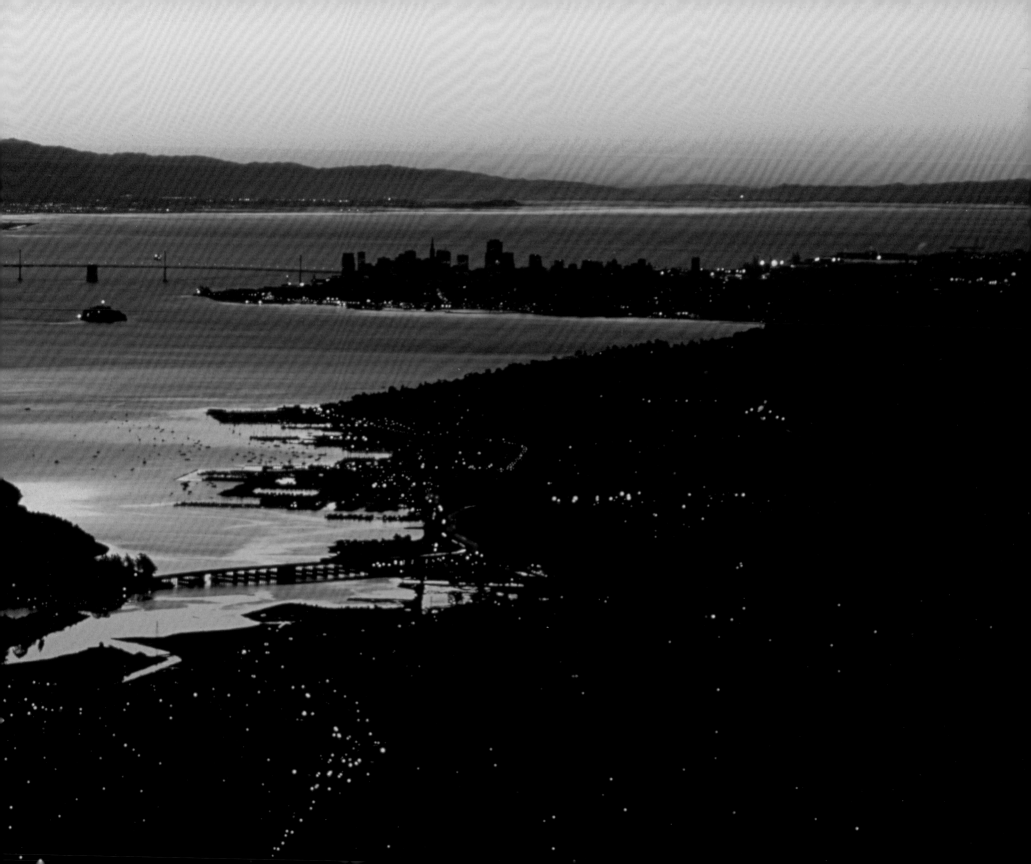

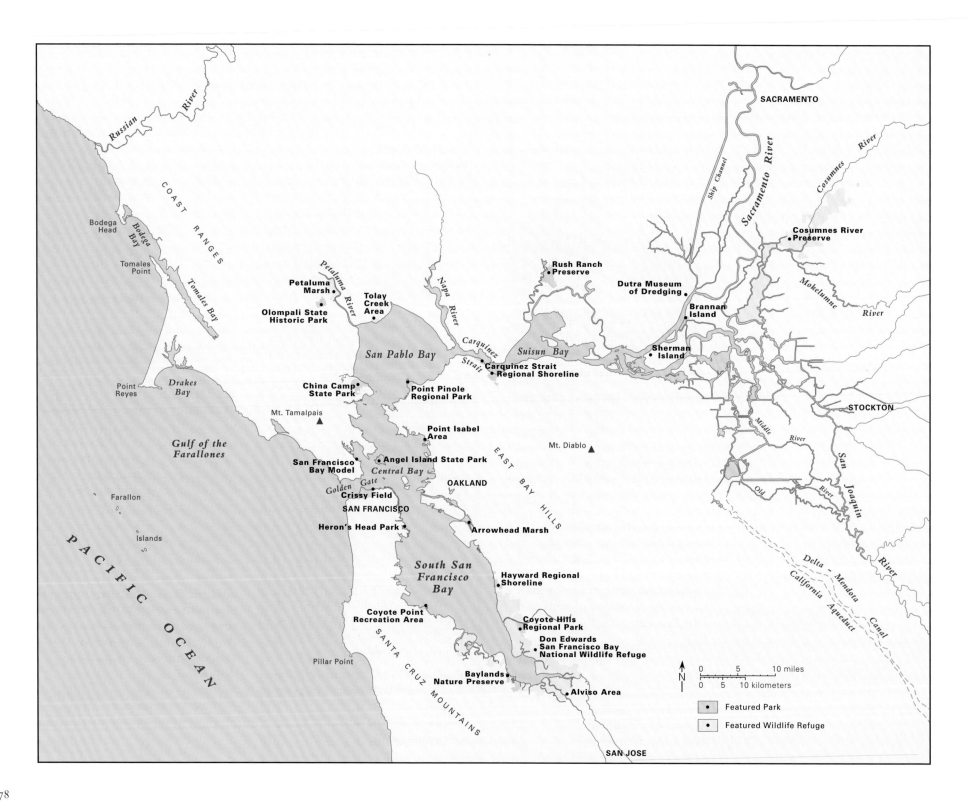

SACRAMENTO

Russian River

Bodega
Head

*Bodega
Bay*

COAST RANGES

*Tomales
Point*

Tomales Bay

Cosumnes River

Cosumnes River
Preserve

Rush Ranch
Preserve

Petaluma
Marsh

Petaluma River

Tolay
Creek
Area

Dutra Museum
of Dredging

Sacramento River

Ship Channel

Olompali State
Historic Park

Napa River

Mokelumne River

Point
Reyes

*Drakes
Bay*

San Pablo Bay

Brannan
Island

Carquinez Strait

Suisun Bay

Sherman
Island

Point
Reyes

Carquinez Strait
Regional Shoreline

China Camp
State Park

Point Pinole
Regional Park

*Gulf of the
Farallones*

Mt. Tamalpais ▲

Point Isabel
Area

Mt. Diablo ▲

STOCKTON

San Francisco
Bay Model

Angel Island State Park

Central Bay

EAST BAY HILLS

Farallon

Golden Gate

OAKLAND

Crissy Field

SAN FRANCISCO

Islands

Heron's Head Park

Arrowhead Marsh

Middle River

San Joaquin River

PACIFIC OCEAN

*South San
Francisco
Bay*

Hayward Regional
Shoreline

Delta–Mendota Canal

Old River

Coyote Point
Recreation Area

Coyote Hills
Regional Park

California Aqueduct

Pillar Point

Don Edwards
San Francisco Bay
National Wildlife Refuge

SANTA CRUZ MOUNTAINS

Baylands
Nature Preserve

Alviso Area

N
↑

0 5 10 miles
0 5 10 kilometers

● Featured Park

○ Featured Wildlife Refuge

SAN JOSE

Appendix A: Twenty Places to Visit

You could spend years exploring the shoreline of San Francisco Bay and the Sacramento–San Joaquin River Delta. Here are some starting points, listed in counterclockwise order from the Golden Gate.

SAN FRANCISCO: CRISSY FIELD

A cove at Crissy Field was the regular anchorage for the Spanish Presidio, located inside the bay on the south side of the Golden Gate. Under the Americans, this embayment was filled in with rubble and garbage from the base. In the year 2000, a part of this fill was removed and a tidal lagoon restored. In time the lagoon is expected to become a tidal marsh. There is an environmental education center nearby. For many people, this is the quickest and easiest place to see and learn about the restoration of San Francisco Bay. Windsurfers use the nearby shore.

Directions: In the Golden Gate National Recreation Area, San Francisco. Follow Mason Street west from the west end of Marina Boulevard. Park near the Crissy Field Center building.
Contact: (415) 561-7690
www.crissyfield.org

SAN FRANCISCO: HERON'S HEAD PARK

Formerly Pier 98, at the southern end of the Port of San Francisco, this artificial point would have supported an approach to the Southern Crossing, a proposed bridge to Oakland. When the plan was cancelled, the point was made a park and fill was removed to permit formation of a forty-eight-acre wetland alongside it. Between the Port of San Francisco and a PG&E power plant, Heron's Head gives a unique view of the urban waterfront. Community groups from the adjacent Bayview–Hunters Point community help to maintain it. In winter you often see herring boats anchored offshore.

Directions: From Interstate 280 in San Francisco, take the Evans Avenue exit and turn east. Turn left on Jenkins to the park entrance.
Contact: (415) 508-0575
www.ci.sf.ca.us/sfport/parks.html

SAN MATEO COUNTY: COYOTE POINT RECREATION AREA

The sandstone cliffs of Coyote Point in San Mateo are a vestige of the original bay shoreline. On the bluff above, the excellent Coyote Point Museum interprets the ecosystem. The windy waters are a popular windsurfing locale.

Directions: From U.S. 101 in San Mateo, take Coyote Point Boulevard to the park entrance.
Contact: (650) 573-2592
www.eparks.net/Parks/Coyote

SANTA CLARA COUNTY: BAYLANDS NATURE PRESERVE, PALO ALTO

One of the first stretches of the bayshore to be preserved, the Palo Alto Baylands are a good place to observe how marshes work. The Lucy Evans Nature Interpretive Center is named for a leading early opponent of bay fill.

Directions: From U.S. 101 in Palo Alto, take Embarcadero Road East.
Contact: (650) 329-2506
www.city.palo-alto.ca.us/ross/naturepreserve/baylands.html

SANTA CLARA COUNTY: ALVISO AREA

The quaint old town of Alviso, once known as New Chicago, lies well below sea level. In town are the San Francisco Bay Bird Observatory and a picturesquely silted-in marina. Nearby is the Environmental Education Center at New Chicago Marsh, part of the Don Edwards San Francisco Bay National Wildlife Refuge.

Directions: From California 237, exit north on North First Street, turn right on Grand Boulevard to Environmental Education Center. Or continue on North First and turn right on Gold Street to downtown Alviso, the San Francisco Bay Bird Observatory, and the marina.
Contact: (510) 792-4275
desfbay.fws.gov

ALAMEDA COUNTY: DON EDWARDS SAN FRANCISCO BAY NATIONAL WILDLIFE REFUGE AND COYOTE HILLS REGIONAL PARK

The headquarters of the Don Edwards National Wildlife Refuge is the starting point for long explorations on dikes among marshes and salt ponds. North of the Dumbarton Bridge approach is Coyote Hills Regional Park, with natural history exhibits, a freshwater marsh, and a village site of the Tuibun band of Ohlone Indians.

Directions: From California 84 just east of the Dumbarton Bridge, take Thornton Avenue south to Marshlands Road for the refuge, or Paseo Padre north to Patterson Ranch Road for the regional park.
Contact:
Don Edwards NWR: (510) 792-4275
desfbay.fws.gov
Coyote Hills Regional Park:
(510) 562-7275
www.ebparks.org (*search* Coyote Hills)

ALAMEDA COUNTY: HAYWARD REGIONAL SHORELINE

The shoreline has salt marshes; fresh- and brackish-water marshes nourished by treated wastewater; several miles of the Bay Trail; and a fine museum, the Hayward Shoreline Interpretive Center.

Directions: On California 92, just east of Hayward–San Mateo Bridge toll plaza, take the Clawiter Road/Eden Landing Road exit and go north. Turn left onto Breakwater, paralleling the highway west to the interpretive center and trail access.
Contact: (510) 562-7275
www.ebparks.org (*search* Hayward Regional Shoreline)

ALAMEDA COUNTY: ARROWHEAD MARSH

Arrowhead Marsh, at the mouth of San Leandro Creek in Oakland, was formed when a dam broke on the creek, sending a gush of sediment into San Leandro Bay. The area was purchased by the Oakland Airport and largely filled, but the Golden Gate Audubon Society and the Bay Conservation and Development Commission halted the fill. Alongside the surviving healthy marsh, some upland areas are being restored to wetland. The area is leased from the Port of Oakland by the East Bay Regional Park District and is now known as the Martin Luther King Junior Shoreline.

Directions: From Interstate 880 in Oakland, take the Hegenberger Road exit and go west. Turn right on Pardee Lane past newly restored marshes to the central area of the park.
Contact: (510) 562-7275
www.ebparks.org (*search* Martin Luther King Jr. Shoreline)

ALAMEDA/CONTRA COSTA COUNTIES: POINT ISABEL AREA

A stretch of the Bay Trail takes you for several miles between the foot of Buchanan Avenue in Albany and the foot of Bayview Avenue in Richmond, past some of the best-preserved mudflats and marshes in the Central Bay. The trip can be extended north or south.

Directions: From Interstate 80, take the Buchanan Street exit. Turn west under the freeway and park at the Albany Shoreline Park.
Contact: (510) 562-7275
www.ebparks.org (*search* Eastshore State Park or Point Isabel)

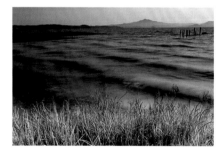

CONTRA COSTA COUNTY: POINT PINOLE REGIONAL PARK

This large peninsula on San Pablo Bay was the site of an explosives factory and the proposed site of a steel plant; it was preserved by a citizen campaign.

Directions: From I-80 in Richmond, exit at the Richmond Parkway. Turn right onto Giant Highway to the park entrance.
Contact: (510) 562-7275
www.ebparks.org (*search* Point Pinole)

CONTRA COSTA COUNTY: CARQUINEZ STRAIT REGIONAL SHORELINE

Between Crockett and Martinez, a stretch of the hilly Carquinez Strait shoreline has been preserved. A pier at the former town of Eckley is popular with sturgeon fishermen.

Directions: On Interstate 80, take the Crockett exit (at the south end of Carquinez Strait Bridge). Turn east on Pomona, which becomes Carquinez Scenic Drive. A spur road leads to the water at Eckley.
Contact: (510) 562-7275
www.ebparks.org (*search* Carquinez Strait)

SACRAMENTO COUNTY: SHERMAN AND BRANNAN ISLANDS

At Brannan Island is a state recreation area with picnic areas, river access, and a delta museum. The Sherman Island Road on the north side of that island is a good place to watch windsurfers on the Sacramento River and birds at the Lower Sherman Island Wildlife Area.

Directions: Along California 160 between Antioch and Rio Vista.
Contact: (916) 777-6671
www.parks.ca.gov (*search* Brannan Island)

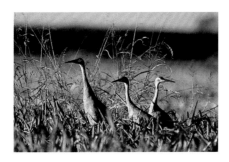

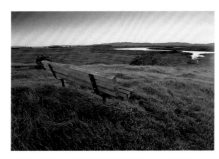

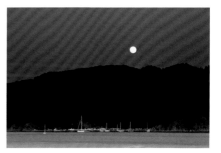

SACRAMENTO AND SAN JOAQUIN COUNTIES: COSUMNES RIVER PRESERVE

The Nature Conservancy, the U.S. Bureau of Land Management, and other organizations jointly manage over sixty square miles of land along the lower course of the only undammed river tributary to the delta. Stop at the visitor center for information about the preserve, trails, canoeing and kayaking, and volunteer opportunities.

Directions: From Interstate 5, take the Twin Cities Road exit, about midway between Stockton and Sacramento. Turn east on Twin Cities Road, then south on Franklin Boulevard to the visitor center.
Contact: (916) 684-2816
www.cosumnes.org

SOLANO COUNTY: DUTRA MUSEUM OF DREDGING

A unique collection in Rio Vista shows the history of the dredging and dike building that created the modern delta and profoundly altered the shores of San Francisco Bay. Visit by arrangement.

Directions: 345 St. Gertrude Street off Highway 12 in Rio Vista.
Contact: (707) 374-6339
www.riovista.org/map.asp

SOLANO COUNTY: RUSH RANCH PRESERVE

This section of the original Suisun Marsh, owned by the Solano Land Trust, adjoins the Potrero Hills at the north edge of the marsh. Exhibits and demonstration projects explore the Patwin Indian tradition, early farming, and marshland ecology. One thousand acres of undiked brackish-water marsh are here.

Directions: From Interstate 80 in Fairfield, take California 12 east; then turn south on Grizzly Island Road. The Rush Ranch entrance is in two miles.
Contact: (707) 432-0150
www.solanolandtrust.org

SONOMA COUNTY: TOLAY CREEK AREA

This section of the San Pablo Bay National Wildlife Refuge is the site of a marsh restoration coordinated by Save the Bay. You'll see marshes rich in birds, expanses of shallow water that are marsh restorations in progress, and wild bayshore.

Directions: On California 37 between Novato and Vallejo, just west of the junction with California 112. Park at the gate on the eastbound side. It's a three-mile walk to the bay.
Contact: (707) 562-3000
www.savesfbay.org/tolay.html

SONOMA COUNTY: PETALUMA MARSH

The largest intact marsh near San Francisco Bay can be visited only by boat. A canoe is perfect for exploring its maze of internal sloughs on a good high tide. For an almost aerial view, hike the Mount Burdell Trail in Olompali State Historic Park nearby.

Directions: From U.S. 101 north of Novato in Marin County, turn east on the road signed to Monte Vista Marina, just opposite the marsh. A boat launch is available. Olompali is across the freeway to the west. However, the marina can be accessed only from the northbound lane on U.S. 101, and the state park only from the southbound lane.
Contact: (707) 944-5500
www.dfg.ca.gov/wildlife_areas/reg3.html
www.parks.ca.gov (*search* Olompali)

MARIN COUNTY: CHINA CAMP STATE PARK

Near San Rafael is a unique shoreline—the one place around the estuary where an intact marsh adjoins undeveloped adjacent hills. A resident Chinese American family fishes for shrimp, the last remaining operation of its kind.

Directions: From U.S. 101 in San Rafael, go east on North San Pedro Road for five miles.
Contact: (415) 456-0766
www.parks.ca.gov (*search* China Camp)

MARIN COUNTY: ANGEL ISLAND STATE PARK

This square-mile island just inside the Golden Gate is a state park and a superb viewpoint for the Central Bay. The top of its central peak, lopped off in the 1950s for a Nike missile site, is being painstakingly restored.

Directions: Access by ferry from San Francisco, Tiburon, or Oakland. For schedules see www.watertransit.org.
Contact: (415) 435-2131
www.parks.ca.gov (*search* Angel)

MARIN COUNTY: SAN FRANCISCO BAY MODEL

The Army Corps of Engineers built this wonderful three-dimensional model of the bay-delta system, complete with tides, in the 1950s to test the feasibility of a plan to dam the bay, turning it into a series of freshwater lakes (the Reber Plan).

Directions: From U.S. 101 in Marin County, take the Sausalito–Marin City exit. Follow the signs to Sausalito. Go left on Harbor, right on Marinship, and follow the signs to the model.
Contact: (415) 332-3870
www.spn.usace.army.mil/bmvc

Appendix B: Selected Reading

Arnold, Anthony. *Suisun Marsh History: Hunting and Saving a Wetland*. Marina, Calif.: Monterey Pacific Publishing Company, 1996. Out of print but well worth consulting in a library.

Bay Conservation and Development Commission. *San Francisco Bay Plan*. San Francisco: BCDC, 2001. This continually updated plan is one of the basic charters of bay preservation.

Bay Institute of San Francisco. *From the Sierra to the Sea: The Ecological History of the San Francisco Bay–Delta Watershed*. San Rafael: Bay Institute of San Francisco, 1998. Weighs the evidence about historic and present river flows, the nature of the original Sacramento–San Joaquin River Delta, and much else.

Bay Nature. Quarterly magazine devoted exclusively to Bay Area natural history. www.baynature.com.

Brower, Kenneth, and Michael Sewell. *The Winemaker's Marsh: Four Seasons in a Restored Wetland*. San Francisco: Sierra Club Books, 2001. The story of a marsh restoration at Viansa Winery, north of San Pablo Bay.

Center for Land Use Interpretation. *Back to the Bay: Exploring the Margins of the San Francisco Bay Region*. Culver City, Calif.: CLUI, 2001. Companion to a 2001 exhibit at the Yerba Buena Center for the Arts, this photographic tour guide focuses on military and industrial uses of the shoreline.

Cohen, Andrew N. *Gateway to the Inland Coast: The Story of the Carquinez Strait*. Crockett, Calif.: Carquinez Strait Preservation Trust, 1996. A regional history.

———. *An Introduction to the San Francisco Estuary*. 3d ed. San Francisco: Save the Bay, San Francisco Estuary Project, San Francisco Estuary Institute, 2000. Indispensable basic guide.

Department of Water Resources, State of California. *Sacramento–San Joaquin Delta Atlas*. Sacramento: State of California, 1995. All manner of graphic information about the delta. http://rubicon.water.ca.gov/delta_atlas.fdr/daindex.html.

Gillenkirk, Jeff, and James Motlow. *Bitter Melon: Inside America's Last Rural Chinese Town*. 3d ed. Berkeley: Heyday Books, 1997. A history of the Sacramento–San Joaquin River Delta town of Locke.

Gilliam, Harold. *Between the Devil and the Deep Blue Bay: The Struggle to Save San Francisco Bay*. San Francisco: Chronicle Books, 1969. Written as the legislature was considering a permanent Bay Conservation and Development Commission, Gilliam's passionate book influenced the debate.

———. *San Francisco Bay*. Garden City, N.Y.: Doubleday, 1957. This first general portrait of the bay emphasizes history and commerce while raising the first concerns about bay fill.

London, Jack. *Tales of the Fish Patrol*. 1905. Reprint, Sandy, Utah: Quiet Vision Publishing, 2001. Fictionalized accounts of early fish and game law enforcement in the San Francisco Estuary. A valuable source though marred by racism.

Margolin, Malcolm. *The Ohlone Way: Indian Life in the San Francisco–Monterey Bay Area*. Berkeley: Heyday Books, 1978. The classic, although somewhat controversial, reconstruction of life in the precontact world.

Martini, John D. *Fortress Alcatraz: Guardian of the Golden Gate*. Kailua, Hawaii: Pacific Monograph, 1990. Lively history of the early days of Alcatraz.

Milliken, Randall. *A Time of Little Choice: The Disintegration of Tribal Culture in the San Francisco Bay Area, 1769–1810*. Menlo Park: Ballena Press, 1995. Excellent if painful study of the key early years.

Misrach, Richard, et al. *Golden Gate*. Santa Fe: Arena Editions, 2001. Sixty art photographs of the Golden Gate Bridge from a front porch in Berkeley.

San Francisco Bay Area Wetlands Ecosystem Goals Project. *Baylands Ecosystem Habitat Goals*. Oakland: San Francisco Bay Regional Water Quality Control Board, 1999. The detailed blueprint for restoring or improving 150 square miles of wetlands around San Francisco Bay (but not in the Sacramento–San Joaquin River Delta).

———. *Baylands Ecosystem Species and Community Profiles: Life Histories and Environmental Requirements of Key Plants, Fish and Wildlife*. Oakland: San Francisco Bay Regional Water Quality Control Board, 2000. In designing the goals described in the above report, scientists looked to the needs of specified plant and animal species. This additional publication spells out the details.

San Francisco Bay Joint Venture. *Restoring the Estuary: An Implementation Strategy for the San Francisco Bay Joint Venture*. Oakland: San Francisco Bay Joint Venture, 2000. Companion document to the two San Francisco Bay Area Wetlands Ecosystem Goals Project titles above.

San Francisco Estuary Institute. *EcoAtlas Information System*. A tremendous database of layered maps and information covering all present and former tidelands west of the delta. www.ecoatlas.org.

Scott, Mel. *The Future of San Francisco Bay*. Berkeley: University of California Institute of Governmental Studies, 1963. Telling portrait of the contemporary state of affairs.

Thompson, J., and E. A. Dutra. *The Tule Breakers: The Story of the California Dredge*. Stockton: University of the Pacific, 1983. The reclamation of the Sacramento–San Joaquin River Delta and the perfection of the long-boom clamshell dredge.

Appendix C: Some Organizations Involved in Bay Affairs

Several hundred groups and agencies are part of the ongoing San Francisco Bay story. Here are a few that we encountered in preparing this book.

CITIZEN GROUPS

Arc Ecology
833 Market Street, Suite 1107
San Francisco, CA 94103
(415) 495-1786
www.arcecology.org
At the intersection of the peace and environmental justice movements; works locally on military base cleanup and re-development.

Audubon
700 Broadway
New York, NY 10003
(212) 979-3000
www.audubon.org
One of the nation's premier environmental organizations; has made the restoration of San Francisco Bay an organizational priority. Membership also enrolls you in an independent local Audubon chapter; see below under Golden Gate, Madrone, Marin, Mount Diablo, Napa-Solano, Ohlone, Santa Clara Valley, and Sequoia.

Audubon California
6042 Monte Vista Street
Los Angeles, CA 90042
(323) 254-0252
www.audubon.org
State office in charge of regional efforts.

Audubon San Francisco Bay Restoration Program
131 Steuart Street, Suite 200
San Francisco, CA 94105
(415) 947-0331
www.AudubonSFbay.org
Special office established in 2000 to support the effort to restore the bay.

Bay Area Open Space Council
c/o Greenbelt Alliance
530 Bush Street, Suite 303
San Francisco, CA 94108
(510) 654-6591
www.openspacecouncil.org
Links public and non-profit agencies that buy and manage land for preservation; posts a good list of local organizations on its website.

The Bay Institute of San Francisco
500 Palm Drive, Suite 200
Novato, CA 94949
(415) 506-0150
www.bay.org
Focuses on bay restoration and water management in the watershed context, combining education, advocacy, and multidisciplinary scientific research. Publishes monthly *Bayletter*. With Center for Ecoliteracy, coordinates the Students and Teachers Restoring a Watershed (STRAW) Project that restores streams and provides watershed education to schools in Marin and Sonoma Counties.

Blue Water Network
311 California Street, Suite 510
San Francisco, CA 94104
(415) 544-0796
www.bluewaternetwork.org
Works to limit pollution from watercraft, including ferries on the bay.

California Academy of Sciences
Golden Gate Park
San Francisco, CA 94118
(415) 221-5100
www.calacademy.org
Operates the Steinhart Aquarium and the Natural History Museum, one of the largest collections of its kind in the world, in San Francisco's Golden Gate Park; publishes the magazine *California Wild;* carries out research in many areas, including the San Francisco Estuary.

Center for Ecoliteracy
2522 San Pablo Avenue
Berkeley, CA 94702
(510) 845-4595
www.ecoliteracy.org
Works to educate people (especially young ones) about ecological principles and sustainable living.

Central Valley Joint Venture
Federal Building
2800 Cottage Way W-2610
Sacramento, CA 95825
(916) 414-6464
Consortium of organizations and agencies; works on waterfowl habitat in the Central Valley.

Citizens' Committee to Complete the Refuge
453 Tennessee Lane
Palo Alto, CA 94306
(650) 493-5540
www.refuge.org
Umbrella organization; unites groups in support of the Don Edwards San Francisco Bay National Wildlife Refuge and wetland restoration.

Citizens for the Eastshore State Park
PO Box 6087
Albany, CA 94706
(510) 526-2629
Ad hoc group; works on behalf of the shoreline park in Emeryville, Berkeley, and Albany.

Communities for a Better Environment
1611 Telegraph Avenue
Oakland, CA 94612
(510) 302-0430
www.cbecal.org
Works on environmental health and justice; fights pollution through grassroots activism, environmental research, and legal assistance.

Ducks Unlimited, Inc.
Western Regional Office
3074 Gold Canal Drive
Rancho Cordova, CA 95670
(916) 852-2000
www.ducks.org
Works to preserve and create habitat for waterfowl.

Environmental Defense

Oakland Regional Office
5655 College Avenue, Suite 304
Oakland, CA 94618
(510) 658-8008
www.environmentaldefense.org
National organization; early advocate of water policy reforms beneficial to the San Francisco Estuary.

Friends of Five Creeks

1236 Oxford Street
Berkeley, CA 94709
(510) 848-9358
www.fivecreeks.org
Among the most active of the organizations working to restore streams that feed the bay; focuses on watersheds from Berkeley to Richmond.

Friends of the River

915 Twentieth Street
Sacramento, CA 95814
(916) 442-3155
www.friendsoftheriver.org
Born in the fight to stop a dam on the Stanislaus River; works to protect and restore California's rivers, streams, and watersheds.

Friends of the San Francisco Estuary

PO Box 2050
Oakland, CA 94604
(510) 622-2337
www.abag.ca.gov/bayarea/sfep
Citizens' group allied to the San Francisco Estuary Project; publishes valuable newsletter *Estuary*.

Golden Gate Audubon

2530 San Pablo Avenue, Suite G
Berkeley, CA 94702
(510) 843-2222
www.goldengateaudubon.org
The largest of eight local Audubon chapters and a catalyst in local efforts to protect and restore wetlands; covers San Francisco and Alameda to San Pablo in the East Bay.

Greenbelt Alliance

530 Bush Street, Suite 303
San Francisco, CA 94108
www.greenbelt.org
Works to protect a network of open landscapes surrounding Bay Area cities.

International Longshore and Warehouse Union

400 North Point Street
San Francisco, CA 94133
(415) 775-0533
www.ilwu.org
Represents over forty thousand workers in the ports of the western United States.

Literacy for Environmental Justice

6220 Third Street
San Francisco, CA 94124
(415) 508-0575
www.lejyouth.org
Works with youngsters in the southeast part of San Francisco to address ecological and social concerns; has many programs at Heron's Head Park.

Madrone Audubon

PO Box 1911
Santa Rosa, CA 95402
(707) 546-7492
www.audubon.sonoma.net
Covers Sonoma County.

Marin Audubon

PO Box 599
Mill Valley, CA 94942
(415) 383-1770
www.marinaudubon.org
Founded in 1956 to oppose a bay fill project in Richardson Bay; has spearheaded the acquisition of local baylands for habitat; covers Marin County.

The Marine Mammal Center

Marin Headlands
1065 Fort Cronkhite
Sausalito, CA 94965
(415) 289-7325
www.marinemammalcenter.org
Rehabilitates ill, injured, or orphaned marine mammals, including seals and others found in San Francisco Bay.

Marine Science Institute

500 Discovery Parkway
Redwood City, CA 94063
(650) 364-2760
www.sfbaymsi.org
Takes thousands of kids a year on research and monitoring trips on San Francisco Estuary waters.

Mount Diablo Audubon

PO Box 53
Walnut Creek, CA 94597
(925) 735-3836
www.diabloaudubon.org
Covers the south shore of the Carquinez Strait and the delta.

Napa-Solano Audubon

PO Box 5027
Vallejo, CA 94591
(707) 643-7089
www.audubon-ca.org
Covers Napa and Solano Counties.

Natural Heritage Institute

2140 Shattuck Avenue, Fifth Floor
Berkeley, CA 94704
(510) 644-2900
www.n-h-i.org
Works on water policy questions in California and worldwide.

Natural Resources Defense Council

San Francisco Regional Office
71 Stevenson Street, Suite 1825
San Francisco, CA 94105
(415) 777-0220
www.nrdc.org
Pursues California water policy reform and bay-delta protection; long involved in efforts to restore the San Joaquin River.

The Nature Conservancy

California Field Office
201 Mission Street, Fourth Floor
San Francisco, CA 94105
(415) 777-0487
calweb@tnc.org
The world's largest private land preservation organization; has many projects in California.

The Nature Conservancy

Cosumnes River Preserve
13501 Franklin Boulevard
Galt, CA 95632
(916) 684-2816
www.cosumnes.org
A consortium of seven public and private agencies; manages thousands of acres of wetlands, farmlands, and streamside oak forests along the lower Cosumnes River and in the adjacent Sacramento–San Joaquin River Delta.

Oceanic Society
Fort Mason Center
San Francisco, CA 94123
(800) 326-7491
www.oceanic-society.org
Protects marine wildlife worldwide
through research, education, and volun-
teerism; monitors gray whales in San
Francisco Bay.

Ohlone Audubon
1922 Hillsdale Street
Hayward, CA 94541
(510) 538-3550
www.members.aol.com/
OhloneAudubon
Covers the southern East Bay.

**Pacific Coast Federation of
Fishermen's Associations**
PO Box 29370
San Francisco, CA 94129
(415) 561-5080
www.pcffa.org
Represents the interests of the fishing in-
dustry on the West Coast, including fish
habitat protection and river flows.

Peninsula Open Space Trust
3000 Sand Hill Road
Building 4, Suite 135
Menlo Park, CA 94025
(650) 854-7696
www.openspacetrust.org
Land trust; acquired Bair Island.

Point Reyes Bird Observatory
4990 Shoreline Highway
Stinson Beach, CA 94970
(415) 868-1221
www.prbo.org
Does biological research and education.

San Francisco Bay Bird Observatory
1290 Hope Street
PO Box 247
Alviso, CA 95002
(408) 946-6548
www.sfbbo.org
Does biological research and education.

San Francisco Bay Joint Venture
530C Alameda del Prado, Suite 139
Novato, CA 94949
(415) 883-3854
www.sfbayjv.org
Partnership of organizations, government
agencies, and businesses dedicated to re-
storing and enhancing wetlands.

San Francisco Bay Wildlife Society
PO Box 524
Newark, CA 94560
(510) 792-0222
www.sfbws.org
Supports the region's national wildlife
refuges.

San Francisco Estuary Institute
7770 Pardee Lane
Oakland, CA 94621
(510) 746-7334
www.sfei.org
The scientific and monitoring offshoot
of the San Francisco Estuary Project; in-
volved in *Baylands Ecosystem Habitat Goals*
report; maintains EcoAtlas.

Santa Clara Valley Audubon
22221 McClellan Road
Cupertino, CA 95014
(408) 252-3747
www.scvas.org
Founded in 1926; covers Santa Clara
County.

**Save San Francisco Bay Association
(Save the Bay)**
1600 Broadway, Suite 300
Oakland, CA 94612
(510) 452-9261
www.savesfbay.org
Founded to bring a halt to bay fill; has
broadened its focus to include all aspects
of bay affairs.

Sequoia Audubon
PO Box 3897
Redwood City, CA 94064
(650) 369-1093
www.sequoia-audubon.org
Covers San Mateo County.

Sierra Club
85 Second Street, Second Floor
San Francisco, CA 94105
(415) 977-5500
www.sierraclub.org
Leading national environmental organi-
zation, active in bay affairs through local
chapters.

Sierra Club—Loma Prieta Chapter
3921 East Bayshore Road, Suite 204
Palo Alto, CA 94303
(650) 390-8411
www.lomaprieta.sierraclub.org
Covers San Mateo and Santa Clara
Counties.

Sierra Club—Mother Lode Chapter
1414 K Street, Suite 500
Sacramento, CA 95814
(916) 557-1100, ext 108
www.motherlode.sierraclub.org
Covers Yolo, Sacramento, and San Joa-
quin Counties.

Sierra Club—Redwood Chapter
PO Box 466
Santa Rosa, CA 95402
(707) 544-7651
www.redwood.sierraclub.org
Covers Sonoma, Napa, and Solano
Counties.

**Sierra Club—San Francisco Bay
Chapter**
2530 San Pablo Avenue, Suite I
Berkeley, CA 94702
(510) 848-0800
www.sanfranciscobay.sierraclub.org
Covers San Francisco, Marin, Alameda,
and Contra Costa Counties.

Solano Land Trust
PO Box 115
Fairfield, CA 94533
(707) 432-0150
www.solanolandtrust.org
Land trust; owns Rush Ranch in Suisun
Marsh.

Trust for Public Land
116 New Montgomery Street
Fourth Floor
San Francisco, CA 94105
(415) 495-4014
www.tpl.org
Acquires land for conservation and com-
munity use.

Urban Creeks Council
1250 Addison Street, #107-C
Berkeley, CA 94702
(510) 540-6669
www.urbancreeks.org
Works to preserve, protect, and restore
urban streams and their riparian habitats,
especially in the Bay Area.

Water Education Foundation
717 K Street, Suite 317
Sacramento, CA 95814
(916) 444-6240
www.water-ed.org
Educates the public about water issues; publishes *Western Water* magazine.

WaterKeepers
Presidio Building 1004
PO Box 29921
San Francisco CA 94129
(415) 561-2299
www.sfbaykeeper.org
Fights pollution through research and litigation; branches include San Francisco BayKeeper, DeltaKeeper, Petaluma RiverKeeper.

GOVERNMENT AGENCIES
Association of Bay Area Governments
PO Box 2050
Oakland, CA 94604
(510) 464-7900
www.abag.ca.gov
Consortium of local governments; hosts Bay Trail Project and San Francisco Estuary Project.

Bay Conservation and Development Commission
50 California Street, Suite 2600
San Francisco, CA 94111
(415) 352-3600
www.bcdc.ca.gov
Controls bay fill and maintains a plan for the immediate shoreline of the bay as far east as Suisun Marsh.

Bay Trail Project
PO Box 2050
Oakland, CA 94604
(510) 464-7935
www.abag.ca.gov/bayarea/baytrail
Located at the Association of Bay Area Governments; coordinates work toward a trail system ringing the bay.

CALFED Bay-Delta Program
1416 Ninth Street, Suite 1155
Sacramento, CA 95814
(916) 657-2666
http://calfed.ca.gov
Consortium of agencies; seeks to reconcile water development and environmental protection in the estuary.

California Coastal Conservancy
1330 Broadway, Eleventh Floor
Oakland, CA 94612
(510) 286-1015
www.coastalconservancy.ca.gov
Buys and enhances coastal lands and access points, including many sites around the San Francisco Estuary; incorporates the San Francisco Bay Conservancy.

California Department of Fish and Game
Central Coast Region
PO Box 47
Yountville, CA 94599
(707) 944-5500
www.dfg.ca.gov
Covers counties of Alameda, Contra Costa, Marin, Napa, San Mateo, Santa Clara, San Francisco, Solano (part), and Sonoma.

California Department of Fish and Game
Central Sierra Region
1701 Nimbus Road
Rancho Cordova, CA 95670
(916) 358-2900
www.dfg.ca.gov
Covers counties of Sacramento, San Joaquin, Solano (part), and Yolo.

California Department of Fish and Game
Central Valley Bay-Delta Branch
4001 North Wilson Way
Stockton, CA 95205
(209) 948-7800
www.delta.dfg.ca.gov
Research office; houses Interagency Ecological Program in bay-delta studies.

California Department of Fish and Game
Lands and Facilities Branch
1812 Ninth Street
Sacramento, CA 95814
(916) 445-3400
www.dfg.ca.gov/lands
Source of information on state wildlife areas around the bay-delta system, including the Petaluma Marsh and the Napa-Sonoma Marshes, north of San Pablo Bay; Grizzly Island, in Suisun Marsh; and Point Edith, east of Martinez.

California Department of Parks and Recreation
PO Box 942896
Sacramento, CA 94296
(800) 777-0369
www.parks.ca.gov
Bay-delta parks include Olompali, China Camp, and Angel Island in Marin County; Franks Tract and Bethany Reservoir in eastern Alameda County; and Brannan Island, Delta Meadows, and Stone Lake in Sacramento County.

Central Valley Regional Water Quality Control Board
3443 Routier Road, Suite A
Sacramento, CA 95827
(916) 255-3000
www.swrcb.ca.gov
Administers pollution control in the delta.

Delta Protection Commission
PO Box 530
Walnut Grove, CA 95690
(916) 776-2290
www.delta.ca.gov
Intergovernmental body; is preparing a regional plan for the delta.

Don Edwards San Francisco Bay National Wildlife Refuge
PO Box 524
Newark, CA 94560
(510) 792-0222
desfbay.fws.gov
Administers the core refuge around the South Bay and also Alameda, Antioch Dunes, Farallon Islands, Marin Islands, and San Pablo Bay National Wildlife Refuges.

East Bay Regional Park District
PO Box 5381
Oakland, CA 94605
(510) 562-7275
www.ebparks.org
Administers numerous bayside parks in Alameda and Contra Costa Counties, including (south to north) Coyote Hills, Hayward Shoreline, Oyster Bay, Crown Beach, Martin Luther King Junior Shoreline, Point Isabel, Brooks Island, Point Pinole, Carquinez Strait Shoreline, Martinez Shoreline, and Browns Island.

Golden Gate National Recreation Area
Fort Mason, Building 201
San Francisco, CA 94123
(415) 561-4700
www.nps.gov/goga
Includes the San Francisco shoreline from the Presidio to Aquatic Park; Alcatraz Island; Marin Headlands.

InterAgency Ecological Program
4001 North Wilson Way
Stockton, CA 95205
(209) 948-7800
www.iep.ca.gov
Coordinates research by nine state and federal agencies on delta issues.

Midpeninsula Regional Open Space District
330 Distel Circle
Los Altos, CA 94022
(650) 691-1200
www.openspace.org
Manages several shoreline properties, including the Ravenswood Preserve in East Palo Alto.

National Marine Fisheries Service
Southwest Regional Office
501 West Ocean Boulevard
Long Beach, CA 90802
(562) 980-4000
swr.nmfs.noaa.gov
Works to understand and protect fish stocks that use both bay and ocean.

National Park Service
See Golden Gate National Recreation Area *and* San Francisco Maritime National Historic Park.

Port of Oakland
530 Water Street
Oakland, CA 94607
(510) 627-1100
www.portofoakland.com
The region's dominant port.

Port of San Francisco
Pier 1
San Francisco, CA 94111
(415) 274-0400
www.sfport.com
The region's original port.

Romberg Tiburon Center for Environmental Studies
3152 Paradise Drive
Tiburon, CA 94920
(415) 338-6063
www.rtc.sfsu.edu
Research center attached to San Francisco State University; site has been a coaling station, a maritime academy, and a naval net depot.

San Francisco Bay Area Water Transit Authority
120 Broadway
San Francisco, CA 94111
(415) 291-3377
www.watertransit.org
Plans for and advocates expanded ferry service.

San Francisco Bay National Wildlife Refuge Complex
See Don Edwards San Francisco Bay National Wildlife Refuge.

San Francisco Bay Regional Water Quality Control Board
1515 Clay Street, Suite 1400
Oakland, CA 94612
(510) 622-2300
www.swrcb.ca.gov
Administers pollution control around the bay west of the delta.

San Francisco Estuary Project
1515 Clay Street, Suite 1400
Oakland, CA 94612
(510) 622-2465
www.abag.ca.gov/bayarea/sfep
Original consortium of agencies working on estuary restoration.

San Francisco Maritime National Historic Park
Fort Mason Center, Building E
San Francisco, CA 94123
(415) 556-3002
www.nps.gov/safr
Administers San Francisco Maritime Museum and historic vessels moored at the nearby Hyde Street Pier.

State Water Resources Control Board
PO Box 100
Sacramento, CA 95812
(916) 341-5250
www.swrcb.ca.gov
Allocates water in California under a byzantine system of water law; also supervises the Regional Water Quality Control Boards; a key power in San Francisco Estuary affairs.

U.S. Army Corps of Engineers
San Francisco District
333 Market Street
San Francisco, CA 94105
(415) 977-8356
www.spn.usace.army.mil
Maintains channels and flood control facilities; regulates filling of wetlands; now works also on bay restoration.

U.S. Coast Guard
Pacific Area, Eleventh District
Coast Guard Island
Alameda, CA 94501
(510) 437-3325
www.uscg.mil/d11
Runs the Vessel Traffic Service on Yerba Buena Island; maintains navigational buoys; performs search and rescue; helps to deal with oil spills and pollution; has increasing security responsibilities.

U.S. Fish and Wildlife Service
See Don Edwards San Francisco Bay National Wildlife Refuge.

U.S. Geological Survey
Water Resources Division
345 Middlefield Road, Mailstop 496
Menlo Park, CA 94025
(650) 853-8300
www.sfbay.wr.usgs.gov
Hosts many research programs of interest; web site summarizes findings.

**A FEW RECREATION CLUBS
AND PROVIDERS**

Bay Area Sea Kayakers
c/o 229 Courtright Road
San Rafael, CA 94901
(415) 459-8727
www.bask.org
Works to establish access points and a "water trail."

Berkeley Boardsports
1601 University Avenue
Berkeley, CA 94703
(510) 843-9283
www.boardsports.com
Sells gear and dispenses advice to board-sailors, kiteboarders, surfers, and snow-boarders.

Dolphin Club
Aquatic Park
502 Jefferson Street
San Francisco, CA 94109
(415) 441-9329
www.dolphinclub.org
Welcomes swimmers, rowers, and other athletes at a historic waterfront clubhouse.

Hawaiian Chieftain
3020 Bridgeway, Suite 266
Sausalito, CA 94965
(415) 331-3214
www.hawaiianchieftain.com
Offers short cruises on a topsail ketch modeled on late-eighteenth-century Spanish vessels but built of steel.

Olympic Circle Sailing Club
One Spinnaker Way
Berkeley Marina
Berkeley, CA 94710
(510) 843-4200
www.ocscsailing.com
A sailing school and supporter of bay conservation efforts.

Red and White Fleet
Pier 43½
San Francisco, CA 94133
(415) 673-2900
www.redandwhite.com
Offers diverse bay tours and regular service to Alcatraz.

**San Francisco Boardsailing
Association**
1592 Union Street, Box 301
San Francisco, CA 94123
(415) 552-9091
www.sfba.org
Represents and informs the region's windsurfers.

Sea Trek
PO Box 1987
Sausalito, CA 94966
(415) 488-1000
www.seatrekkayak.com
Offers kayak trips locally and worldwide.

South End Rowing Club
500 Jefferson Street
San Francisco, CA 94109
(415) 776-7372
www.south-end.org
Welcomes swimmers, rowers, and other athletes at a historic waterfront clubhouse.

**Yacht Racing Association of San
Francisco Bay**
Fort Mason Center
San Francisco, CA 94123
(415) 771-9500
www.yra.org
Administers races in northern California; web site lists numerous local clubs.

Index

Designer: Jennifer Barry,
 Jennifer Barry Design
Compositor: Kristen Wurz
Cartographer: Ben Pease, Pease Press
Text: 10/14 Bembo
Display: Centaur Festive MT
Printer/Binder: Graphicom, Inc.

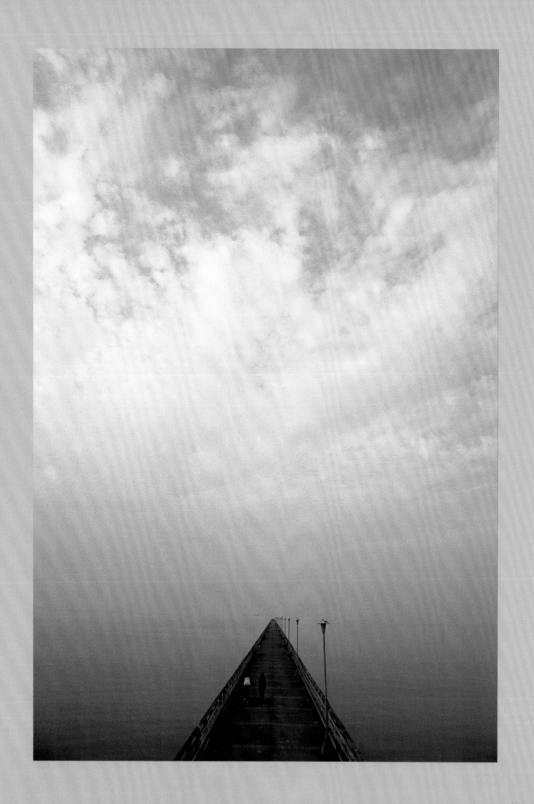

Berkeley Pier in fog.